FACES OF
UNION SOLDIERS
AT ANTIETAM

JOSEPH STAHL & MATTHEW BORDERS

THE
History
PRESS

Published by The History Press
Charleston, SC
www.historypress.com

Unless otherwise noted, images are from the private collection of Joseph Stahl.

First published 2019

Manufactured in the United States

ISBN 9781467142786

Library of Congress Control Number: 2019935363

Notice: The information in this book is true and complete to the best of our knowledge. It is offered without guarantee on the part of the authors or The History Press. The authors and The History Press disclaim all liability in connection with the use of this book.

To the thirty-six soldiers whose stories are contained within these pages.

CONTENTS

Acknowledgements

No significant amount of research or writing was ever done in a vacuum, and the same is true for this work. The authors would like to thank the following individuals for their kind assistance in making this book possible. Firstly, our colleagues in the Antietam Battlefield Guides, dedicated historians all, were very enthusiastic and encouraging when we were developing this work. In particular, Dr. Thomas Clemens, the editor of the three-volume work on the Maryland Campaign by Ezra Carman, looked at several of the early chapters and gave insights into officers' uniforms and how they were obtained. The former chief of the Antietam Guides, Jim Rosebrock, also reviewed the manuscript, as did retired guide William Sagle. Both gave valuable advice regarding consistency when blending two writing styles. Jim Buchanan, an expert on the intense fighting in the West Woods, was of great assistance in scanning and preparing the soldier CDVs for publication. Finally, Kevin Pawlak, like Matt a graduate of the 2012 class of guides, helped in the opening stages of the publication process, giving advice on potential publishers and providing information on publishers he had worked with. This advice led to The History Press and Kate Jenkins, the acquisitions editor who helped guide this work to publication.

In addition, Joe had Dr. John Hiller, a former co-worker, review the work as well. His insights regarding the flow of the manuscript were greatly appreciated. Joe was also able to retain the assistance of Dr. Brad Gottfried and his excellent troop movement maps of Antietam National Battlefield.

ACKNOWLEDGEMENTS

Brad was gracious enough to edit and allow us to use these maps for this work. Thank you.

Matt would also like to thank his comrades in Company A of the 3rd Maryland Volunteer Infantry. Jon "Private Hardcore" Psotka's dedication to period dress, both military and civilian, was of great assistance when examining the CDVs for details. Jimmy Thomas, a veteran of the United States Marine Corps and the 3rd's determined lieutenant, gave insight into wearing an officer's uniform. While David Bloom, Sarge, a true historian of the 3rd Maryland Infantry, was able to provide significant information on Private William Keiner of the 3rd Maryland Infantry and discussed the equipage of the regiment throughout the war.

Finally, for their ever-present support, Matt would like to thank his parents, Drs. Dale and Janet Borders, who started his Civil War obsession with that first trip to Gettysburg all those years ago. Also, his wonderful wife, Kira, who has taken up the torch of feeding his Civil War obsession and patiently listened to him babble on about uniforms and regulations during the writing of this work. Love to you all.

Maps

INTRODUCTION

The purpose of this book is to introduce to the reader a number of individual Union soldiers who fought in the Battle of Antietam on September 17, 1862. These are not famous names, and they were not generals at the time of the battle; they were common soldiers just trying to do their duty. Here you will find their stories, who they were, where they came from and what happened to them. Each soldier's image is included so the reader has a face to see; the images themselves come from author Joe Stahl's personal collection of cartes de visite. The soldiers' units and their location on the field are presented using maps provided with permission from Brad Gottfried's book *The Maps of Antietam*. The time stamps on these maps and the descriptions of the events that these units were involved in are based on information obtained in the *Official Records of the War of the Rebellion* and their individual unit histories. We hope that readers will use this book as they tour Antietam National Battlefield and that it helps to make the events of 155 years ago all that more real to them.

CARTE DE VISITE (CDV)

Carte de visite is French for "visiting card." By 1860, these paper images had become common in the United States. Since the price was within reach of many people ($2.50 to $3.00 per dozen), it was not unusual to have an

album of images of the family and relatives. The cameras of the era took four images from four lenses at one time. The glass negative could produce multiple copies, which accounted for the low price. The images were then pasted onto a piece of card to make them sturdier; this was done for all CDVs at the time, and a lack of a seam can be a good indicator for determining if an image is a modern reproduction. These images became very popular with soldiers, allowing them to show off their uniforms, leave a keepsake for someone at home or give a copy to a comrade.

Some of the CDVs included in this work have a stamp on the back of them. From September 1, 1864, to August 1, 1866, the images were taxed by the Federal government and required a revenue stamp on the reverse of the card (this helps in dating some cards). The tax was to help raise revenue for the war effort: two cents on photographs under twenty-five cents, three cents on photos up to fifty cents and five cents for those costing up to a dollar. Photos were to be canceled, usually by having a line drawn through the stamp, with the photographer's initials and the date of the sale, but sadly this regulation was often ignored and the stamps were either struck out or rubber stamped for convenience.[1] Collecting images of the generals became popular during the war; as a result, many different poses of some generals exist and are available today. By the 1880s, other sizes of photographs replaced the CDV in popularity.

We have also included a description of each soldier's image to discuss the details that can be made out in each CDV. Specifics such as uniform features, rank and other aspects of the images are discussed. It is hoped that these details will help readers see these men as the individuals they were and not just faces from a bygone era.

THE MARYLAND CAMPAIGN OF 1862

By the fall of 1862, the American Civil War had been raging for nearly a year and a half. Thousands had fallen on both sides, and the fortunes of war had swayed back and forth. General Robert E. Lee was given command of Confederate forces outside of Richmond following the Battle of Seven Pines, May 31–June 1, 1862, and soon launched the blistering counteroffensive known as The Seven Days. These bold strokes by the Confederates cost them dearly in manpower but convinced the Union army to fall back to its fortified base of supply at Harrison's Landing on the James River. This freed

Lee to open the Northern Virginia Campaign, which culminated at the end of August 1862 at the Second Battle of Bull Run (Second Manassas), fought August 28–30. There Lee defeated the Union Army of Virginia under Major General John Pope and sent it retreating to the defenses of Washington. Lee's Army of Northern Virginia now had an open road north and proceeded to cross the Potomac River into Maryland on September 4, 1862. Lee's communications with Confederate president Jefferson Davis reveal some of his thoughts on why he chose to take this risk, including resupplying his army off the farmlands of Maryland, keeping the pressure on Washington and keeping the Federals out of war-ravaged northern Virginia as long as possible.[2]

The first Confederate invasion of the North sparked a drastic and dramatic reorganization of Union forces around Washington, D.C. All Federal soldiers in the vicinity of the national capital were placed under Major General George B. McClellan. The recently defeated Army of Virginia and elements of the Washington garrison were merged into the Army of the Potomac. McClellan was ordered to take this still-reorganizing command, move into western Maryland and drive Lee out, all while keeping Washington and Baltimore protected.[3] This pursuit of Confederate forces set into motion a campaign of long marches, lost orders and desperate engagements, all before approximately 100,000 men in blue and gray clashed near Antietam Creek on September 17, 1862, the bloodiest one-day battle of America's costliest war.

The thirty-six men presented here were part of this campaign, one that would see some of the worst fighting in the American Civil War. This campaign, and their sacrifices in it, helped to ensure the defeat of the First Confederate Invasion of the North, a major turning point in the war, and the beginning of a new birth of freedom for over four million enslaved peoples.

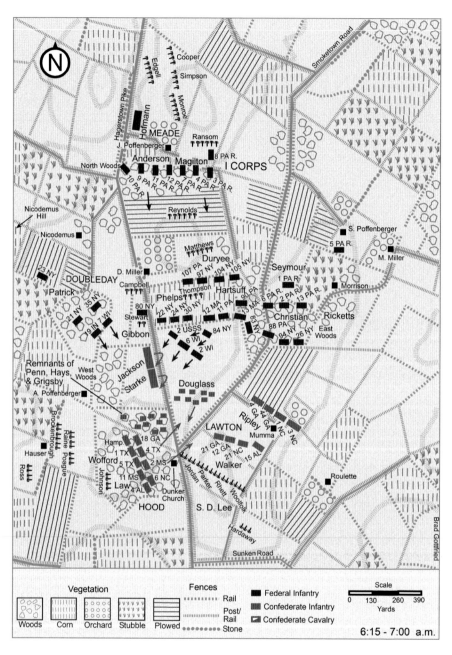

Major General Joseph Hooker's 1st Corps opens the attack in the Cornfield, 6:15–7:00 a.m. *Courtesy Brad Gottfried.*

1

CORNFIELD

B etween about 6:15 and 7:00 on the morning of September 17, Union
brigadier general Abner Doubleday's division of the 1st Corps, Army of
the Potomac, moved south from its position around the Joseph Poffenberger
farm toward the Dunker Church. On Doubleday's right was the brigade of
Brigadier General Marsena Patrick and on the left the brigade of Colonel
Walter Phelps. In support was the 1st New Hampshire Light Artillery,
massed with other Federal batteries on the Poffenberger farm to suppress
the Confederate horse artillery bombarding the Federal advance from
Nicodemus Heights. In General Patrick's brigade was the 23rd New York
Infantry, sent to guard the right flank of the division's advance. Also in the
brigade was the 35th New York Infantry, advancing in support of Brigadier
General John Gibbon's western troops. The 35th advanced south across an
open field with a high rock ledge on its left.

The 22nd New York was on the right of Phelps's brigade as it moved south
through the Cornfield, parallel to the Hagerstown/Sharpsburg Turnpike.
The 24th New York was in the center of Phelps's brigade, with the 30th
New York Infantry on the left. The following soldiers were a part of that
fighting and were members of those units. Map 1 shows the dispositions of
these units at between 6:15 and 7:00 the morning of the seventeenth. The
movements of these units are indicated by arrows on the map.

23ʳᵈ New York Infantry

The 23ʳᵈ was composed of three companies from Steuben County, two from Tioga, two from Chemung, one from Alleghany, one from Cortland and one from Schuyler and was known as the Southern Tier Regiment due to it being raised entirely from counties in New York State's Southern Tier region. It was mustered into Federal service at Elmira on July 2, 1861, for a two-year term and left the state for Washington, D.C., on the fifth. After its two years of service, on June 26, 1863, the unit was mustered out in New York City, having lost seventy-two killed from wounds and other causes.[4]

At Antietam, the 23ʳᵈ was moved to the west behind the West Woods; however, the 10ᵗʰ Pennsylvania Reserve Infantry was already there. Thus, the 23ʳᵈ was marched forward. A history of the unit says that "the 23ʳᵈ marched forward into battle, replacing the 7ᵗʰ Wisconsin at the rock ledge….[T]he men of the 23ʳᵈ leapt up onto the ledge and let forth a burst of hurrahs as they ran in line through the clove field and up to the post and rail fence along the pike."[5] The regiment reported its strength to be 238 officers and enlisted men.[6] It suffered 4 killed, 35 wounded and 3 missing in action for a total of 42 over the course of the morning.[7]

As the 23ʳᵈ advanced on the right of the brigade during the Battle of Antietam, one of the soldiers who was moving south with the regiment was Private Harlow Ames. Harlow Ames stated that he was nineteen years old when he mustered into Company D of the 23ʳᵈ New York State Volunteer Infantry on May 16, 1861, for two years of service. He mustered in at Elmira, although he was from Corning. Private Ames's service records show that for the period from May 16 to November/December, his status was "not stated," which was common for this period of the war. The February 28, 1862 roll shows that Harlow was "present." The succeeding rolls also show him as "present" until the April 10, 1863 roll. So, he was on the field at Antietam. However, the April 10 report states Ames "died at Regt. Hospital March 24, 1863 of consumption." It also reports that Private Ames had last been paid on October 31, 1862. The Casualty Sheet from Ames's military record says he died at Bell Plains, Virginia, of chronic diarrhea. Regardless, Harlow is one of the many soldiers who paid the ultimate price for his service, not from combat but disease. In 1879, his mother filed for a pension.[8]

The image here is of Private Harlow Ames of Company D, probably taken close to his muster-in date. The image of Private Harlow Ames is

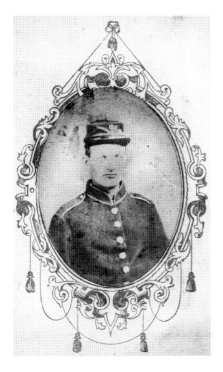

Left: Private Harlow Ames, 23rd New York Infantry. *Right*: Back of Ames's image.

interesting for several reasons. The most obvious is the intricately drawn decorative card that the trimmed image has been attached to. Unfortunately, the photographer was not identified on the CDV. The second is that the image is flipped due to the printing process from glass-plate negative to the card. This can be seen by the brass letter on Private Ames's kepi. While it looks like a *G*, this is actually a *D*, for Company D, the only company in which Private Ames served during his brief enlistment. Company letters and sometimes regimental numbers were attached to the front of the kepi or on top of a forage cap.[9]

Finally, there is Private Ames's attire. This distinctive uniform jacket was distributed by the State of New York to its forces starting in 1861.[10] While the image of Private Ames is quite faded, the characteristic shoulder straps with their light-blue piping can be clearly seen, as can the blue piping around the collar. There are eight large New York State buttons running down the front of the jacket, as well as two small brass buttons for opening the shoulder straps. This style of militia jacket also has belt loops for the soldier's accouterments.

35ᵀᴴ New York Infantry

The unit to the left of the 23ʳᵈ New York was the 35ᵗʰ New York Infantry. The 35ᵗʰ Infantry was known as the Jefferson County Regiment. It was composed of six companies from Jefferson, one from Lewis, one from Steuben, one from Madison County and one from New York City, Buffalo and Elmira and was mustered into Federal service at Elmira on June 11, 1861, for two years. It left the state on July 11 for Washington, D.C., where it passed the winter of 1861–62. On May 18, 1863, the three-year men were transferred to the 80ᵗʰ New York Infantry, and the next day the regiment left Aquia Creek for Elmira, where it was mustered out on June 5, 1863, having lost 44 members by death from wounds and 56 from accident, imprisonment or disease, out of a total enrollment of 1,250.[11]

A letter written by a soldier in the 35ᵗʰ says of the Battle of Antietam, "the 35ᵗʰ and 23ʳᵈ were thrown forward to a cliff, in a position at right angles to the advancing rebel line. Covering ourselves behind the cliff we poured a raking fire into them."[12] At Antietam, the 35ᵗʰ was reported to be 230 officers and enlisted men strong.[13] The regiment lost 8 killed, 55 wounded and 4 missing, for a total of 67.[14]

Among the members of the 35ᵗʰ was Lieutenant Jay McWayne. Lieutenant McWayne mustered into Company K of the 35ᵗʰ New York Infantry on June 11, 1861. McWayne was listed as an "Ensign," and he enlisted for two years at Elmira. He was twenty-seven years old. On July 15, 1861, McWayne was listed as "present." One form indicates his rank as second lieutenant, but another still shows him as an ensign. McWayne's status is "not stated" from July 29 to December 31, 1861. The January/February report shows him as "present" and that he was promoted to first lieutenant on January 17, 1862. It also indicates that he was due "back pay." In April 1862, Lieutenant McWayne was detached to the Brigade Provost Guard, so he was absent from the regiment. He remained detached until September 14, 1862, when he returned to the regiment. McWayne's service records show him present until March/April 1863, when his status was "not stated." Lieutenant McWayne mustered out on June 5, 1863, at Elmira, New York. He had last been paid on February 28, 1863, and was due an additional ten dollars per month as commander of the company since September 13, 1862.[15] In a letter published in the brief regimental history, Lieutenant McWayne reported, "Early on the morning of September 14, I called on the general [Brigadier General Marsena Patrick, the brigade commander]

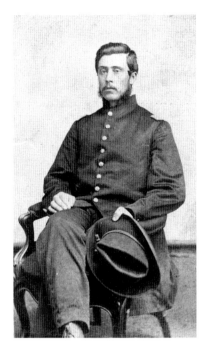 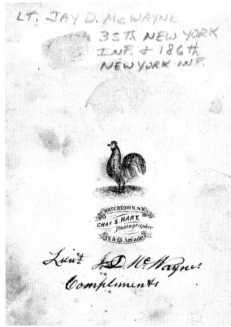

Left: Second Lieutenant Jay McWayne, 35ᵗʰ New York Infantry. *Right*: Back of McWayne's image.

and requested to be relieved from the command of the guard, so that I could take command of my old beloved Company 'K.' He looked me in the face for some time in silence—holding my hand in a firm grip—and then said I could go that day."[16] McWayne died long after the war on February 13, 1927, in Sacket Harbor, New York.[17]

This photo was taken in Watertown, New York, by Charles S. Hare Photographer and appears to have been a gift or calling card of sorts due to it being signed on the back and including the word "compliments." The picture studio provided a chair for Lieutenant McWayne to sit in, and his posture allows for much more of his uniform to be seen than is common for seated pictures. The top of his shoe can be seen at the very bottom of the image. Though the whole shoe cannot be seen, it does appear that Lieutenant McWayne was wearing a variation of the Federal-issue footwear, commonly called brogans, Jefferson booties or a variety of more colorful nicknames. Simple leather shoes with leather soles, they were mass manufactured with the rough out and tied with leather laces. At the beginning of the war, shoes for both sides were

notoriously shoddy, with a life expectancy between twenty and thirty days, but as the war progressed, better-quality shoes became available, at least in the Union.[18]

Lieutenant McWayne is wearing the dark-blue trousers that were commonly worn by officers. It should be noted that his trousers do not have the regulation sky-blue piping running down the seam. As with many officers, Lieutenant McWayne is wearing a nine-button single-breasted frock coat that is buttoned to the neck with large U.S. eagle buttons. His frock coat also has his shoulder boards, though with the angle of the photo it is not possible to determine if this was taken when he was a second or first lieutenant.

The image is rounded out with a slouch hat held by Lieutenant McWayne. The slouch hat was a soft, comfortable, wide-brimmed hat that was very popular with officers in both armies and all theaters of the war.[19] In the western theater, these privately purchased hats were common among Federal enlisted men as well. Lieutenant McWayne's hat features a hat cord for decoration, likely an officer's gold-and-black cord, and has a binding tape running around the brim. It is thought that this hat might be a prop used by the photographer to add to the photo. The hat seems a bit large for Lieutenant McWayne, but this is just speculation. Wrapping up his photo, Lieutenant McWayne neatly combed and oiled his hair, giving it the shine that is being picked up in the photo, and grew a set of mutton chops.

22ND NEW YORK INFANTRY

Serving in Colonel Phelps's brigade in the Cornfield was the 22nd New York Infantry. The 22nd Infantry was known as the 2nd Northern New York Regiment. It was composed of four companies from Washington County, three from Essex, two from Warren and one from Saratoga County and was mustered into U.S. service at Camp Rathbone, Troy, on June 6, 1861, for two years. The regiment was mustered out at Albany on June 19, 1863, having lost seventy-two men by death from wounds and twenty-eight by death from other causes.[20]

In his official report on the Battle of Antietam, Colonel Phelps states:

I was ordered by General Hooker, who in person designated the position for this brigade to occupy, to move by flank through the open field in which this battery had taken position, and, passing into a corn-field, to form line of battle and support [Brigadier General John] *Gibbon's brigade, which I observed was steadily advancing to the attack. The direct and cross artillery fire from the enemy's batteries playing upon this field was very heavy, but my brigade was moved without loss to a position some 90 paces in advance of* [Battery B, 4th U.S. Light Artillery, Captain Joseph B.] *Campbell's battery, where I deployed column, and in line of battle moved steadily forward some 50 paces in rear of Gibbon's infantry, who at this time had not engaged the enemy, but were cautiously advancing through the corn-field. This command consisted of the Second U.S. Sharpshooters* [which was temporarily detached from the brigade during the engagement of Sunday], *the Fourteenth New York State Militia, the Twenty-second, Twenty-fourth, and Thirtieth New York Volunteers.*[21]

At the Battle of Antietam, the 22nd Infantry lost two killed, twenty-eight wounded and none missing for a total of thirty.[22] The unit's strength at the time is unknown.

One of the soldiers in the 22nd that day in the Cornfield was John J. Baker. John Baker mustered into Company E of the 22nd New York Infantry on June 6, 1861, as a private for two years at Troy, New York. He stated he was twenty-two. He did not give a residence. John's status was "not stated" through to December 31, 1861. However, during that period, on September 1, John was promoted to fifth sergeant. He also had extra accouterments to the amount of eighty cents issued to him. Sergeant Baker was "present" from January 1862 to the May/June period when he was listed as "absent sick in hospital" and as first sergeant of his company. Apparently, Baker recovered, as he was "present" for July/August. On August 31, 1862, Baker was promoted again, this time to second lieutenant. On December 26, Lieutenant Baker was transferred to Company K, and he owed the government thirty-nine cents for one haversack. Presumably, he had lost it. The following March, 1863, John Baker was a first lieutenant and listed as present until he mustered out on June 19, 1863, at Albany, New York. He was last paid on February 28, 1863.

Baker returned to the service in the 2nd New York Veteran Cavalry on September 3, 1863, as a first lieutenant. On December 14, 1863,

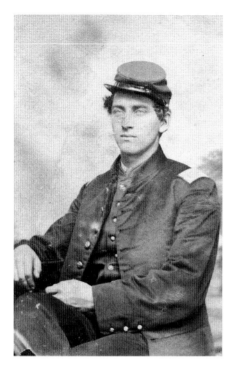
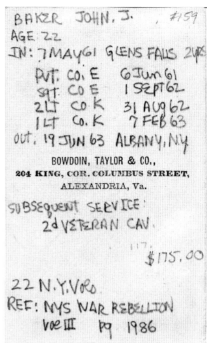

Left: Second Lieutenant John J. Baker, 22nd New York Infantry. *Right*: Back of Baker's image.

he was promoted to captain, but he resigned on September 18, 1864.[23] John Baker passed away in 1909 according to the index card for his pension file.[24]

John Baker was promoted to the rank of second lieutenant on August 31, 1862, just before the launch of the Maryland Campaign. He had his picture taken in Alexandria, Virginia, likely just after his promotion. One potential reason for Lieutenant Baker's promotion to the 22nd New York's officer corps could have been due to the tremendous casualties the regiment's officers sustained at the Second Battle of Bull Run. The date of his promotion seems to suggest this, as the 22nd was involved in the heavy fighting at Bull Run on August 30.[25]

Photographed in Alexandria, Virginia, by Bowdoin, Taylor and company, Lieutenant Baker is in a seated position, limiting some of the potential details of the image. However, it can be seen that he is wearing dark-blue trousers, as well as an officer's frock coat. The button hole that can be seen just underneath the left arm is in line with the stitching that

attaches the frock coat's long skirt to the coat itself. This distinct line of stitches, as well as the three small U.S. eagle buttons on the cuff and the nine large U.S. eagle buttons running down the coat, identify this coat as a frock.[26] On the frock itself, Lieutenant Baker has the traditional gold-trimmed shoulder boards with no bars indicative of a second lieutenant's rank. Of particular interest is the lieutenant's dark-blue vest; the vest was worn to allow him to conform to uniform regulations that the shirt, considered an undergarment, should not be seen while still allowing the officer to have his coat unbuttoned if desired.[27] The vest appears to have two different types of buttons, likely indicating repair work over time. From the neck moving down, there would be nine small U.S. eagle buttons on an officer's vest. The vest worn by Lieutenant Baker may have been one he wore as a noncommissioned officer prior to his promotion to the officer ranks, as it appears to have at least three New York State buttons. The first, second and most definitely the fifth button all appear to have the prominent ring design used by New York State buttons, while the other buttons that can be seen are the small U.S. eagle buttons.

Another possible clue to how recently Lieutenant Baker had been promoted to the officer ranks of the 22nd New York Infantry is his forage cap. Far from a fancy embroidered cap or even an officer's patch on the front, the forage cap Lieutenant Baker is wearing is quite standard. A square leather visor with rounded corners—with a glazed leather chin strap, picking up the glare in the photo—can be seen.[28] This cap appears in very good shape and could be a new purchase specifically for the promotion and rank. Finally, Lieutenant Baker rounds out his image with a clean-shaven face and hair brushed forward.

The back of Lieutenant Baker's photograph lists his name, age at time of enlistment and place of enlistment. It also runs through his progression through the ranks of the 22nd New York Infantry, starting as a private in Company E in 1861, up through making first lieutenant of Company K on February 7, 1863. He retained this rank until mustered out of the 22nd New York on June 19, 1863.

24TH NEW YORK INFANTRY

On the left of the 22nd New York was the 24th New York Infantry. The 24th, the Oswego County Regiment, contained nine companies from Oswego County and one from Jefferson. It was mustered into U.S. service for a two-year term on July 2, 1861, at Elmira and left for Washington the same day. On May 29, 1863, the 24th was mustered out at Elmira, having lost ninety-one men by death from wounds and thirty-one by death from other causes.[29]

As a part of Colonel Walter Phelps's brigade, the 24th was advanced. Carman says "the brigade moved without loss to a point some 90 yards in advance of and on the right of the battery [Captain Campbell's Battery B, 4th US Artillery], when the column was deployed, the right resting on the Hagerstown road, and the line moved forward some 50 yards in the rear of Gibbon [Brigadier General John Gibbon commanding brigade]."[30]

At the Battle of Antietam, the 24th reported three killed, fifteen wounded and one missing for a total of nineteen.[31]

With the 24th was William H. Adriance. Adriance mustered into Company B of the 24th New York Infantry on May 17, 1861, as a sergeant for two years at Elmira, New York. He gave his age as twenty-eight. Adriance's status was "not stated" until December 31, 1861. On January 1, 1862, William Adriance was promoted to sergeant major and was "present" until November 21, 1862. On August 30, 1862, Sergeant Adriance was discharged to allow him to be promoted to second lieutenant. On November 21, 1862, Lieutenant Adriance was detached to the ambulance corps. Adriance was reassigned to Company A in January/February 1863 and mustered out on May 29, 1863, at Elmira. He had last been paid on February 28, 1863.[32] William Adriance died on March 24, 1885, in Butler County, Pennsylvania, according to the index card for his pension file.[33]

Lieutenant Adriance's rank can be determined by the open, or bare, shoulder boards he is wearing. The lack of any bars or other insignia within the board indicates he was, at the time of this photo, the lowest rank of commissioned officer, a second lieutenant. The photo, according to the note on the back of the image, was taken on or around April 9 or 10, 1863. However, there is no indication of who took the image. Even though Lieutenant Adriance was seated for this photo, there are a number of interesting details that can be determined. The coat that he is wearing is an officer's sack coat, a long coat with five buttons often worn

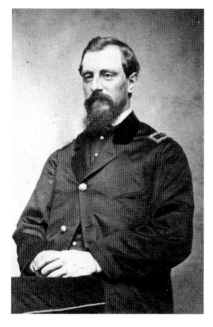

Left: Second Lieutenant William H. Adriance, 24th New York Infantry. *Above*: Back of Adriance's image.

in the field for comfort as opposed to the more formal frock coat. The coat has a velvet collar and a breast pocket, though possibly a civilian purchase; this style of coat was also manufactured by government contractors such as Niehaus & Hock.[34] The buttons on the coat appear to be brass eagle buttons, which were standard on Federal coats, while the uppermost button may be a New York State Seal button, judging by its bulbous design and prominent ring.[35] Additionally, Lieutenant Adriance appears to be wearing a nine-button dark-blue vest. Finally, as per regulations, Lieutenant Adriance has made sure his hair and beard have been trimmed. Officers could wear facial hair as they saw fit, but both beard and hair were to be short and trimmed.[36]

The back of Lieutenant Adriance's CDV has several details, including his name, rank and unit, as well the approximate date the photo was taken. Interestingly, this image appears to be a gift from "M.E.A." to Julia A. Emmet. While Ms. Emmet's relationship to Lieutenant Adriance is not known, M.E.A. may be his mother's initials.

30ᵀᴴ New York Infantry

The 30th New York was on the left end of the brigade front next to the 24th New York as the units advanced south through the Cornfield on September 17, 1862. The 30th New York State Volunteers organized in Troy, New York. The various companies were from the surrounding area. They were in the Washington, D.C. area for the fall of 1861. At the end of its service, the regiment was sent to Albany and mustered out on June 18, 1863.[37] As with the 24th New York, the 30th advanced as a part of Colonel Walter Phelps's brigade into the Cornfield in support of Brigadier General John Gibbon's brigade. At the Battle of Antietam, the regiment reported losses of six killed, five wounded and one missing, for a total of twelve.[38] Its strength was not reported; however, it was probably very small.

Asa Gurney mustered in on June 1, 1861, for two years in Company G of the 30th New York Infantry according to his service records. He gave his age as twenty-three. Captain Gurney was mustered out on June 18, 1863, and he had last been paid on February 28, 1862. As was common with soldiers' early service records, Gurney's status is shown as "not stated" from June to December 31, 1861. However, there is a note that Gurney was promoted to first lieutenant on November 28, 1861. Gurney's bimonthly reports show him as "present" starting with the January/February 1862 report. The next entry in his records shows that Gurney was promoted to captain on March 11, 1862. Since he signed the image as a lieutenant, the photo was probably taken before his promotion to captain. On August 3, 1863, less than two months after Asa Gurney's discharge from the 30th, he mustered into the 2nd New York Veteran Cavalry for three years as a captain. He mustered into Company C. According to *The Union Army*, "This regiment, known as the Empire Light Cavalry, was largely composed of veterans of the 30th N.Y. infantry."[39] On September 4, 1863, Gurney was promoted to major. His final promotion was to lieutenant colonel on December 19, 1863. The regiment was first in the vicinity of Washington and then on to New Orleans. His service records show his status as "not stated" during January and February 1864. Major Gurney was "present" the next two months and then went on leave. He returned to the unit but was captured while on an illegal pass on July 31, 1864. This resulted in Gurney being dismissed from the service on August 11, 1864. Afterward, it was found that he had been captured, and when he was exchanged at Red River, Louisiana, his status was changed to an honorable discharge on February 26, 1865.[40] Asa Gurney died on April 28, 1927, in Wichita, Kansas, according to the index card for his pension file.[41]

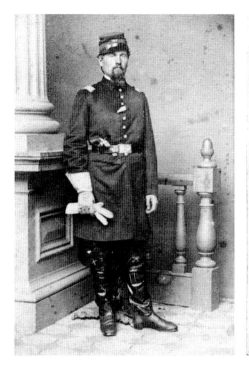

Left: Captain Asa Gurney, 30th New York Infantry. *Right*: Back of Gurney's image.

Captain Asa Gurney had his photo taken in a gallery, likely in Washington, D.C., or New York City, with a decorative railing and column set as the background. Behind Captain Gurney's boots, the base for the supporting stand can be seen. This stand supports a brace for his head that can be seen just under his ear in the photo. This brace kept the head still during the photographic process so that the facial features would be as clear as possible.

Captain Gurney's uniform has a number of interesting details, including privately purchased boots. Boots were issued to the mounted services in the Union army and to officers. These particularly high boots were not issued, and including the soft leather flap at the top, they come up well past the knees.[42] Tucked into the boots is a pair of dark-blue officer's trousers. The sky-blue infantry piping can just be seen above the boot on the captain's right leg. The long, dark-blue, single-breasted frock coat makes up the bulk of his uniform and has nine Federal eagle buttons, in addition to his rank-identifying shoulder boards. There appears to be a handkerchief or perhaps some sort of favor between the third and fourth buttons down from the collar.

The waist belt, judging by the loop close to the rectangular officer's belt buckle and the bronze stay, is probably a Model 1851 Field and Company Grade Officer Sword Belt.[43] The pistol in the sword belt is a personal firearm brought from home or purchased, as it is not a full-size issued revolver but likely a pocket revolver, which had a considerably shorter barrel. The details on the back of the image indicate that it could be either a .31-caliber Whitney or Marston Revolver, but neither of these firearms seems to match the look of the revolver here. The Colt Model 1849 Pocket Revolver appears closer to the mark,[44] but the apparent ring trigger of the firearm suggests a Savage, another brand of revolver. Captain Gurney's gauntlets are a type popular with Federal officers, made of white leather with some embroidery on the back of the hand.

His final piece of the uniform is a Model 1858 or "McDowell"-style forage cap, which is identifiable by its short, rounded leather bill.[45] The forage cap was similar to the short French cap known as a kepi, but had more cloth, giving it its distinctive flopped appearance. Captain Gurney has taken the extra step, often favored by officers of the period, by having an embroidered insignia, likely the infantry's hunter's horn, sewn to front of his forage cap. Finally, Captain Gurney has kept his appearance clean and crisp with a neatly trimmed beard and his forage cap at a slight jaunty angle.

The back of Captain Gurney's CDV lists his personal roll of honor, the various engagements in which he participated, as well as his enlistment history, age at time of enlistment and where he mustered in and out of the service. This history gives his muster in and out dates, as well as the ranks he held in various units over the course of the war. Captain Gurney climbed the ranks quickly in the infantry, mustering out as a captain on June 18, 1863, when the 30th's term of enlistment ran out. The colonel, Morgan H. Chrysler, received authorization to reorganize the 30th as a three-year mounted regiment, later known as the 2nd Veteran Cavalry.[46] Captain Gurney reenlisted as a first lieutenant in the 2nd New York Veteran Cavalry. It was not uncommon for cuts in rank when changing units, but this would not last long for Gurney, as he was made lieutenant colonel of the regiment by December 1863. Gurney remained in this rank until mustering out with the regiment at Talladega, Alabama, in 1865.

1ˢᵀ New Hampshire Light Artillery

The 1ˢᵗ Light Artillery, the only battery of artillery furnished by the State of New Hampshire, was recruited at Manchester and mustered in on September 25, 1861. The original members, not reenlisted, were mustered out near Petersburg, Virginia, on September 25, 1864. The reenlisted men and recruits were mustered out on June 9, 1865, at Concord. In November 1864, it became Company M, 1ˢᵗ New Hampshire Heavy Artillery, but later continued as a separate light battery. It numbered 258 men and lost 12, of whom half were killed or died of wounds. At the Battle of Antietam, the 1ˢᵗ—with about 120 officers and enlisted men—reported losses of 3 men wounded.[47] Captain J. Albert Monroe's reports that "immediately after the First Hampshire Battery, Lieutenant Edgell, was ordered to follow. General Hooker directed me to move forward beyond the second cornfield, if possible, and take position as near the wood as the ground would admit. I advanced, followed by Lieutenant Edgell, First New Hampshire Battery, and went into battery about 50 yards from the wood, the New Hampshire battery taking position, and about 100 yards to the rear."[48]

Among the enlisted men in the Battery was Ephraim Fisk. He saw a large portion of the north end of the Antietam battlefield, as the 1ˢᵗ New Hampshire was moved around over the course of the day. Fisk mustered into the 1ˢᵗ New Hampshire Light Artillery on September 16, 1861, at Manchester as a private. He gave his age as twenty-two and enlisted for three years. Fisk's service records show his status as "not stated" from October 31, 1861, to December 1861. In the January/February 1862 period, his status was shown as "present," and Fisk was appointed a corporal on January 1, 1862. Corporal Fisk's records show him present until September 19, 1862, when he was sent to a hospital. The reason was not given in his records. Whatever it was that sent Fisk to the hospital was serious, as he did not return to his unit until September 30, 1863, over a year later. On December 23, 1863, he reenlisted and, in January/February, was granted a furlough. He returned in March/April and was present until his muster out on December 20, 1864, when Fisk was promoted to first lieutenant in Battery M. Sometime in March 1865, Lieutenant Fisk was absent without leave until he returned to the unit on April 14, 1865. On March 15, he received a letter that stated his mother was about to die and asked him come home as soon as possible. Ephraim requested a twenty-day leave on March 20. After his return, Lieutenant Fisk mustered out on June 9, 1865, at Concord; he had last been paid on February 28, 1865.[49]

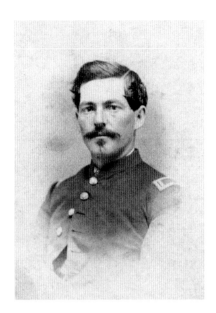

PHOTOGRAPHED BY

D. O. FURNALD,

Manchester, N. H.

Left: Corporal Ephraim Fisk, 1ˢᵗ New Hampshire Light Artillery. *Right*: Back of Fisk's image.

Lieutenant Fisk was born in Sutton, New Hampshire, and, after the war, moved to Old Orchard, Maine, where he died on August 28, 1918.[50]

At the time of the Battle of Antietam, Ephraim Fisk was a corporal. His image, however, was taken sometime after March 1865, when he was promoted to the rank of first lieutenant. The image is difficult to decipher, as it fades to essentially just a bust shot. As per regulations, Corporal, later Lieutenant, Fisk is wearing a nine-button officer's frock with a short collar.[51] The shoulder boards he is wearing would be gold trimmed, but the interior would have been red for the artillery, as opposed to the blue seen with the infantry officers.[52]

Fisk has a neat goatee and mustache, a popular combination during the war, and has combed his hair for the image. The image itself has been colorized ever so slightly, as there is a very subtle blush that has been applied to Fisk's cheeks. Colorizing was done by hand by the photographer to give some additional life to the image. The photographer was not identified. Fisk may have requested the colorization, because this image appears to have been a gift. He has signed the image on the back, "Yours Truly, E. Fisk—1ˢᵗ N.H. Battery."

By 8:00 A.M., OR shortly thereafter, the twenty-four acres of Miller's Cornfield and the area surrounding it were in shambles, thousands had fallen and the battle was just beginning. The six men who have been examined went through some of the deadliest hours in American history. At the end of the day, all of them had survived the fighting and saw further action in the war. Harlow Ames paid the ultimate price and died of disease later in the war, and William Adriance died twenty years later, while Jay McWayne, John J. Baker, Asa Gurney and Ephraim Fisk lived into the twentieth century. The units of General Doubleday's division returned to the positions they held that morning, north of the Joseph Poffenberger farm. Though these men survived the fighting, it is likely they carried the memory of this nondescript little cornfield in western Maryland for the rest of their lives.

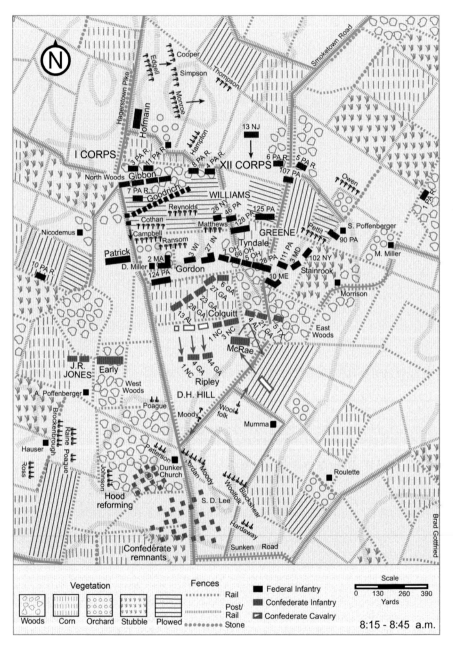

Major General Joseph Mansfield's 12th Corps enters the Battle in the East Woods, 8:15–8:45 a.m. *Courtesy Brad Gottfried.*

2

EAST WOODS

B etween about 6:00 and 8:30 on the morning of the seventeenth,
Brigadier General James Ricketts's division of the 1st Corps moved
south toward the Dunker Church. Later that morning, soldiers from the 12th
Corps joined the fighting. Brigadier General George Hartsuff's brigade in
General Rickett's division contained the 12th Massachusetts Infantry. It was
on the right of the brigade. Looking at the first map, the 12th Massachusetts
can be located on the south edge of the Cornfield coming from the north.
The 13th Massachusetts Infantry was to the left of the 12th Massachusetts
in the brigade line. That regiment was just inside the East Woods as it
moved south. In the rear of General Hartsuff's brigade was the brigade of
Brigadier General Abram Duryee. On the right of this brigade was the 107th
Pennsylvania Infantry, roughly behind the 12th Massachusetts Infantry. To
the left of General Hartsuff's brigade was the brigade of Colonel William
Christian. This brigade contained the 26th New York Infantry. The 26th was
on the left end of the brigade line on the eastern edge of the East Woods.
Joining the fight were units of the 12th Corps. The map to the left shows the
positions as the fighting was ending in this area. On the right of Brigadier
General Samuel Crawford's brigade was the 28th New York Infantry; this
brigade was in support of the lead brigade. On the far left was Colonel
Henry J. Stainrook's brigade. In the middle of the brigade line was the 3rd
Maryland Infantry. The 3rd entered the East Woods coming from the north.
The following soldiers were a part of that fighting and were members of
those units. The movements of these units can be found on the maps.

12ᵀᴴ MASSACHUSETTS INFANTRY

The 12th Massachusetts was a part of the first wave of Union units that was on the right of Hartsuff's brigade as they advanced through the Cornfield. The 12th Regiment Massachusetts Volunteer Infantry, known as the Webster Regiment, was recruited in the latter part of April 1861 through the personal efforts of Fletcher Webster, son of the statesman Daniel Webster. On June 26, 1861, Colonel Webster and the majority of the officers and men of the regiment were mustered into the service.

The regiment saw much fighting over the course of its service until its three years were up. After three years, the men started for home in June 1864; the 12th sent its recruits and reenlisted men over to the 39th Regiment. The returning men reached Boston on July 1, 1864. A week later, the regiment was reassembled on Boston Common and mustered out of U.S. service.[53]

At Antietam, the 12th Massachusetts Infantry fought in the Cornfield and East Woods, losing 49 killed, 165 wounded and 10 missing for a total of 224 out of an estimated 325 officers and men present.[54] "The regiment advanced about 50 yards beyond the south edge of the corn to a swell of ground trending southwest, then throwing its right 10 or 12 yards farther from the corn than its left, which was about 180 yards from the East Woods. [Confederate brigadier general Alexander] Lawton's main line was not seen until the regiment crowned the knoll and the battle-smoke had drifted away."[55] "[Confederate colonel] S.D. Lee's guns tore great gaps in the ranks of the 12th Massachusetts; the musketry fire rapidly thinned it; Major Burbank, its commander, was mortally wounded; the colors and the entire color guard went down in a heap; the men closed up on the colors, which still lay on the ground, and continued their fire."[56]

The officer who led the 12th into the fight was Major Elisha Burbank. According to his service records, Elisha Burbank mustered into the 12th Massachusetts Infantry on June 26, 1861, for three years. He stated his age was fifty-one. Elisha resided in Woburn, Massachusetts, before his service. Major Burbank's status was "not stated" from June 1861 to December 1861, as was common with these early reports. Elisha was "present" from January 1862 until his wounding in September 1862. Major Burbank was badly wounded in the foot on September 17, 1862, at Antietam. He was sent to a hospital in Frederick, Maryland, and was placed in a private home along with two other 12th Massachusetts officers.[57] Sadly, Elisha died from complications of his wound on November 30, 1862.[58] His widow filed for a pension on July 2, 1863.[59]

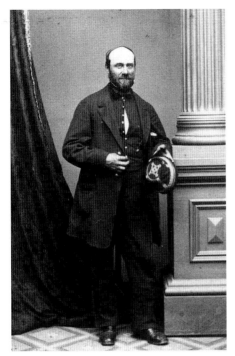

Left: Major Elisha Burbank, 12th Massachusetts Infantry. *Right*: Back of Burbank's image.

The major seems to have had his photo taken on May 12, 1861, just after he was commissioned on May 9 as the major of the 12th Massachusetts Volunteer Infantry.[60] The back of the image lists the date the regiment was mustered in, June 26, 1861; the date of the Major Burbank's mortal wound at Antietam, September 17, 1862; and the date of his death, November 29, 1862. It also has listed the date of May 12 for no apparent reason, unless it is giving the date of the photograph. This date would also help to explain the image itself, as Major Burbank is wearing a mix of military and civilian items.

Major Burbank had his image taken by Silsbee, Case & Company in a gallery in Boston, Massachusetts, and signed the bottom of the CDV, likely to use it as a gift or calling card. The gallery used a number of props often seen in period images, including a column and a curtain; the latter seems to be helping to cover a brace for the major to lean against. The major's footwear is too nondescript to be certain if they are shoes or boots. His trousers, however, do appear to be dark-blue officers' trousers with the light-blue piping just visible running up the seams.[61] The vest the major is wearing

is dark blue with likely nine buttons; eight are visible in the image. The size and shine of the buttons implies this is an officer's vest most likely with small eagle buttons. The vest is covering a nondescript white shirt, as per military regulations at the time.[62] Why the second through fifth buttons of the vest are undone is unknown but may be for ventilation.

For ornamentation, the major has what looks to be his watch fob and chain showing. A watch was an important instrument for both military and practical use but was a privately purchase item, as was the cravat the major is wearing. The coat itself seems to be a mix of civilian and military, as it is a civilian frock coat with what appears to be gold military buttons. This implies that the major had his image taken before the entirety of his uniform was ready. To finish off his attire, he is holding an officer's kepi, distinguishable by its extensive use of gold braid.[63] Lastly, Major Burbank has presented himself with a neatly trimmed beard and combed hair for the image.

13th MASSACHUSETTS INFANTRY

On the left of the 12th Massachusetts was the 13th Massachusetts Infantry. The 13th Regiment, Massachusetts Volunteer Infantry, had for its nucleus the 4th Battalion Rifles, Massachusetts Volunteer Militia, which furnished Companies A, B, C and D of the regiment. These companies, with Company E, Roxbury Rifles, were ordered to Fort Independence, Boston Harbor, on May 25, 1861. On June 29, two companies were added from Marlboro and one each from Natick, Stoneham and Westboro. The regiment was mustered into the service on July 16, 1861, with Samuel H. Leonard as its colonel.

On July 29, 1861, the regiment was sent immediately into Maryland. The spring and early summer of 1862 were spent reconnoitering in various parts of northern Virginia. The 13th Massachusetts spent the rest of its service assigned to the Army of the Potomac and was involved in many of its battles in 1863 and 1864. The regiment continued to perform active duty until July 14, 1864, when, its term of service having ended, its recruits and reenlisted men were transferred to the 39th Regiment, the same regiment to which the reenlisted men of the 12th Massachusetts had been assigned, and it was withdrawn from the front and sent to Washington.

After this, those who were to muster out were sent to Boston, Massachusetts, on July 21, 1864. The members of the regiment were furloughed until

August 1, on which date they reassembled on Boston Common and were officially mustered out of the U.S. service.[64]

At Antietam, September 17, 1862, the 13th Massachusetts fought in the Bloody Cornfield and near the Dunker Church, losing 14 killed, 119 wounded and 3 missing for a total of 136.[65] The regiment did not report its strength prior to the battle.

"On the left [of the brigade] the 13th Massachusetts and the 83rd New York swept through the East Woods, and, wheeling to the right, faced nearly west at the edge of the woods, where they became immediately engaged.—the 13th Massachusetts poured in a deadly fire and, struck in front and flank, [Brigadier General Harry T.] Hays and the Georgians [Trimble's brigade], who had advanced with him, were soon checked, then repulsed and fell back slowly and sullenly to seek cover."[66]

In the 13th Massachusetts was "Drummer" Appleton Sawyer. On July 16, 1861, twenty-year-old Appleton Sawyer mustered into Company K of the 13th Massachusetts Infantry. Sawyer stated that he was working as a clerk before his enlistment in Shrewsbury, Massachusetts. Upon enlistment, he was made a drummer. His service records show him as "present" from July 1861 to his muster out on August 1, 1864, having enlisted for three years. Appleton Sawyer was promoted to drum major of the drummers and fifers following the Maryland Campaign on October 31, 1862.[67]

On January 1, 1864, Sawyer was transferred to the noncommissioned staff of the regiment as "chief musician." When he mustered out, he was due a bounty of $100. Appleton Sawyer was born in Shrewsbury in 1841 and returned to live in Worcester, Massachusetts. He applied for a pension on August 12, 1889, but his date of death was not recorded on his pension card.[68]

While "Drummer" was not a rank in the army at the time, it was a position with the military musicians. Drums had been used on battlefields and while marching since the ancient days of warfare. By the time of the American Civil War, military musicians, be they drummers, buglers or fifers, were used to convey orders over a wide area and to keep up the cadence while on the march. They could also be used to keep up spirits while in camp, and many regiments had bands that were formed to perform martial music for them at the beginning of the war. The 13th Massachusetts was no different, it having a large band for the first year of the war. It was on the outset of the Maryland Campaign, however, that the 13th Massachusetts's band was broken up, and the regiment made due with the company drummers and fifers.[69]

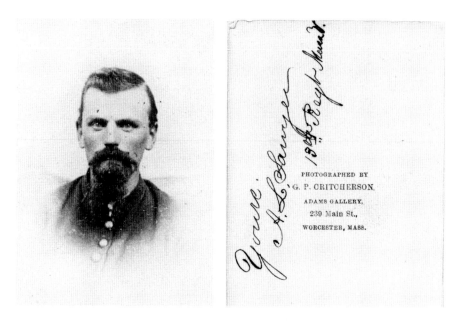

Left: Drummer Appleton Sawyer, 13ᵗʰ Massachusetts Infantry. *Right*: Back of Sawyer's image.

In his photo, which judging from the inscription on the back, "Yours, A.S. Sawyer, 13ᵗʰ Reg. of Mass. Vol.," was likely a gift, there are only a few details available. Sawyer appears to be wearing either an enlisted man's frock coat or a shell jacket with eagle buttons and a clasped collar. It should be noted that the coat does not have the worsted lace bib often associated with military musicians.[70] What makes this image particularly interesting is his overcoat, which can just be made out due to the collar folds. It is not the standard sky blue of an enlisted man's greatcoat and is instead dark blue or black. It seems likely that this is a civilian coat of some sort. That makes sense, as the gallery stamp on the back of the image lists the address as being in Worcester, Massachusetts. It is probable this was taken shortly after Sawyer mustered out of Federal service at the beginning of August 1864. To finish off his appearance, Sawyer has neatly trimmed his beard and mustache and has cut his hair short. This hairstyle was popular among veteran soldiers, as it made it easier to deal with camp vermin such as lice.

107ᵀᴴ Pennsylvania Infantry

The 107ᵗʰ Pennsylvania Infantry was on the right end of Brigadier General George Duryee's brigade as the soldiers advanced south. The 107ᵗʰ was recruited in the counties of Franklin, York, Dauphin, Cumberland, Lebanon, Lancaster, Schuylkill, Luzerne, Mifflin, Juniata, Bedford and Fulton and was mustered into the U.S. service at Harrisburg on March 5, 1862, for a three-year term. Four days later, it proceeded to Washington. The regiment fought in the major engagements of the Army of the Potomac until the end of the war. The 107ᵗʰ then returned to Washington, where it participated in the Grand Review and was mustered out on July 13, 1865.[71]

Captain James MacThompson wrote the official report for the regiment describing the action at Antietam:

> Sɪʀ: *I have the honor to make the following report respecting the One hundred and seventh Regiment Pennsylvania Volunteers in the two actions, September 14 and 17, at South Mountain and Antietam: At early dawn, agreeably to orders, I moved the One hundred and seventh Regiment by the flank to the field on the right.…Shortly we were again advancing and passing the battery, and over a clover field reached the spot so frequently mentioned in the reports of this battle—the corn-field. Deploying into line, we entered the field and pushed rapidly through to the other side. Here we found, in different positions, three full brigades of the enemy. We opened fire immediately upon those in front, and in fifteen minutes compelled them to fall back. Receiving re-enforcements, however, he soon regained his position, and an unequal conflict of nearly three-quarters of an hour resulted in forcing us back through the corn-field. Our brigade had, however, done its work. We had held at bay a force of the enemy numerically five times our superior for considerably more than an hour, and at one time driving them. We were now relieved by re-enforcements coming up, and retired to the rear.…In the Battle of Antietam the One hundred and seventh Regiment had 190 men engaged, and lost 19 men killed and 45 wounded, a total loss of 85 killed and wounded in both engagements. Too much cannot be said of the dashing bravery of both officers and men at South Mountain or of their heroic firmness and cool bearing when standing still in line of battle at Antietam.*[72]

One of the privates who experienced the confusion and fear of Antietam was Private Philip Sellers of Company F. Philip Sellers mustered into Company F of the 107th Pennsylvania Infantry on April 26, 1862, for three years. He stated he was twenty-one years old and working as a farmer before his enlistment. Sellers was described as five feet, six and a half inches tall, with light complexion, light eyes and light hair. He was born in Center County, Pennsylvania. Private Sellers is shown as "present" as of the April 30, 1862 roll. Sellers was "present" until he was listed as "absent missing in action at Gettysburg July 1, 1863" for the July/August 1863 period. A prisoner-of-war form states that Philip Sellers was at Camp Parole, West Chester, Pennsylvania, in July 1863. With the note that he was a paroled prisoner not a deserter, Private Sellers returned to his unit and was present from September/October 1863 until March/April 1864, when he received a leave. Sellers reenlisted for another three years with the 107th on February 27, 1864, and received a bounty of $100. The next important entry in his service records is that Sellers was wounded in action on August 18, 1864, at Reams Station. The wound is described as a gunshot wound of the left thigh. Private Sellers was listed in a hospital on August 26, 1864. Sellers remained in the hospital until his discharge for a disability on June 6, 1865, at White Hall USA Hospital near Bristol, Pennsylvania.[73] After the war, Sellers moved west. He filed for a pension on June 11, 1870. His pension card noted that he died in Horton, Kansas, on September 16, 1909.[74]

Private Philip Sellers had the following photograph taken by J.P. Brooks of Bristol, Pennsylvania, in the winter of 1865 prior to his discharge from White Hall Hospital. This CDV was a gift for Sellers's cousin, as he signed it "Your cousin Philip E. Sellers Co. F 107th Regt Pa Vet Vols White Hall." The photography studio provided a decorative column base for Sellers to rest his arm on, and the base of the brace being used to help keep his head steady can be seen between his legs.

Private Sellers's uniform is dominated by his greatcoat, but there are some details that can still be made out. Sellers's footwear, for example, appear to be boots at first glance; however, on close examination, a large seam can be seen over the top of each foot. This indicates that he wore black leather gaiters over his issued leather shoes for this image, as opposed to boots, which he would have had to purchase himself, being in the infantry. Gaiters were an issued item meant to cover the soldiers' shoes and pant legs to help keep out debris and other irritants.[75] Sellers is wearing the sky-blue trousers common to the volunteers and a short jacket under his greatcoat. The short jacket stops right at the waistline, and five closely spaced buttons are

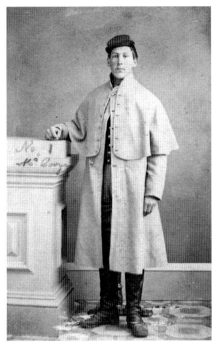

Left: Private Philip Sellers, 107th Pennsylvania Infantry. *Above*: Back of Sellers's image.

visible. This indicates that the jacket is likely a shell jacket, which was more common in mounted arms of the army, but not unheard of in the infantry. The greatcoat that Sellers is wearing is an infantryman's greatcoat, as the cape comes down to the elbow; if it were a mounted soldier's greatcoat, the cape would go all the way to the wrist.[76] Buttoned at the collar for this image, the greatcoat also has two hooks on the high collar that keep it tightly closed. The greatcoat is in remarkably good shape, suggesting it was either a recent issue or perhaps a prop of the photo gallery.

To finish the image off, Sellers in wearing his forage cap, upturned slightly for a better view of his face, which is clean shaven. Philip Sellers looks directly into the camera for this image, conveying a sense of pride in his service.

26TH NEW YORK INFANTRY

The 26th New York was on the extreme left of Colonel William Christian's brigade of General James B. Ricketts's division. The 26th, the 2nd Oneida

Regiment, was composed of six companies from Oneida County, two from Monroe, one from Tioga and one from Madison and was mustered into U.S. service on May 21, 1861, at Elmira for a two-year term. It left the state on June 19, bound for Washington. Two years later, it was mustered out at Utica on May 28, 1863, having lost 108 members by death from wounds and 42 by death from other causes.[77]

At Antietam, the unit was of unknown strength. The 26th reported losses of five killed, forty-one wounded and twenty missing, for a total of sixty-six, at the Battle of Antietam.[78] The regiment is described as "moving south through the woods, crossed the Smoketown road, and formed behind the fence on the south edge of the woods, the 94th [New York Infantry] rested its right on the Smoketown Road, the 26th was on its left."[79]

Among the men moving south on September 17 was Jabez L. Miller, who mustered into Company A of the 26th New York Infantry on May 21, 1861, at Utica, New York. Miller gave his age as twenty, but he did not list a residence. He enlisted for two years and stated that he was a blacksmith before enlisting. The company descriptive book page shows that Miller was five feet, nine inches tall, with a dark complexion, he had blue eyes and dark hair and was born in New York. Miller was the first sergeant of Company A at the time of his mustering in. On August 7, 1861, he was promoted to sergeant major of the regiment. His service records show him as "not stated" from his muster-in date until the March/April 1862 report, which shows him as "present." This was not uncommon, and the same report shows Miller received a clothing allowance of $47.29. On April 2, 1862, Sergeant Miller was promoted to second lieutenant and transferred to Company H. He was promoted again to first lieutenant on August 31, 1862, the rank he held at the Battle of Antietam. After the battle, Jabez Miller was "present" until the January/February 1863 period, when he was reported as "present under arrest." Lieutenant Miller was charged with being absent without leave on November 16–17, 1862. There is no further reference to this charge in his records. Lieutenant Miller was mustered out on May 24, 1863, after serving his two years. He had last been paid on February 28, 1863.[80] He applied for a pension on December 7, 1891, and his widow applied on March 21, 1912. Miller's pension card notes that he passed away on March 12, 1912.[81]

First Lieutenant Jabez Miller had this image taken some time after his promotion to first lieutenant on August 31, 1862. While there is

Left: First Lieutenant Jabez L. Miller, 26th New York Infantry. *Above*: Back of Miller's image.

no photographer's information on the back of the image, it is possible this was used as a gift or calling card, as it is signed and gives his rank, company and regiment. For this image, Lieutenant Miller is wearing the dark-blue trousers of an officer, as well as a privately purchased sack coat. The coat has a breast pocket, turned-out lapels and velvet collar similar to those manufactured by Nehaus & Hock.[82] The buttons on his sack coat appear to be New York State buttons, as they have a prominent ring design, as opposed to the Federal eagle button. The 26th New York was originally armed and equipped by the State of New York,[83] but by the time Lieutenant Miller was promoted to the officer corps of the 26th New York, the regiment would have been supplied directly by the Federal government. It is possible that Lieutenant Miller specifically requested the buttons when he ordered his coat. Finishing off the sack coat are Lieutenant Miller's shoulder boards. Though the image is faded, the single bar of a first lieutenant can just barely be made out on the shoulder board. Lieutenant Miller is wearing a number of items in addition to his sack coat, including a nine-button officer's vest as well as a small white cravat around his neck. The most unusual piece, however, is the large button attached to his lapel. This is likely a fraternal order pin of some sort. Lieutenant Miller's forage cap lacks the additional decorations often

seen with officers' caps. This forage cap may have been a holdover from his days as an enlisted man, one of over four million caps purchased by the Federal government over the course of the war.[84] Finally, Lieutenant Miller has a trimmed mustache and has brushed his hair for the image.

28ᵀᴴ New York Infantry

The 28th New York Volunteer Infantry was the lead regiment for Brigadier General Samuel Crawford's brigade as it advanced south along the west edge of the East Woods. The 28th, the Niagara Rifles, was composed of five companies from Niagara County, two from Orleans County, one from Ontario, one from Genesee and one from Sullivan. The regiment was mustered into U.S. service for two years on May 22, 1861, at Albany. A month was spent at Camp Morgan, and on June 25, the regiment left the state for Washington.

During the Second Battle of Bull Run, the command was posted at Manassas Junction and was then withdrawn to Centerville and Alexandria, leaving there on September 3 for Maryland. At Antietam, the command was closely engaged: "[T]he 28th New York and the 46th Pennsylvania, moved through the small cornfield, into the East Woods and deployed, part in the woods and part in the open ground west of them, and opened fire on the Confederates directly south."[85]

The 28th was a small unit, reporting only sixty men present; it lost two killed, nine wounded and one missing for a total of twelve.[86] Soon after, the regiment returned to New York and was mustered out at Albany on June 2, 1863. The total loss of the regiment during its term of service was sixty-eight members killed or died of wounds, and forty-nine died from other causes.[87]

On May 22, 1861, Peter B. Kelchner mustered into Company B of the 28th New York Infantry as a sergeant. Kelchner was twenty-eight years old when he mustered in at Albany according to his service records.[88] He signed up for two years of service, and his status was "not stated" from May 22 to the January/February 1862 report. On the March/April report, Kelchner was listed as "present," and it notes that as of March 13, 1862, Kelchner was promoted to first sergeant. The next event shown in Kelchner's record was that he was "wounded in the leg seriously" on September 17, 1862 near Sharpsburg Md." Although the wound is described as "serious,"

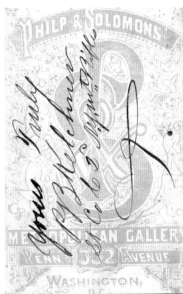

Left: First Sergeant Peter B. Kelchner, 28th New York Infantry. *Right*: Back of Kelchner's image.

Sergeant Kelchner is shown as being "present" in November/December and for the rest of his service. On March 5, 1863, Sergeant Kelchner was promoted again to second lieutenant. Kelchner mustered out on June 2, 1863, having last been paid on March 1, 1863. He was due $11.29 for his clothing allowance not drawn. Peter Kelchner decided to rejoin the war, as he enlisted in Company C of the 2nd Mounted Rifles New York as a first lieutenant on January 26, 1864. Kelchner was promoted one more time, to captain of Company A, on August 1, 1864. Surviving the war, Kelchner's service to his country ended on August 10, 1865, at Petersburg, Virginia, where he was mustered out. Kelchner filed for a pension on February 26, 1879. His pension card shows he died in a Nation Home in Illinois on January 12, 1919.[89]

First Sergeant Peter Kelchner is pictured in his first lieutenant's uniform from his second enlistment in 1864, with New York's 2nd Mounted Rifles. The image was taken by Philip & Solomons in Washington, D.C., and appears to have been a gift, as it is signed "Yours Truly PB Kelchner Lt Co C 2nd N.Y. Mt Rifles," with a large stylized flourish underneath. As opposed to many CDVs of the era, which had a printed logo or name for

the gallery and photographer on the back, the entire back of this CDV is an advertisement for the Philip & Solomons Metropolitan Gallery.

As for Kelchner's image, he is wearing a nine-button Federal frock coat with a first lieutenant's shoulder boards to designate his rank. It is interesting to note that though he is in a mounted unit, the shoulder boards have a blue interior designating infantry as opposed to yellow, which was used by cavalry. The mounted infantry moved like cavalry, on horseback, but fought like infantry, on foot; thus they fell under the infantry branch of the army.[90] Finally, Kelchner has a neatly trimmed beard and looks to have oiled and combed his hair for his picture.

3RD MARYLAND INFANTRY

The 3rd Maryland Infantry began its organization on June 18, 1861, at Baltimore and Williamsport, but it was not completed until February 17, 1862. The four companies enlisted in the summer of 1861 at Williamsport were composed largely of Union men and refugees from Jefferson and Berkeley Counties, Virginia. Upon the organization of the regiment, they became Companies A, B, C and I, and the Baltimore companies were designated as D, E, F and G. On May 11, 1862, Companies E, F, H and I were broken up and the men distributed among the other companies. The companies thus dissolved were replaced by four companies from the German Rifles, or 4th Maryland Infantry and the Baltimore Light Infantry, both of these regiments having failed to complete their organization. The regiment was mustered out at Arlington Heights, Virginia, on July 31, 1865. While in service, the unit lost 225 men, 91 of whom were killed in battle. From the time of its muster in to the close of its service, it traveled by rail 2,903 miles, by water 289 miles and by land 1,771 miles.[91]

At the Battle of Antietam, the 3rd Maryland was on the far left of the brigade. Lieutenant Colonel Joseph M. Sudsburg wrote a report of the battle, in which he recorded the following:

> *After again being formed, we advanced over a meadow toward the battery of the enemy, who had vigorously shelled us during our advance from the woods. Arriving behind the crest of a little elevation, we were ordered to lie down and await the arrival of a battery which had been ordered to our*

*support, and of which a section shortly came up and unlimbered. A full
battery, said to have been Knap's, came up soon after and went directly into
action. The enemy's infantry advanced from the right, apparently designing
to take our battery. We were ordered up, fixed bayonets, and charged forward
past the battery, which in the mean time had given the enemy the benefit
of two rounds and across the road leading from Bakersville to Sharpsburg.
On the other side of the road is a church or school-house, surrounded by
woods. Charging through this piece of woods, we drove the enemy out, and
held possession nearly two hours. The enemy occupied a corn-field in front
of us, and, judging from his fire, must have been in strong force. In this
woods I lost most of my men. I took 148 men into action. Our casualties
amount to 1 killed and 25 wounded, some of whom have since died. Four
were missing.*[92]

Serving in the regiment was Private William Keiner. Keiner's records
are confusing. One source shows he enlisted on July 2, 1862, as a private
in Company E of the 3rd Maryland Infantry; however, his service records
first show him as a corporal on March 1, 1862, with nothing for 1861.
Regardless, William Keiner was "present" as of May 1862. His status
remained "present" until January or February 1864 when Keiner received
a furlough as part of his reenlistment. Before this, Keiner was promoted
to sergeant in February 1863. However, something happened in July or
August, as Keiner was demoted to private, the rank at which he remained
for the rest of his service. When William Keiner reenlisted on March
1, 1864, he was due a bounty of $100 and gave his age as twenty-one.
Sometime in the July/August 1864 period, Keiner reportedly received a
gunshot wound in the left leg, which was described as "slight." This was
at Poplar Grove. Keiner was more severely wounded on September 30, as
his records show he owed the government $2.00 for his transportation to
a hospital. In November or December 1864, Keiner's pay was reduced by
$0.67 for a lost haversack. On February 5, 1865, Keiner was reported to
be in a hospital, and on April 2, 1865, he was in Baltimore in a hospital.
As a result, he was "absent" from the regiment. One source indicates
that William was mustered out on July 31, 1865, at Arlington Heights,
Virginia; however, in his service records is a contradictory note: "Deserted
on November 30, 1866 while on furlough."[93]

This image of Private William Keiner is something of a conundrum.
The photographer's advertisement on the back of the card is for McAdams
in Alexandria, Virginia. The 3rd Maryland, however, did not spend much

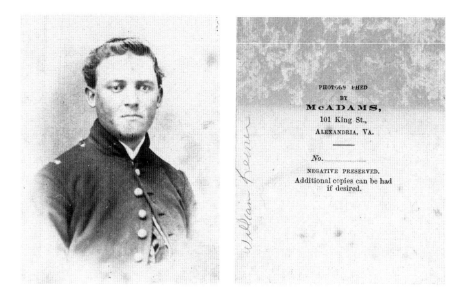

Left: Corporal William Keiner, 3rd Maryland Infantry. *Right*: Back of Keiner's image.

time in Alexandria, suggesting that the image was likely taken near the end of the regiment's service, when it was posted to Alexandria prior to the Grand Review or perhaps just before or after the regiment was mustered out of service at Arlington Heights on July 31, 1865. However, the image itself, with the fixtures for shoulder scales on the shoulders, suggests an early war uniform.[94]

Private Keiner is wearing a nine-button frock coat, with the distinctive devices that locked the decorative brass epaulets into place for formal events, guard mount and dress parade. For the volunteers, these were rarely worn in the field.[95] It also appears that he is wearing some sort of vest, which can be seen due to the majority of his buttons being open. Lastly, Private Keiner has his hair combed back for the photo and may have a light goatee.

The fighting in the East Woods was over for the morning; thousands of soldiers had fought and bled there. The quiet wood lot had seen and heard much; today, there are still trees there that witnessed these events. These six soldiers were there that morning on September 17 and saw significant fighting. Among the six, one died of a wound he received at Antietam, Major Elisha Burbank; another was wounded but lived into the twentieth century. One would become a prisoner of war, Private

Philip Sellers, and then be wounded before his service was over. He also lived into the twentieth century. The fourth was to be wounded twice before the end of the war, and the remaining two survived the war and returned to civilian life, one living into the twentieth century. As 9:00 a.m. approached, so did the third and final major Union push in the northern portion of the battlefield. Coming through the East Woods was the 2nd Corps division of Major General John Sedgewick. This division soon pushed across the landscape, heading for the West Woods.

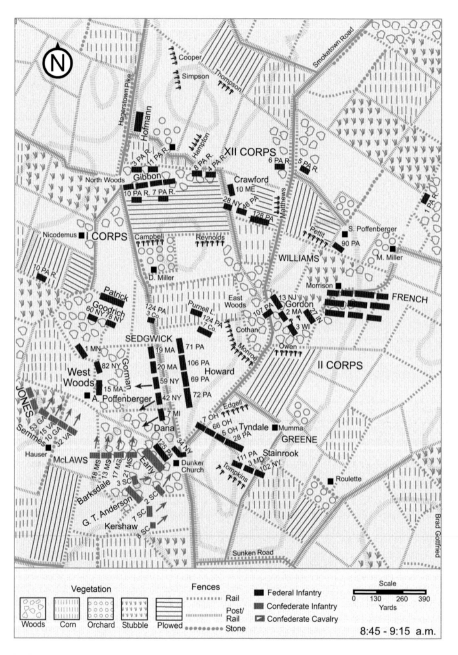

Major General John Sedgwick's division drives east into the West Woods, 8:45–9:15 a.m.
Courtesy Brad Gottfried.

3

WEST WOODS

Between about 9:00 and 11:30 on the morning of the seventeenth, Major General John Sedgwick's division of the 2nd Corps moved west from the East Woods toward the West Woods. In the lead brigade of Brigadier General Willis Gorman was the 34th New York Infantry. Looking at the map, the 34th can be located near the Dunker Church. Serving in the same brigade to the north of the 34th was the 15th Massachusetts Infantry. It is north and west of the 34th on the western edge of the West Woods. The second brigade approaching the West Woods was commanded by Brigadier General Napoleon Dana. It contained the 19th Massachusetts Infantry on the north end of the brigade front. On the map, it is shown crossing what is today Philadelphia Brigade Park. To the left of the 19th was the 20th Massachusetts Infantry, also crossing Philadelphia Brigade Park. The next regiment in the brigade was the 59th New York Infantry, which was behind and in support of the 15th Massachusetts as it crossed the park. The last unit to be examined is from Brigadier General George Greene's division of the 12th Corps. The 60th New York Infantry was detached and marched north of the Cornfield to enter the West Woods coming from the northeast. It is farther north than the other units discussed. The following soldiers were a part of that fighting and were members of these units.

34TH New York Infantry

The 34th New York Infantry was on the south end of the 2nd Corps battle line. The men were in the area of the Dunker Church at their most westward advance. The 34th, the Herkimer Regiment, was composed of five companies from Herkimer County, two from Steuben, one from Albany, one from Clinton and one from Essex County and was mustered into the U.S. service at Albany on June 15, 1861, for two years. The regiment returned home on June 9 and was mustered out at Albany on June 30, 1863, the three years' men having been transferred to the 82nd New York Infantry on June 8.

At Antietam, this regiment contained 311 officers and enlisted men.[96] The regiment suffered 33 killed, 111 wounded and 10 missing for a total of 154.[97] The report of Colonel James A. Suiter, 34th New York Infantry, says:

> *On my left and rear I was entirely unsupported by infantry or artillery. The enemy were in strong force at this point, and poured a tremendous fire of musketry and artillery upon me. At this time I discovered that the enemy were making a move to flank me on the left. Lieut. Howe arriving at this time, I informed him of my suspicions. He replied that he thought they were our friends. Lieut. Wallace, of Company C, proposed going to the front, to make what discovery he could, which I granted. He returned, saying that the enemy were moving upon my left flank with a strong force.*[98]

The 34th retired back toward the East Woods.

First Lieutenant Irving D. Clark of Company B was a member of the 34th on the field that day. On June 15, 1861, Irving Clark mustered into Company B of the 34th New York Infantry at Little Falls, New York. Clark enlisted for two years and gave his age as twenty-two. He was commissioned as a second lieutenant (ensign). According to Clark's service records, his status was "not stated" through to March/April 1862. Clark was reported as "wounded at Fair Oaks on May 31 or June 1 in the shoulder and arm near the elbow"[99] according to his service records. On July 16, 1862, Clark was listed as absent due to sickness. However, he was "present" in September/October 1862. His records also show that he was promoted to first lieutenant on June 24, 1862, to replace Lieutenant Gorman of Company C. This appears to be a back date, as the records for the periods after this date still listed him as a second lieutenant. Clark was also reported to be promoted to first lieutenant on December 30, 1862, in Company C. He was shown as detached as

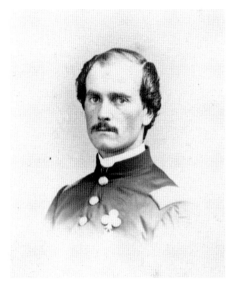

J. H ABBOTT,
PHOTOGRAPHIST,
480 BROADWAY, ALBANY, N. Y.

Left: First Lieutenant Irving D. Clark, 34th New York Infantry. *Right*: Back of Clark's image.

adjutant on December 1, 1862. Clark was promoted again, to captain, on January 22, 1863, and was due an additional ten dollars per month for commanding the company since November 1862. On February 9, 1863, Irving Clark requested a leave "for the period of ten days for the following reasons to recover the remains of a brother killed at Antietam and to visit my family at home."[100] His older brother was Roswell Clark Jr., a member of Company I, 97th New York Infantry, who died of wounds received on September 17, 1862. He received his leave. Captain Clark was "present" until he mustered out on June 30, 1863, at Albany, New York. Clark had last been paid in February 1863. Captain Clark filed for a pension on February 24, 1869. According to his pension card, he died on August 14, 1905.[101]

While only a bust, there is a lot that can be determined from Irving Clark's image as taken by J.H. Abbott of Albany, New York. A second lieutenant at Antietam, by the time he had this image produced, Clark had been promoted to captain according to the inscription on the back. He wears a single-breasted frock coat with Federal eagle buttons as well as an officer's shoulder boards for rank. The shoulder boards have been washed out by the image exposure, so the captain's bars cannot be made out.

What really stands out in this image, however, is the large white trefoil on the left breast, the symbol of the 2nd Division, 2nd Corps in the Army of the Potomac. Clark mentions this as well on the reverse of the image, which was likely a gift, as it is signed. The presence of the 2nd Corps badge is important because it dates this image after March 21, 1863, when Major General Joseph Hooker ordered the creation of the corps badges with separate division colors to help better determine whose troops were whose on the march or in battle.[102] With Clark referring to himself as captain, along with the photographer's stamp coming from Albany, it seems very likely that this image was taken at or near the end of Clark's enlistment when the 34th New York mustered out of service in Albany. Clark's clean shirt, small cravat and neat, possibly oiled, hair all seem to support this idea of an officer having time to get the best image possible.

15TH MASSACHUSETTS INFANTRY

The 15th Massachusetts Infantry was in the middle of the brigade line as it advanced into and through the West Woods on September 17. The regiment was organized at Worcester to serve for three years and mustered in during the month of July 1861. The regiment left for Washington, D.C., on August 8, 1861.[103] In 1865, the remaining men, with those who returned from hospitals or from detached service, were attached to the 20th Massachusetts of the same brigade until July 12, when the remnant of the regiment was sent home, arriving in Worcester, Massachusetts, on July 21. Five days later, nine companies were mustered out of the service.[104]

At Antietam, the 15th Massachusetts Infantry consisted of 606 officers and men.[105] It lost 57 killed, 238 wounded and 23 missing for a total of 318.[106] In the regimental history of the 15th, the fighting at Antietam is described thus: "In less than twenty minutes, more than half the regiment has been killed or wounded, yet the men obey with reluctance the command to withdraw. The movement is made in good order, and when it had retired about one hundred yards to the right and rear. Gorman's brigade faces about and by a volley checks the advancing foe."[107]

Serving in Company F was Second Lieutenant Edward Justin Russell. Edward Russell, who was born in Hadley, Massachusetts, mustered into

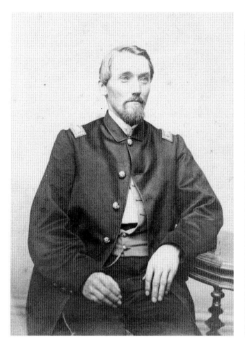

Left: Second Lieutenant Edward Justin Russell, 15th Massachusetts Infantry. *Right*: Back of Russell's image.

Company F of the 15th Massachusetts Infantry on July 12, 1861, as third sergeant. He gave his age as twenty-eight and stated that he was living in North Brookfield, Massachusetts, working as a carpenter before his enlistment. Russell's status was "not stated" to March 1862. Sergeant Russell was "present" from March 1862 to January 1863. During this period, Russell was promoted to first sergeant on March 1, 1862, and later to second lieutenant on July 24, 1862. There is a note in his service records from the September period that he was in command of the company on September 17, 1862. On September 28, he was promoted again, to first lieutenant. Russell was promoted to captain on January 27, 1863. During January or February 1863, he was listed as "absent" sick. Russell returned to duty in March and was present until the middle of June, when he was reported to have suffered sunstroke on June 16, 1863. Based on this, Captain Russell requested a sick leave of twenty days. This leave was approved. He returned the next month and was present until his discharge for chronic diarrhea on September 8, 1863. Russell seems to have recovered, as he was commissioned as a second lieutenant

in Company K of the 3rd Massachusetts Heavy Artillery on May 4, 1864. Lieutenant Russell was promoted to first lieutenant on May 28, 1864, and finally to captain on July 1, 1865. Edward Russell mustered out of the 3rd on September 18, 1865, in Washington, D.C.[108] He requested a pension on June 1, 1904, and his pension card shows he lived in Leicester, Massachusetts, until December 16, 1915, when he passed away.[109]

Lieutenant Edward Russell sat for this photo as a first lieutenant; the single bar on his shoulder boards can just be made out, indicating his rank. This image was taken by H.J. Reed of Worcester, Massachusetts, as can be seen on the back of the image. In addition, he is also wearing infantry officer's trousers of dark blue with sky-blue piping running up the seam.[110] Lieutenant Russell has his fatigue blouse open, showing off his civilian vest and shirt underneath. A watch chain can just be seen looping out from under his coat, with the chain hooked to the bottom button of the vest.

Lieutenant Russell's sack coat, while not as fancy as the frock coat, would have been his day-to-day coat for duties and drill around camp or in the field. Long in the trunk, it is the four Federal eagle buttons that give the coat away. Being an officer's jacket, however, it does have three cuff buttons, unlike most enlisted coats,[111] and he has his shoulder boards predominately displayed. To finish off his appearance, Russell has his beard trimmed neatly and his hair combed. He also appears to have some sort of cravat or necktie peeking out just above his top jacket button.

19TH MASSACHUSETTS INFANTRY

The 19th Massachusetts Infantry was mustered for three years at Lynnfield in August 1861. It moved to Washington, D.C., and arrived on August 30. It also participated in the Grand Review at the end of the war and mustered out on June 30, 1865.[112]

The 19th Massachusetts was on the north end of General Dana's brigade during the advance toward the West Woods. It contained 418 officers and men.[113] It lost 8 killed, 108 wounded and 30 missing, for a total of 146.[114] The regimental history describes part of the action this way: "[A]t the northern edge of the woods the Nineteenth halted on the top of a ledge. In front, and slightly below were the Forty-Second New York and the First

Minnesota, hotly engaged with the rebels, while the Nineteenth, suffering severally from the galling fire of short range, could not reply because of the position of the lines and the conformity of the ground."[115]

In the north end of the West Woods, serving in the 19th as first sergeant was Marcus Kimball. Kimball stated that he was living in Groveland, Massachusetts, working as a shoemaker when he joined the army as a member of Company A of the 19th Massachusetts Infantry. Kimball mustered in on August 28, 1861, as a corporal for three years at age nineteen. Kimball was "present" from August 28 to December 31, during which time he was issued one cap, one blouse, one pair of pants, one overcoat, two shirts, two pairs of drawers, two pairs of socks and two pairs of shoes. On July 1, 1862, Kimball was promoted to sergeant and promoted again on September 7, 1862, to first sergeant, the rank he held at the Battle of Antietam. Kimball, however, did something wrong, as he was demoted to corporal on November 1, 1862. His troubles continued, as he was "in arrest" in January/February 1863. On the April 10 muster roll, Marcus Kimball was listed as a private. He was listed as "wounded in action" on May 3, 1863, at Fredericksburg, but the wound was described as "side, slight." On July 27, 1863, Kimball was detached to serve on conscript detail and sent to Boston. Marcus remained in Boston until he reenlisted on February 25, 1864, when he received a thirty-day furlough and was shown as "absent." He was described as five feet, eight inches tall, with blue eyes, brown hair and a light complexion on his enlistment form. Kimball returned on May 3, 1864, and on June 22, 1864, he was listed as captured during the fighting around Petersburg. As a prisoner of war, he was sent to Lynchburg on June 29 and paroled at Charleston, South Carolina, on December 16. He reported to Camp Parole, Maryland, on December 22, 1864. Kimball was released on furlough for thirty days and reported for duty on February 20, 1865. On May 24, 1865, Sergeant Kimball mustered out, having last been paid on January 21, 1865. He was due $340 of his bounty, and he owed the government $9.13 for transportation. Kimball had also drawn $38.67 of his clothing allowance.[116] Following the war, Kimball applied for a pension on June 26, 1880. He received his pension and lived in Lynn, Massachusetts, until his death on December 4, 1908. His wife, Nellie, survived him and received a pension until 1917, when she remarried.[117]

First Sergeant Marcus Kimball had his image taken in a studio belonging to L.D. Judkins of Haverhill, Massachusetts. The back of the image is signed, suggesting it was meant as a calling card, and a previous owner has

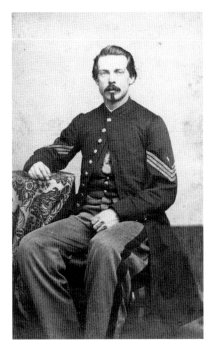

Left: First Sergeant Marcus Kimball, 19th Massachusetts Infantry. *Right*: Back of Kimball's image.

gone to length to list various key points in Kimball's service. It is interesting to note that the photographer is based out of Massachusetts, Kimball's home state, but Kimball would not have been able to get home to have this image taken until at least July 1863, when he was on conscript detail. It is more likely, however, that this image was taken sometime in the winter of 1864, when Kimball was home on furlough. The photographer's address was in Haverhill, close to Kimball's home in Groveland. Sergeant Kimball is pictured here with his first sergeant diamond above his chevrons, even though he was likely no longer a first sergeant at the time the image was taken. The sergeant's chevrons themselves have been colorized for the photo, giving them a blue appearance.

Even in his seated position, there are still many details that can be made out. Sergeant Kimball's sky-blue trousers have the one-and-a-half-inch dark-blue stripe running up the seam, another indicator of his rank.[118] Sergeant Kimball's nine-button frock coat is easily identifiable not only by its long skirting, but also the cuff buttons can just be made out along his left wrist. There were many contractors making these coats, and unlike

others that have been examined, this frock appears to be lacking the light-blue piping on the cuffs and collar that is attributed to the infantry, nor does it have the high collar that is often seen on frock coats.[119]

On the less formal side, Sergeant Kimball has a civilian vest on beneath his frock, allowing the coat to be open in polite company, and what is likely his government-issue flannel shirt can just be made out underneath the vest. There is some sort of decorative line that appears to be fastened to one of the vest buttons as well; its purpose is unknown, but a line for a pocket watch or some other important item seems likely. Finally, Sergeant Kimball has swept his hair back for the image and has a neatly trimmed his mustache and goatee, making for a dashing look.

20ᵀᴴ MASSACHUSETTS INFANTRY

The 20th Massachusetts Infantry was recruited at Camp Massasoit, Readville, in July and August 1861. The main part of the regiment was mustered on August 28. About July 18, 1865, the men—present and absent, about sixty in number—whose time was about to expire after their reenlistment were sent to Boston to be mustered out.

During the Battle of Antietam, the 20th Massachusetts Infantry was just south of the 19th Massachusetts in the line of battle on September 17. The 20th Massachusetts Infantry was reported to be about 400 officers and enlisted men;[120] it lost 12 killed, 84 wounded and 28 missing for a total of 124 casualties.[121] In the regimental history, the actions of the 20th are described as follows: "The Twentieth faced about, but was so crowded in the centre of the division that only a few could fire without killing men on our side.…The Twentieth retired by the right flank with arms at a shoulder and at the ordinary step. Although crowds of men were rushing by us in great disorder and confusion, the regiment was kept perfectly steady, and we were able to bring off every man except those killed or wounded."[122]

First Lieutenant William F. Milton of the 20th was detached and was serving on General Dana's staff on September 17. Milton was a twenty-four-year-old merchant when he mustered into Company G as a second lieutenant on August 28, 1861. He enlisted for three years at Readville, Massachusetts, according to his service records.[123] On September 30, Milton was detached on recruiting duty from which he returned to the regiment on October 19. On October 24, Lieutenant Milton was acting adjutant. His December 31 return shows that Milton was promoted to

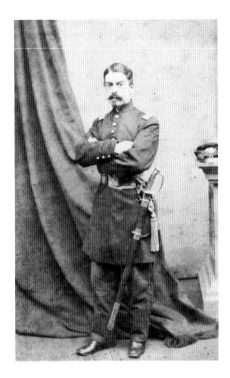

Left: First Lieutenant William F. Milton, 20th Massachusetts Infantry. *Right*: Back of Milton's image.

first lieutenant on October 12, 1861. He was present until February 23, when he was appointed aide-de-camp. With this appointment, Milton was reported "absent," as he was now serving on General Dana's staff at brigade headquarters. Milton was transferred to Company I on September 19, 1863, while still detached. Lieutenant Milton was transferred again in the March/April period of 1864 to Company D. Lieutenant Milton was listed as having received a "severe contusion" on September 17, 1862, at the Battle of Antietam. He received a furlough on September 19. When he returned is not shown in his records. Milton mustered out on July 9, 1864, in Boston; he had last been paid on June 1, 1864.[124] He never received a pension.

According to the back of this CDV, the image was taken on October 7, 1861, at the Black & Batchelder Studio in Boston, Massachusetts. This makes sense, as Second Lieutenant William Milton was detached on recruiting duty at the time and would have had his full uniform with him for that purpose. Taken in studio, this standing shot is ornamented with

a large drape and a column, specifically to present Lieutenant Milton's forage cap.

Starting with his footwear, it is difficult to determine if Milton is wearing a either a Federal-issued shoe or a more expensive private-purchase boot, which was permitted for officers. The shine of the footwear and the tapering of the toe suggests a boot[125] or at least a purchased shoe. Milton's pants are dark blue, with sky-blue piping running down the seam, signifying an infantry officer.[126]

Lieutenant Milton has a long frock coat with nine buttons going down the front and three on each cuff. The buttons are hard to identify in the picture and could be either the standard Federal eagle buttons found on most frock coats, or as this is an early war image, they could be Massachusetts state buttons.[127]

The frock has two bare shoulder boards, indicating the rank of second lieutenant. In addition, Lieutenant Milton is also wearing his regulation sash and sword for this image. The sash for most field-grade officers was crimson and wrapped twice around the body.[128] The hilt of Lieutenant Milton's sword, along with its sheath, leaves little doubt that this blade is likely a variation of the 1850 Foot Officer's Sword,[129] which was very popular with officers throughout the war. The belt itself, likely a Model 1851 Field and Company Grade Officers Sword Belt,[130] was between one and a half and two inches wide with a belt plate described in regulation 1513 as:

> For all Officers and Enlisted Men—*gilt, rectangular, two inches wide a raised bright rim; a silver wreath of laurel encircling the "Arms of the United States;" eagle, shield. Scroll, edge of cloud and ray bright. The motto, "E Pluribus Unum," in silver letters, upon the scroll; stars also of silver; according to pattern.*[131]

Lieutenant Milton's forage cap sits on the pillar, prominently displaying the hunter's horn of the infantry and the brass numbers "20" under it. The short, rounded brim forage cap is a model 1858, better known as a McDowell forage cap,[132] due to its use by that officer. Finally, the lieutenant has carefully parted his hair, trimmed his goatee and given a slight twist to the ends of his mustache for his image.

59TH NEW YORK INFANTRY

The 59th New York Infantry was on the left flank of the 15th Massachusetts Infantry as they advanced through the West Woods on the morning of the seventeenth. The 59th was also known as the Union Guards and was organized in New York City from the U.S. Vanguard, President's Life Guard, U.S. Volunteers, Union Guard, Cameron Highlanders, Kossuth Guards and Cameron Legion. It mustered into the U.S. service from August 2 to October 30, 1861, for a three-year term. It was present at the final assault on the Petersburg fortifications and was then stationed at Munson's Hill, Virginia, where it was mustered out on June 30, 1865.[133]

At Antietam, the 59th New York Infantry was reported to be 381 officers and men strong.[134] Losses were 48 killed, 153 wounded and 23 missing for a total of 224.[135] This regiment was in a bad position: "the 59th New York closed upon and began firing through the left wing of the 15th Massachusetts....[Major General Edwin] Sumner rode up and his attention being called to this terrible mistake, he rode to the right of the 59th New York and ordered it to cease firing and retire which it did in great confusion. Survivors of the regiment say they fired but seven or eight rounds were subjected to a cross fire and Sumner 'cussed them out by the right flank.'"[136]

In Company I was Sanford Purdy, serving as a corporal. He mustered into Company I of the 59th New York Infantry on October 11, 1861, as a private. He gave his age as twenty-two and enlisted for three years. The company descriptive book page says Private Purdy was five feet, ten inches tall, with a light complexion, dark eyes and dark hair. The private stated he was a mechanic before enlisting. Purdy's service records show his status as "not stated" to March/April 1862, when he was "present." He was present until December 28, 1862, when he was reported to be sick in a hospital in Washington, D.C. During this period, he was promoted to corporal on June 23 or July 20—both dates are shown in his records. Thus, at the Battle of Antietam Purdy was a corporal. Corporal Purdy remained in the hospital until February 28, 1863, when he was transferred to a convalescent camp. He remained there until July 1, when he was transferred again, this time to the Invalid Corps. When and where he mustered out are not listed.[137] Purdy applied for a pension on September 21, 1891. His pension card shows that he died on August 15, 1901, in Philadelphia, Pennsylvania.[138]

Left: Private Sanford Purdy, 59th New York Infantry. *Right*: Back of Purdy's image.

While a corporal at Antietam, Sanford Purdy is pictured here as a first sergeant in the Veteran Reserve Corps. The image was taken by photographer J. Jones of Virginia. First known as the Invalid Corps, the Veteran Reserve Corps[139] was developed during the Civil War for those soldiers who were fit for light duty, but due to health, recovery or injury, could not necessarily sustain themselves in the field. The reserves were used as cooks, guards, nurses and stewards at the numerous forts and hospitals around Washington, D.C.[140]

The Veteran Reserve Corps uniform was distinct from that of the volunteer or regular enlisted men. The jacket, in particular, being the reverse of the standard Federal jacket, was made of sky-blue kersey wool with dark-blue trim.[141] The design seems to have varied widely depending on the contractor; in Purdy's case, he has nine Federal eagle buttons running down his jacket, with another two small eagle buttons on the shoulders for the dark-blue epaulets. Purdy's dark-blue cuffs can just be seen at the bottom of the image. Multiple variations on the height of the collar, piping and the cuffs existed.[142] Sanford Purdy has dark-blue sergeant stripes, with the first sergeant diamond in the center; Purdy was the first sergeant of Company B, 14th Veteran Reserve Regiment.[143] First sergeants were the highest-ranking noncommissioned officers in a company.

Finally, Purdy has a neatly trimmed beard and has combed his hair for this image. Taken by photographer J. Jones, the image has a stylized photographer's mark, though no specific address. Purdy likely intended the image as a gift or calling card, as he has signed the back of it.

60TH NEW YORK INFANTRY

The 60th New York Infantry, also known as the 1st St. Lawrence Regiment, was organized at Ogdensburg and there mustered into the U.S. service for three years on October 30, 1861. The 60th New York served with the 12th Corps during the Maryland Campaign but ended the war in the 22nd Corps. The regiment was mustered out of service in Alexandria, Virginia, on July 17, 1865.[144]

During the Battle of Antietam, the 60th New York moved west across the area north of the Cornfield to support General Sedgwick's attack into the West Woods, fighting west of the Hagerstown Pike. The 60th New York Infantry entered the fighting with 226 officers and enlisted men. It suffered 4 killed, 18 wounded and 0 missing for a total of 22 casualties during the battle.[145]

Serving in the 60th was Lieutenant Lester Willson. According to his service records Willson mustered into Company A of the 60th New York Volunteer Infantry on October 30, 1861, with the rank of sergeant at Canton, New York. He stated he was twenty-two years old, five feet, eight inches tall, had blue eyes, brown hair and a light complexion and worked as a clerk before his enlistment. In November, he was assigned to recruit duty in New York so he was "absent" until the January/February 1862 period. After this, Willson was shown as "present" until May 1863. During this period, he was promoted to sergeant major on June 1, 1862, and then to second lieutenant on August 6, 1862, the rank he held at the Battle of Antietam. However, in the regimental history it says, "Lester Willson, who had not yet received his commission as Lieutenant, had been acting for some time as Sergeant Major."[146] It also says, "Colonel Goodrich anticipated a fight, and seems to have had a presentiment of his fate, the day before the battle of Antietam. While marching the regiment up to join [the] other troops advance, on the morning of the 16th, he remarked to Acting Sergeant-Major Willson, who was riding by his side, that in the event of a fight it was possible he might [be] killed, and, writing down the address of his

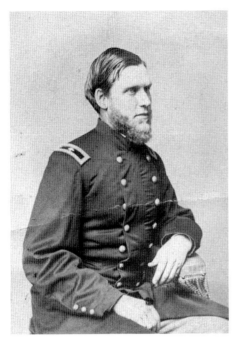

Left: Sergeant Major Lester Willson, 60th New York Infantry. *Right*: Back of Willson's image.

wife, gave it to Willson, with the request that he should telegraph her."[147] In the account of the battle, it continues, "In a short time he was seen to fall [Colonel Goodrich]. Willson went immediately to him, and assisted in raising him from the ground…taken to a barn at the rear of the field, where he soon revived. Seeing Willson near him, he smiled , and seemed greatly comforted."[148] Sergeant Willson, "with the permission of Gen. Greene, had gone North with the body of Col. Goodrich."[149] So Willson was on the field and in the middle of the action, and after the battle he had the task of escorting his brigade commander's body home. Willson's records show he drew $43.39 of his clothing allowance when promoted. Probably because of the battle, Lieutenant Willson was promoted again, to first lieutenant, on October 8, 1862. The next key event in Willson's service records was his casualty report. On May 3, 1863, at Chancellorsville, Willson was severely wounded in the right thigh by a grapeshot, likely a canister ball. Lieutenant Willson was sent to Washington and remained there through June 30. He returned to the unit sometime in the July/August period, as he was listed as "present." Willson remained "present" until he was detached to serve

on the brigade commander's staff in November 1864. Prior to this, on September 13, 1864, Willson was promoted to captain. Captain Willson returned to the regiment in April 1865, and on April 4, he was promoted to lieutenant colonel. Willson became colonel of the regiment on June 9, 1865, mustering out on July 17 of that year. Willson received brevet ranks of colonel for "gallant and meritorious services in the Campaign under Major General William T. Sherman resulting in the fall of Atlanta Ga" and received the rank of brigadier general for the same reason. Both are listed in General Order #67, dated July 16, 1867.[150] Willson filed for a pension on February 24, 1891.[151] He passed away on January 28, 1919, at the age of seventy-nine in Bozeman, Montana.[152]

Lester Willson is seen here wearing his brigadier general's uniform, having received his brevet rank at the end of the war as an acknowledgment of his fine service. He had this image taken shortly thereafter in Albany, New York, by Churchill & Denison, likely on his way home to Canton. As he is seated in a studio and resting his left arm on a tasseled pillow of some sort, there are numerous details that can be made out.

In the image, Willson's sky-blue trousers can just be made out; the bulk of the image is dominated by his brigadier general's frock coat. The frock has three small eagle buttons that can be seen along the right cuff, along with a double row of eight large eagle buttons running down the front of the frock, seven of which can actually be seen. The double rows of buttons are in pairs, signifying a brigadier general.[153] The shoulder boards, with their single star, are a far more common indication of rank and can be seen in this image also.

No doubt wanting to look his best, Willson has a neatly trimmed beard and has combed his hair for this image. The image itself was likely a gift, as the inscription on the back is "Very Truly Lester S Willson Bvt Brigadier General." This same signature can be seen on the front of the CDV, under the image. The CDV once had one of the tax stamps seen on other images, but this one has been removed, likely by a stamp collector. Finally, Willson is wearing a small ring on his left pinkie finger. No inscription can be made out, but this could have been a small favor from an admirer.

THE FIGHTING IN AND around the West Woods was among the most brutal during the Battle of Antietam. The majority of the soldiers examined here were from Sedgewick's Division of the 2nd Corps, which entered the woods with about 4,500 men; it sustained roughly 2,200 casualties

in approximately twenty minutes. One of these men, Clark, though he survived, lost his brother earlier in the fighting. Another, Milton, was wounded, while a third, Purdy, was disabled later in the war due to sickness. Kimball survived Antietam but was captured in 1864, while Russell was plagued by sickness through most of his enlistment. Willson, in support of Sedgewick's attack north of the West Woods, had the dubious honor of escorting his commanding officer's remains home following the battle. As the fighting turned south, the three sections of the northern portion of Antietam battlefield, the Cornfield, East Woods and West Woods, had claimed a combined total of over 12,000 killed, wounded and missing, and the day was not even half over.

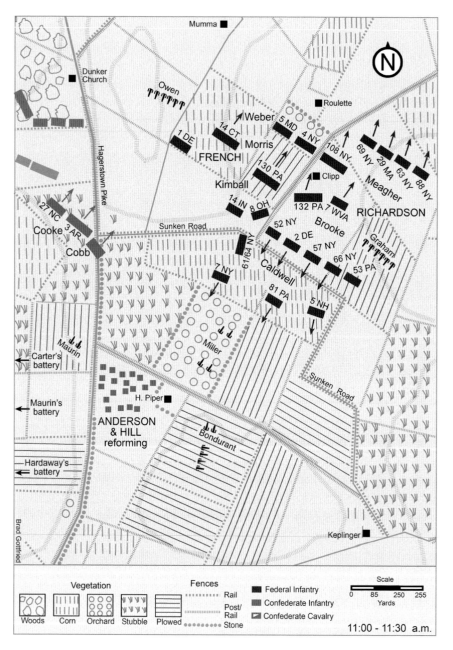

The Sunken Road, 11:00–11:30 a.m. *Courtesy Brad Gottfried.*

4

SUNKEN ROAD

B etween 9:00 and 9:30 on the morning of the seventeenth, Brigadier
General William French's Division of the 2nd Corps approached the
Sunken Road (soon to be known as Bloody Lane). In the lead was the
brigade of Brigadier General Max Weber, followed by the brigade of
Colonel Dwight Morris and finally the brigade of Brigadier General
Nathan Kimball. In Colonel Morris's brigade was the 14th Connecticut
Infantry, which was in the middle of the brigade line. The map shows
the positions of the units near the end of the engagement at the Sunken
Road. Following the fighting, the 14th Connecticut withdrew back toward
the Roulette farmhouse north of the Roulette Farm Lane. Following
General French's division was the division of Major General Israel
Richardson. Leading Richardson's division was the famed Irish Brigade,
commanded by Brigadier General Thomas Meagher. On the right of
the brigade was the 69th New York Infantry. To the left of the 69th was
the 29th Massachusetts Infantry. The next brigade on the field, which
included the 5th New Hampshire Infantry on the left, was commanded
by Brigadier General John Caldwell. It passed around the east side of
the Sunken Road and moved toward the high ground through a cornfield
south of the road. The final brigade to join the fighting was commanded
by Colonel John Brooke and contained the 57th New York Infantry in
the middle of the brigade line. This unit crossed the Sunken Road and
entered the cornfield south of the road. The far left unit in Brooke's
brigade was the 53rd Pennsylvania Infantry; it also crossed the Sunken

Road and entered the cornfield, on the map.[154] The fighting was intense and lasted until the afternoon. The following soldiers were a part of that fighting and members of these units.

14ᵀᴴ CONNECTICUT INFANTRY

The 14th Connecticut Infantry Regiment was recruited from the state at large and organized in the summer of 1862 when, after Union reverses on the Peninsula, the president called for 300,000 volunteers for three years or the war's duration. The unit had its rendezvous, named Camp Foote, at Hartford. On August 23, 1862, the regiment was mustered into the U.S. service for three years. "The regiment never lost a color, but captured several colors from the enemy; lost comparatively few men as prisoners, though capturing many from the foe....It participated in the Grand Review at Washington on May 23rd, and on the 30th the recruits were transferred to the 2nd Conn Heavy artillery, and the original members were mustered out near Alexandria."[155] At Antietam, the 14th was reported to be 1,014 officers and enlisted men strong. It suffered 20 killed, 88 wounded and 48 missing in action, for a total of 156 casualties.[156] In the regimental history, the actions of the 14th at Antietam are described, beginning with the following:

> *After the fourteenth had passed through the cornfield and stood on a little ridge on the side next the enemy, there burst upon them a perfect tempest of musketry. The line of troops in front had passed well into the open field. It seemed to melt under the enemy's fire and breaking many of the men ran through the ranks of the Fourteenth toward the rear. The enemy could be seen, only a thin cloud of smoke rose from what was afterwards found to be their rifle-pits. As by one impulse the line halted on the edge of the cornfield and opened fire. Probably they did then but little damage as the enemy were well protected, but upon our side the bullets whistled past, cutting off the cornstalks, and every moment some one of the men would fall. This rifle-pit was the Sunken Road which at this time was plentifully filled with a quota of Confederate men while the line of troops skirted the crest of the hill above them, thus able to fire over their heads.*[157]

Second Lieutenant James Ferdinand Simpson, who was born in Massachusetts, served as a member of the 14th. Simpson mustered into

Company C of the 14ᵗʰ Connecticut Volunteer Infantry on August 4, 1862, at Camp Foote, Hartford, Connecticut. He stated his age was twenty-one and he lived in Waterbury, Connecticut. Lieutenant Simpson's service records show he was "present" starting on August 20, 1862. Simpson continued to be "present" until August 25, 1864. In between, he was promoted on February 4, 1863, to first lieutenant and transferred to Company D. From March 23 to April 9, Simpson was on a furlough. He was reported missing in action on May 3, 1863, possibly a prisoner. He was paroled on May 9, 1863, at Guiney Station and at City Point on May 15. Assigned to Camp Parole on May 19, 1863, Simpson seems to have gone AWOL to visit Washington, D.C., on May 22. He was charged with being AWOL on June 11 but appears to have been ordered to return to the regiment. Later, on July 3, 1863, Lieutenant Simpson was sent to a hospital in Baltimore. He returned to the regiment and was "present" in September and October. On October 20, 1863, Simpson was promoted again, to captain, and returned to Company C. On November 4, 1863, Simpson was back in a Georgetown hospital, but he returned to duty on December 7, 1863. Captain Simpson was "present" with the regiment until August 25, 1864, when he was wounded in action at Reams' Station in Virginia. Simpson spent two months in the hospital before returning to duty on October 28, 1864, but he was not a well man. On November 2, 1864, he requested to be sent to a hospital for diarrhea and fever. Based on his illness, Simpson resigned on November 14 or 16, 1864, due to disability. In the spring of 1865, Simpson returned to the service (February 16, 1865) as a captain in the 2ⁿᵈ Veteran Volunteer Infantry, where he remained until mustered out on March 26, 1866. Not done with the army, Simpson had subsequent service in the U.S. Army from August 17, 1867, until retiring on November 25, 1887. During his service, Simpson received two brevet ranks, first lieutenant on August 17, 1867, for action at the Wilderness and captain on the same date for Reams Station. Simpson died on June 29, 1899.[158]

According to the back of this CDV, Lieutenant James Simpson had this image taken in the studio of William King on April 7, 1863, in Waterbury, Connecticut. It is possible Simpson was home on leave. What is interesting about the date and this image is that Simpson was promoted from second to first lieutenant on February 4, 1863. It is hard to tell for certain, but it does not look like Simpson is wearing his first lieutenant's shoulder boards for this image. The CDV itself may have been intended as a gift or calling card, as it is signed on the back, listing his name, rank and regiment, as well as the aforementioned date of the picture.

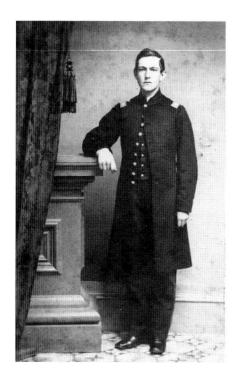 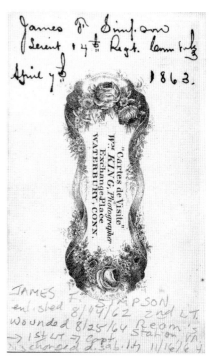

Left: Second Lieutenant James Ferdinand Simpson, 14th Connecticut Infantry. *Right*: Back of Simpson's image.

Lieutenant Simpson is wearing what appears to be a pair of boots judging by the slightly tapered toe. The image does not give a lot of details for these, and they could easily be a private-purchase version of the Federal-issue boot.[159] Most of his footwear is hidden by his pants. The lieutenant's trousers are dark blue with sky-blue piping that can just be made out running up the seam, signifying the infantry.[160] He has a nine-button officer's vest on underneath his frock, allowing him to have the coat open, while the frock coat itself has nine Federal eagle buttons. The cuff buttons are difficult to see in this image but are along the wrists. Besides his shoulder boards signifying his rank, there is very little decoration on Lieutenant Simpson's uniform. The lieutenant is clean shaven for the image and has taken time to comb his hair for posterity.

69ᵀᴴ NEW YORK INFANTRY

The 69ᵗʰ New York Infantry, the 1ˢᵗ Regiment of the Irish Brigade, was the outgrowth of the 69ᵗʰ New York State Militia and contained members from New York City, Chicago, Brooklyn and Buffalo. It was mustered into the U.S. service in New York City between September 7 and November 17, 1861, for three years and left for Washington on November 18.

THE REGIMENT WAS FINALLY mustered out at Alexandria on June 30, 1865. The 69ᵗʰ lost the greatest number of men killed or wounded of any of the New York regiments during the war. It ranks sixth in total loss among all the regiments in the Union army and seventh in percentage of loss to total enrollment. The total number enrolled was 1,513, of whom 261 died from wounds and 151 from other causes, 63 dying in prisons.[161] The 69ᵗʰ entered the Battle of Antietam with a strength of 317 officers and men; it reported 44 killed, 152 wounded and 0 missing, for a total of 196.[162]

When James P. McMahon mustered into Company K of the 69ᵗʰ New York Infantry, he stated that he was twenty-six years old. He did not list a residence; however, he enlisted in New York City. McMahon was commissioned as the captain of the company on November 17, 1861, and his service records show that he was present starting in January 1862.[163] He was then detached to General Meagher's staff in the March/April period. After four months, McMahon was assigned to the provost marshal's staff. At Antietam, Captain McMahon was on the field and mentioned in the report filed by Brigadier General Hancock after the battle:

HEADQUARTERS FIRST DIVISION, SECOND CORPS D'ARMEE,
Harper's Ferry, September 29, 1862
Lieut. Col. J.H. Taylor,
Chief of Staff, Assistant Adjutant-General,
Hdqrs. Second Corps d'Armee, Harper's Ferry, Va.

Colonel*: In obedience to instructions from the major-general commanding the corps, I have the honor to submit a narrative of the operations of this (Richardson's) division during the battle of Antietam, and the time subsequent thereto, until the enemy had retreated from the field, Major-General Richardson's wound being of such a nature as to render it*

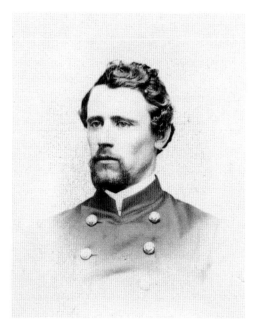

Left: Captain James P. McMahon, 69th New York Infantry. *Right*: Back of McMahon's image.

impracticable for him to make the report as to the period during which he exercised the command.

The staff officers of Major General Richardson, Maj. J.M. Norvell, assistant adjutant general; Capt. James P. McMahon, of the Sixty-ninth New York Volunteers; *First Lieut. D. W. Miller, First Lieut. Wilber L. Hurlbut, First Lieut. C. S. Draper, badly wounded, acted with heroism. After General Richardson was wounded,* Captain McMahon, *Lieutenant Miller, and Lieutenant Hurlbut joined me, and were very efficient, and deserve the highest commendations for their good conduct.*
am, sir, very respectfully, your obedient servant,
 Winf'd S. Hancock,
 Brigadier-General, Commanding Division[164]

After Antietam, Captain McMahon was discharged for a promotion on October 20, 1862. McMahon was promoted to lieutenant colonel of the 155th New York Infantry, with which he served for about five months. He was discharged and promoted again on March 23, 1863, when he became colonel of the 164th New York Infantry. Colonel McMahon was killed in action on June 3, 1864, at Cold Harbor, Virginia.[165]

His death is described in the report filed by General Hancock on the events between May 28 and June 12, 1864. General Hancock writes, "Colonel McMahon with a part of his regiment, the One hundred and sixty-fourth New York, reached the enemy's works, planting with his own hand his regimental colors on the parapet, where he fell covered with wounds and expired in the enemy's hands, losing his colors with honor."[166]

Captain James McMahon, pictured here in his colonel's uniform, is wearing a double-breasted frock coat with two rows of seven eagle buttons.[167] According to the information on the back of McMahon's CDV, it was the frock coat's distinctive cuff buttons that helped to identify him following his death at Cold Harbor in 1864.

The colonel had taken over command of the 164th New York, the Corcoran Zouaves, from his brother, Colonel John E. McMahon, following his death from disease.[168] Colonel James McMahon led his Zouaves in the assault at Cold Harbor, taking the regimental standard and planting it on the Confederate parapet, where he was cut down.[169]

29TH MASSACHUSETTS INFANTRY

The 29th Regiment Massachusetts Volunteer Infantry had for its nucleus seven companies of the 3rd and 4th Regiments, Massachusetts Volunteer Militia, "Minute Men." These seven companies were sent to Fort Monroe in the middle of May 1861, having enlisted for three years. Until July, when the 3rd and 4th Regiments were mustered out, they served with these regiments. From that time until December, they constituted a battalion. Near the close of the year, three new companies were added, and the organization of the 29th Regiment was completed. After the war had completed, it was mustered out at Tenallytown, Maryland, July 29, 1865.[170]

At Antietam, the Irish Brigade suffered heavily. In General Meagher's official report, he states:

> [T]*he Sixty-ninth and Twenty-ninth* [were] *on the right of the line, and the Sixty-third and Eighty-eighth Regiments on the left. On coming into this close and fatal contact with the enemy, the officers and men of the brigade waved their swords and hats and gave the heartiest cheers for their general, George B. McClellan, and the Army of the Potomac. Never were*

men in higher spirits. Never did men with such alacrity and generosity of heart press forward and encounter the perils of the battle-field.

My orders were, that, after the first and second volleys delivered in line of battle by the brigade, the brigade should charge with fixed bayonets on the enemy. Seated on my horse, close to the Sixty-ninth Regiment, I permitted them to deliver their five or six volleys, and then personally ordered them to charge upon the rebel columns, while at the very same moment I ordered Captain Miller, assistant adjutant-general of the brigade, and Lieutenant Gosson, first aide on my staff, to bring up the Eighty-eighth and Sixty-third immediately to the charge. It was my design, under the general orders I received, to push the enemy on both their fronts as they displayed themselves to us, and, relying on the impetuosity and recklessness of Irish soldiers in a charge, felt confident that before such a charge the rebel column would give way and be dispersed.[171]

Lieutenant Colonel Joseph Barnes, who commanded the 29th, apparently did not submit a report of the unit's actions, as there is no report in the official records for the 29th. However, the regimental history by William Osborne says at the Sunken Road: "A hundred yards in front was a Virginia fence; on the other side was another field and slightly raising ground; over the crest of the raising ground, a sunken road; and on the farther side of the road, an extensive corn field and orchard."[172] Osborne continues:

That part of the line held by the Sixty-ninth and the Sixty-third was much exposed, while the Twenty-ninth, its usual "good luck'" not forsaking it even here, was protected by a little ridge in its front and a slight depression of the ground upon which it stood. This did not in any way affect their range on the enemy,—the corn field opened wide before them, their shots cutting off the stalks of the green corn as would a scythe, and having their effect upon the enemy who were hiding there.[173]

On November 5, 1861, Waldo Corbett mustered into Company H of the 29th Massachusetts as a corporal for three years. Corbett stated that he was nineteen and working as a clerk before joining the regiment. His early service records show his status as "not stated" until February 28, 1862, when it was changed to "present." Corporal Corbett was present until the July/August period when he was absent part of the time "sick." However, Corbett was present for the Battle of Antietam and from then until September/October 1863, when he was absent on recruiting duty. During January/February

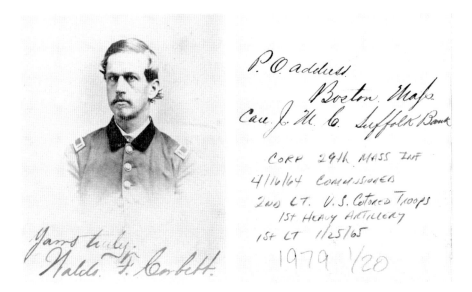

Left: Corporal Waldo Corbett, 29th Massachusetts Infantry. *Right*: Back of Corbett's image.

1863, Corporal Corbett's pay was reduced by the "value of 1 cartridge box belt & plate." Corporal Corbett mustered out on January 1, 1864, to reenlist; he received a bounty of $402, but his pay was reduced by $0.64 for some reason. Corbett was detached from the regiment that January and sent to Knoxville, Tennessee, to study to be an artillery officer. On April 10, 1864, he was discharged from the 29th to accept an appointment as a second lieutenant in Company E of the 1st U.S. Artillery Colored (Heavy).[174]

Pictured here much later in his military career as a first lieutenant, Waldo Corbett obviously had this image taken as a gift for someone judging by the dedication and signature on the front. The reverse of the image has the address for a banker in Boston, Massachusetts. More recently, someone has written Corbett's enlistment and various promotions on the back of the image. If this information is accurate, the image was taken sometime after January 25, 1865, as that is listed as his promotion date to first lieutenant.

Being a bust shot, the image does not give a lot to work with. There are some details that can be made out, however. The coat Waldo Corbett is wearing is dark blue with four large buttons visible. These buttons appear to be of a shape similar to Massachusetts state seal buttons.[175] When the colors on this image are inverted, the raised sword arm of Massachusetts can almost be made out on the buttons. The coat itself is one of two items;

it is either an officer's frock, or an officer's shell jacket. The shell jacket was popular with artillery men, just as it was with the cavalry, and the short velvet collar of this coat implies a private purchase.[176]

Corbett's shoulder boards are also visible in this shot. The gold-trimmed board is filled in with red for the artillery and single bar indicating a first lieutenant. Just under his collar a white shirt is visible, as is a small cravat. Corbett has combed his hair and has a neat mustache and goatee. It is his deep-set eyes, however, that are most striking. Staring directly at the camera, he looks weary after over three years of war.

5TH NEW HAMPSHIRE INFANTRY

The 5th New Hampshire Regiment was organized at Concord, and the men enlisted for three years. Edward E. Cross of Lancaster was appointed colonel on August 27, 1861, and at once undertook the duties of the office. The regiment camped east of the Merrimack River and called the place "Camp Jackson." Company A entered camp on September 28, 1861, and the regimental organization was completed on October 26.[177] Colonel Cross was an experienced American Indian fighter and had seen service in the Mexican War; his experience was valuable in organizing and disciplining the regiment.

The regiment was assigned to the 1st Brigade, Sumner's Division, Army of the Potomac, on November 27, 1861. It marched through Washington and Alexandria, Virginia, on November 28, and the next day camped near Alexandria, at "Camp California," where it remained until March 10, 1862.[178] The unit left Camp California on the fourteenth and was assigned to the 1st Brigade, Richardson's Division, 2nd Army Corps. It participated in a reconnaissance to the Rappahannock River on March 28. The 5th participated in the Peninsula Campaign from April to July 1862 and was at Harrison's Landing, following the Federal retreat, until August 16. Though it did not participate in the fighting at Manassas in August, the 5th New Hampshire did help cover the retreat of Major General John Pope's Union Army of Virginia following its defeat.

At South Mountain the 5th New Hampshire was in the reserve, but at Boonsborough, on September 15, it was in the advance of the army and two days later performed marked service at Antietam, losing in killed and wounded more than one third of those present. The 5th reported 8 killed,

102 wounded and 1 missing for a total of 111. In the official reports, the 5th was given the credit of having discovered and frustrated the attempt of the enemy to turn the left flank of the 2nd Corps.

On May 23, 1865, the 5th New Hampshire marched in the Grand Review of the Union army at Washington, and on the June 28, it was mustered out near Alexandria, Virginia.

After the Battle of Antietam, Colonel Cross, the commander of the regiment, wrote the following report of the actions of his regiment. Note that in the report Colonel Cross mentions Lieutenant Goodwin:

HEADQUARTERS FIFTH NEW HAMPSHIRE VOLUNTEERS,
On the Battle-field, September 18, 1862.

CAPT.: In reference to the part taken by my regiment in the battle of the 17th instant, I have the honor to report that, on arriving at the scene of action, I was ordered forward to relieve on of the regiments of the Irish Brigade, which was done under fire. We then advanced in line of battle several hundred yards and entered a corn-field. While marching by the right flank to gain our position in line of battle, we received a heavy fire of shell and canister-shot, which killed and wounded quite a number of officers and men, a single shell wounding 8 men and passing through the State colors of my regiment.

Maj. Sturtevant, Adjutant Dodd, Capts. Pierce, Long, Murray, Cross Perry, Randlett, and Crafts deserve especial mention for their gallant conduct; also Lieuts. Graves, George, and Bean, each commanding companies, and Lieuts. Livermore, Ricker, and **Goodwin***.*

The following officers were wounded: Col. Cross (slightly); Capts. Long and Randlett; First Lieuts. Graves and Parks; Second Lieuts. Bean, George, Twitchell, Little, and Hurd. Lieut. George A. Gay, a gallant young officer, was killed. Sergeant-Maj. Liscomb was also wounded. Of enlisted men, as far as can be ascertained, 107 were killed and wounded. Our wounded were attended to by Drs. Knight, Davis, and Childs as rapidly and as well as possible, and were all made very comfortable.

Very truly,
EDWARD E. CROSS,
Col. Fifth New Hampshire Volunteers[179]

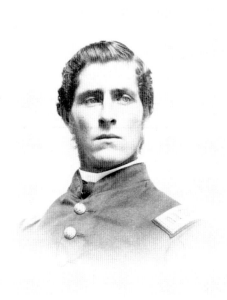

Left: Second Lieutenant George Goodwin, 5th New Hampshire Infantry. *Right*: Back of Goodwin's image.

George Goodwin mustered into Company D of the 5th New Hampshire on October 23, 1861, as a sergeant. He gave his residence as Lebanon, Maine, and his age as twenty-five. His service records show his status as "not stated" from his muster in through the November/December period. Sergeant Goodwin was "present" starting in January 1862 until December 1862. During this period, Goodwin was promoted to first sergeant on April 13, 1862, and then to second lieutenant on August 11, 1862. With this promotion, Lieutenant Goodwin was assigned to Company F. On December 13, 1862, at the Battle of Fredericksburg, Goodwin suffered a musket shot to the left side of his head described as a "sever[e] wound scalp" and was sent to a hospital. However, it must not have been too bad, as Goodwin is shown as "present" for the January/February 1863 period. Shortly after his wounding, Goodwin was promoted again, to first lieutenant, on December 17, 1862. After he returned to his unit on March 3, 1863, he was promoted to captain and transferred back to Company D. At the Battle of Chancellorsville on May 3, 1863, Goodwin suffered his second wound; he was hit by a shell in the right arm/elbow. As a result, Captain Goodwin received a thirty-day furlough on May 7. The captain returned to the unit in June and was present until September/October when he was "sick." Goodwin was "detached for

C[ourt] M[atrial] duty" and absent from the 5th for some time; he remained on detached duty until May or June 1864. On June 3, 1864, Captain George Goodwin was killed in action at Cold Harbor.[180]

Likely taken in the spring of 1863, this image shows George Goodwin in his captain's uniform. This time frame is likely given Goodwin's wounding at Chancellorsville and his subsequent furlough to recuperate. The reverse of the image shows that it was taken in Concord, New Hampshire, by J. Morgan, a relatively short distance from Goodwin's home of Lebanon, Maine. The back of the image also has a two-cent tax stamp, meaning the image cost less than twenty-five cents.[181]

While bust shots tend to have much less to work with, there are a few details that can be made out. Goodwin is wearing an officers' frock with Federal eagle buttons, on which the infantry *I* can almost be made out.[182] His shoulder boards have the usual gold border, along with the two bars signifying a captain's rank. He is wearing a clean white shirt as well as a small cravat. Goodwin is looking sidelong off frame with his hair is neatly combed and perhaps oiled; he is also sporting long mutton chops.

57TH NEW YORK INFANTRY

According to *The Union Army* (published in 1908) the 57th New York Infantry, the National Guard Rifles, was mustered into the U.S. service at New York City between August 12 and November 19, 1861, for three years. It was mustered out by companies from July 14, 1864, to December 6, 1864.[183]

The 57th New York consisted of 309 officers and enlisted men and reported 19 killed, 79 wounded and 3 missing, for a total of 101 casualties at Antietam.[184] The regiment received orders to march on the enemy, who were at that time drawn up in a deep ditch at the foot of the hill overlooking the "Sunken Road," or "Bloody Lane." After attacking the Sunken Road, the regiment drove the Confederates through the cornfield beyond and captured the colors of the 12th Alabama Infantry along with many prisoners. Later in the fighting, the 57th supported a battery to the rear of the brigade. Afterward, the 57th was ordered to form on the left of the 2nd Delaware Infantry and remained there for the next two days.

On September 25, 1861, George Jones mustered into Company G of the 57th New York State Volunteers as a first lieutenant. Jones was twenty-one, and he signed up for three years. His service records show

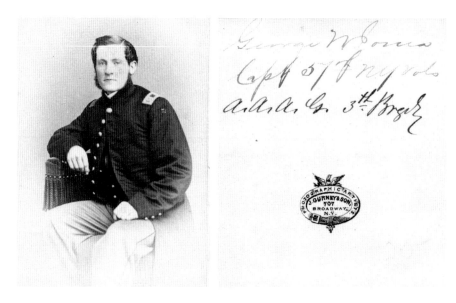

Left: Captain George Jones, 57th New York Infantry. *Right*: Back of Jones's image.

him as "present" from November 1861 to February 7, 1862, when he was detached and assigned to recruiting duty in New York. Jones returned to the regiment sometime in May or June 1862. On August 2, 1862, he was promoted to captain of Company H. George Jones was erroneously reported killed at Antietam. He suffered a wound to the shoulder, but it was not as serious as first thought, and he was back with the regiment for November/December 1862. On March 23, 1863, he received a ten-day leave and returned on April 10. Jones was "present" for the rest of his service, except for leave in December 1863 to visit Iowa and another leave in February 1864 to visit Ohio. This leave was extended to March 28, 1864. In the May/June period, his records contain a note that Captain Jones was due an additional ten dollars per month for the period February 29 to June 30, 1864, for commanding the company. In June 1864, Captain Jones commanded the regiment and was wounded on the seventeenth at Petersburg. On July 4, 1864, Jones was promoted to major and mustered out on August 14, 1864. When Jones mustered out, he owed the government for five cartridge box belt plates and screwdrivers. There is some indication that Jones may have received a brevet promotion to lieutenant colonel.[185] George Jones is mentioned in Major Chapman's report on the Battle of Antietam:

CAMP ON BOLIVAR HEIGHTS,
September 24, 1862.
Lieutenant CHARLES P. HATCH,
Acting Assistant Adjutant-General.

LIEUTENANT: I have the honor to submit the following report of the movements of my command during the action of the 17th instant near Sharpsburg:

About noon of that day we became actively engaged with the enemy, our brigade having relieved that of General Meagher.

It is with gratification that I have to speak of the general conduct of my command, both officers and men. They acted nobly throughout. I would especially mention Captain N. Grarrow Throop (severely wounded); Captain James W. Britt (who, although wounded, refused to leave the field); Captains Kirk, Curtiss, and Mott; Lieutenant John H. Bell (severely wounded), Lieutenants **Jones***, Wright, Higbee (killed), and Folger (killed). The medical officers of the regiment, Surgs. Robert V. McKim and Asst. Surgs. Henry C. Dean and Nelson Neely, are deserving of all praise for their care and attention to the wounded, and the promptness with which they caused them to be removed from the field.*

We took into the battle 309 officers and men, and lost during the day 97 killed and wounded and 3 missing. A detailed list of casualties has already been sent in.

I am, sir, with much respect, your obedient servant,

A.B. CHAPMAN, Major, Commanding Fifty-seventh New York Volunteers[186] [emphasis added]

Captain George Jones, seen here seated in J. Gurney & Son's Broadway photo gallery, had this image taken most likely for use as a gift or calling card. He has signed the back, giving his name, rank and his post as the acting assistant adjutant general of the 3rd Brigade. He was in this temporary posting for much of 1863.[187]

Unlike the majority of officer images that have been examined so far, Captain Jones is wearing the post–December 1861 sky-blue trousers with a dark-blue welt down the seam.[188] His frock coat can be identified by the skirting and three cuff buttons, along with the single row of nine buttons running down the front. The buttons, particularly the topmost, look large in this image and could be New York State seal buttons, but the details cannot

be made out for certain. Jones's rank is also indicated on the frock coat's double bar shoulder boards.

Beneath his frock is a partially opened Federal officer's vest; several of its Federal eagle buttons can be seen in this image.[189] Captain Jones is also wearing a clean white shirt for the image and has combed his hair, sweeping it forward above the ears, a style that has been used in several images. He is also sporting a set of mutton chops and looks to have had the photographer give his cheeks just the slightest blush, to give the image a little life.

53ʳᵈ Pennsylvania Infantry

The 53ʳᵈ Pennsylvania Regiment was organized at Camp Curtin, Harrisburg, on November 7, 1861. It was recruited from the counties of Chester, Montgomery, Blair, Huntingdon, Northumberland, Juniata and Westmoreland. At the end of the war, it marched in the Grand Review at Washington and was mustered out near Alexandria on June 30, 1865.[190]

The 53ᵗʰ Pennsylvania Infantry participated in the Maryland Campaign, being in reserve at South Mountain and in the hottest of the fight at Antietam. The regiment reported 6 killed, 18 wounded and 1 missing, for a total of 25.[191] Part of the action is described in Lieutenant Colonel Richards McMichael's report:

> *Gen. Richardson ordered Col. Brooke to send the Fifty-third Regiment forward, and hold in check the rebel brigade now on our right and in front; also to hold at all hazard the barn and orchard a short distance in front, the barn being used as a hospital. Steadily, under a shower of musketry, my regiment advanced to the orchard and gained the barn about 100 yards in front of the main line, and, still pressing onward, reached the crest of the hill and drove back the enemy. We moved forward until we formed a connection with Gen. French' division, and held that position until ordered by Col. Brooke to support a battery.*[192]

After the battle, the 53ʳᵈ was engaged for two days in the work of interring the dead, after which the regiment marched to Harpers Ferry and remained at Bolivar Heights until October 30.

On September 18, 1861, Tobias Schmearer mustered into Company A of the 53ʳᵈ as a corporal for three years. Schmearer stated that he came

from Montgomery County, Pennsylvania, and he was twenty-one years old. He was a basket maker before the war and was five feet, five and a half inches tall, with gray eyes, sandy hair and a light complexion. His service records show his status as "not stated" through to December 31, 1861. Schmearer was "present" starting with the January and February bimonthly return. Corporal Schmearer was present through December 31, 1863, when he reenlisted and received a bounty of $100. However, Schmearer owed the government $0.23 for clothing. During the January/February 1863 period, Corporal Schmearer was promoted to sergeant; the exact date is not listed. Sergeant Schmearer was wounded in action on June 16, 1864, at Petersburg; the wound was described as a slight neck wound. On October 1, 1864, Sergeant Schmearer was promoted to first sergeant, and thirty days later, on October 30 or November 1, 1864, he was promoted again, to second lieutenant. On April 28, 1865, Schmearer requested a twenty-day furlough to "arrange for the comfort and support of a Widowed Mother." Lieutenant Schmearer mustered out on June 30, 1865; he had last been paid on April 30, 1865.[193]

Corporal Tobias Schmearer had this picture taken in H.C. Vansyckel's Philadelphia gallery, likely in 1863 following his promotion to sergeant. Note the price of six for a dollar. Besides the decorative drapery and carpet, Schmearer has been provided a chair on which to rest his hand, as well as a head brace to keep him from moving during the exposure. The brace can just be made out behind him and between his legs.

Starting with his shoes, these appear to be a variation on the Federal-issue leather shoe.[194] Multiple contractors made these over the course of the war, each varying with the form and fit. Schmearer's trousers are sky blue with the one-and-a-half-inch dark-blue stripe up the seam indicating his rank as a sergeant.[195] His rank is also identified by the chevrons on the sleeves of his frock coat. The coat itself is easily identifiable by its long skirting, cuff buttons and the piping at the cuffs and collar as well as the nine Federal eagle buttons down the front, of which eight can be seen in this image.

Schmearer is also wearing an enlisted man's vest under his frock, partially unbuttoned, with all nine buttons visible. Again, the vest allowed a soldier to have his coat open in public. From his pocket and looped through a button hole is what appears to be a watch chain with some sort of decorative fob attached to it. Watches were private purchase items but important to make sure the troops were following orders in a timely manner.

In his left hand is an interesting item, an oilcloth kepi. This item was a private purchase and was used for wet weather.[196] There does appear to be

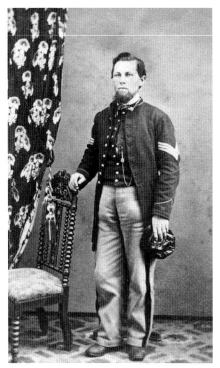

Left: Corporal Tobias Schmearer, 53rd Pennsylvania Infantry. *Right*: Back of Schmearer's image.

some sort of decoration on the front of the kepi; at the tip of Schmearer's index finger is what looks to be a brass 3, no doubt part of the 53 for the 53rd Pennsylvania Infantry.[197]

Finally, Schmearer has spruced himself up for the shot, not only with a clean uniform and neatly trimmed facial hair but also with either a new paper collar or freshly starched collar and cravat for the image.

These six soldiers were present at one of the most infamous locations in the Civil War, the Sunken Road, forever known after the battle as Bloody Lane. They marched with their units across the Antietam Creek that morning to join the attack. In the first division to attack the road was James Ferdinand Simpson, a green soldier entering his first engagement of the war. Later in his service, he was a prisoner of war and afterward wounded; he was fortunate to survive. The other five individuals were all in Major General

Richardson's division, the second of the two divisions of troops attacking the road. Leading this attack was the famed Irish Brigade. James P. McMahon was a member of that brigade; he survived Antietam but was killed in action in 1864. Also in the Irish Brigade was Waldo Corbett, who survived the war and eventually received a pension for his service. In the next brigade to arrive was George Goodwin; after Antietam, George was wounded twice before finally being killed in action at Cold Harbor in 1864. In the final brigade of Richardson's division was George Jones, who was slightly wounded on this field. He survived and continued to serve until his three years were up in 1864. The final soldier was Tobias Schmearer, who came through Antietam only to be wounded later in the war. This may have been slight, as Tobias was present until the end of the war. After the fighting at the Sunken Road, these units withdrew to the high ground north of the road.

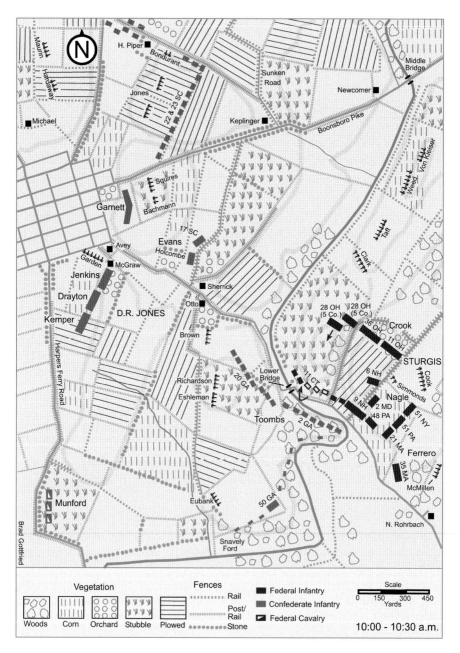

The Lower (Burnside's) Bridge, 10:00–10:30 a.m. *Courtesy Brad Gottfried.*

5

BURNSIDE'S BRIDGE

etween about 10:00 a.m. and 1:30 p.m. on the seventeenth, the
Lower Bridge, known forever after the battle as Burnside's Bridge,
was attacked by regiments from three different brigades. In the first attack
was the 11th Connecticut Infantry from the brigade of Colonel Edward
Harland. It approached the bridge from the south along the farm lane
that ran to the bridge. In the next attack was the brigade of Colonel James
Nagle, including the 6th New Hampshire Infantry. In the same brigade was
the 9th New Hampshire Infantry, a new regiment mustered into service
in August 1862. This unit was on the left of the 11th Connecticut. In the
attack that finally captured the bridge were the 51st Pennsylvania and the
51st New York Infantries of Brigadier General Edward Ferrero. In support
was the 35th Massachusetts Infantry of the same brigade. On the map,
the 11th can be seen approaching the bridge while the other regiments are
to the east and south. The 6th New Hampshire was north of the 9th New
Hampshire, which was following the 11th as they moved up the road. The
51st Pennsylvania was in front of the 51st New York. The 35th Massachusetts
was farther south. The following soldiers were a part of that fighting and
were members of these units.

11ᵀᴴ Connecticut Infantry

The 11th Connecticut Infantry Regiment was organized and mustered into the U.S. service at Hartford, Connecticut, on October 24, 1861, for three years. The 11th was finally mustered out December 21, 1865, having been in the service four years and two months.[198]

At Antietam, the 11th was in the advance on the Union left attempting to capture the Lower Bridge. The 11th lost 181 men in this attack, including every field officer. Being nearly out of ammunition, it was relieved, but before the men's cartridge boxes could be filled, the regiment was again called up to support a battery with the bayonet. With the retreat of Confederate forces, the regiment went into camp at Pleasant Valley, Maryland, and Lieutenant Colonel Stedman was promoted to colonel.[199] The regiment went into the battle consisting of about 440 officers and enlisted men.[200]

Serving in the 11th as its lieutenant colonel was Griffin Alexander Stedman Jr. When he enlisted, Stedman was twenty-three years old and living in Hartford according to his service records. He was born on January 6, 1838, in Hartford. Stedman had originally been commissioned as a captain in Company I of the 5th Connecticut Infantry on July 22, 1861. He served in the 5th Connecticut Infantry until November 27, 1861, when he was discharged to be commissioned as major in the 11th Connecticut Infantry. Major Stedman was promoted to lieutenant colonel on June 11, 1862. At the Battle of Antietam, Lieutenant Colonel Stedman was wounded, but the nature of his wound was not reported. It may not have been serious, as a note in his service record reports that he assumed command of the regiment on October 25, 1862. His date of rank as colonel was September 25, 1862. Stedman was mortally wounded on August 5, 1864, in the fighting at Petersburg, Virginia. Major General Ord, the corps commander, attempted to get Colonel Stedman promoted to brevet brigade general before the colonel passed away. While the date of his commission is August 5, 1864, it was not issued on that date, so Stedman probably did not know of his promotion before his death.[201]

Colonel Griffin Stedman is pictured here wearing his colonel's uniform. Though the shoulder boards are washed out, obscuring the eagles that should be there, the double-breasted frock with two evenly spaced rows of eagle buttons is a giveaway.[202] The colonel has obviously prepared himself for the image, as he has not only a fantastic mustache and combed hair but also a clean uniform with a starched shirt.

Left: Lieutenant Colonel Griffin Alexander Stedman Jr., 11th Connecticut Infantry. *Right*: Back of Stedman's image.

The reverse of the image is fascinating because it has no identification for the colonel; instead, it describes the colonel as a friend of someone else entirely. It also has a clear three-cent tax stamp, indicating the image cost no more than fifty cents. Sadly, the photographer neglected to cancel the stamp with his signature and gives no indication where the photo was taken or by whom.[203]

6TH NEW HAMPSHIRE INFANTRY

The 6th New Hampshire Regiment was organized at Keene in November 1861, the men coming from all parts of the state. The men were mustered between November 27 and 30, and the 6th remained on duty in Alexandria until the July 17, 1862.[204] "The original members not reenlisted, were mustered out Nov. 27 and 28, 1864 near Petersburg, Va. And the renlisted men and recruits were mustered out July 17th 1865 near Alexandria, Va."[205] At Antietam, the 6th New Hampshire took part in a charge designed to take

the stone bridge (afterward known as Burnside's Bridge), on Antietam Creek. The 6th reported a strength of 150 men and losses of 4 killed, 13 wounded and 1 missing for a total of 18.[206] The regimental history describes the first attack on the bridge as follows: "As the attacking party, led by Colonel Griffin, debouched from the field into the road, the rebels, from their intrenched position, redoubled the fury of their fire, sweeping the head of the column with murderous effect. Of the first hundred men who passed through the opening in the fence, at least nine tenths were either killed or wounded."[207]

Simon Griffin was born in Nelson, New Hampshire, on August 9, 1824. Educated at Roxbury, New Hampshire, he taught school, represented his native town in the state legislature (1859–60), studied law, was admitted to the bar and, in 1860, began to practice in Concord. When the war came, Griffin was commissioned captain of Company B of the 2nd New Hampshire Volunteers on June 1, 1861. Griffin was discharged to become lieutenant colonel of the 6th New Hampshire Regiment on October 26, 1861. He paid his own expenses to return to Keene from Washington, D.C., to join the regiment and was promoted to full colonel on April 22, 1862. His service records showed him as "present" from muster in to December 17, 1862, when he received a thirty-day furlough. Following Antietam, he was present at Fredericksburg, where his regiment lost one third of its number. After this, he was commanding the 1st Brigade, 2nd Division, 9th Corps, as of January 19, 1863. In May 1863, Griffin was given permanent command of the 1st Brigade, 2nd Division, 9th Army Corps, and with it joined Sherman in the defense of the rear of Grant's army before Vicksburg. On October 31, 1863, he was placed in command of Camp Nelson, Kentucky, where he was at the head of nine thousand troops. On April 20, 1864, Griffin commanded the 2nd Brigade, 2nd Division, 9th Corps. He commanded the brigade in the Battles of the Wilderness and Spotsylvania Court House. After these engagements, General U.S. Grant recommended Simon Griffin be promoted to brigadier general, effective May 12, 1864. Brigadier General Griffin commanded his brigade at the Battles of North Anna, Totopotomy, Bethesda Church and Cold Harbor and commanded two brigades in the assault on Petersburg, carrying the works and capturing one thousand prisoners, together with arms, ammunition and artillery. On April 2, 1865, he arranged and planned the assault at "Fort Hell" and, for gallant conduct, was brevetted major general of volunteers to date from April 2, 1865, participating afterward in the pursuit and capture of Lee's army. He was mustered out of the volunteer service on August 24, 1865, declined an appointment in the regular army and returned to New Hampshire, where he was a representative in the state

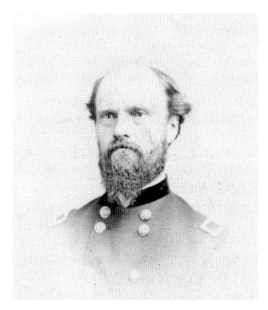

Left: Lieutenant Colonel Simon Griffin, 6th New Hampshire Infantry. *Right*: Back of Griffin's image.

legislature (1867–69), was chairman of the Republican state convention in 1868 and in 1888 became commander of the Massachusetts commandery of the Military Order of the Loyal Legion. He subsequently became extensively interested in land and railroad enterprises in Texas and devoted much time to literary work. General Griffin died on January 4, 1902.[208]

Pictured here in his brigadier general's uniform, Simon Griffin was a colonel commanding a regiment at Antietam. While the bust image is limited on details, it does easily establish Griffin as a brigadier general. His frock coat has the double row of eight staff and general officer's eagle buttons[209] prescribed for that rank, as well as the single-star shoulder boards, indicative of a brigadier. The frock also has a velvet collar, with a freshly starched shirt or paper collar underneath. Finally, the colonel has trimmed his beard and combed his hair back for the image.

Interestingly, the back of the image provides more details than the image itself. The photo was taken at the Addis Gallery in Washington, D.C., by P.R. Marvin. Besides Griffin's signature, rank and division, the back of the image also has a three-cent tax stamp. The stamp has been struck though, indicating that the tax has been paid and the image cost no more than fifty cents.[210]

9ᵀᴴ NEW HAMPSHIRE INFANTRY

Recruiting for the 9th New Hampshire Infantry began in May 1862, and by July 31 many recruits had been mustered in at "Camp Colby," Concord, and the organization was completed on August 23, 1862. In camp for nearly a month, the 9th New Hampshire participated in the Grand Review in Washington on May 23, 1865, and on June 10 the 9th mustered out, broke camp and returned to New Hampshire.[211] The regimental colors were delivered to the governor at Concord on June 14, 1865, and that same day the regiment was paid and discharged.[212]

On September 17, at 9:00 a.m., the 9th New Hampshire was ordered to the front at Antietam and took position on the left, opposite the stone bridge over Antietam Creek. After two hours of exposure to incessant musketry fire at short range, from Confederates posted on the high and heavily wooded bank across the stream, the bridge was carried by storm. The 9th New Hampshire was one of the first regiments over Antietam Creek; it fought for the rest of the day and that night guarded the bridge. As such, it entered the battle with 710 officers and enlisted men.[213] Its losses were 10 killed, 49 wounded and 0 missing for a total of 59.[214]

Charles Judkins was eighteen when he mustered into Company A of the 9th New Hampshire Infantry on July 3, 1862, as a private at Concord, New Hampshire. Private Judkins was five feet, six inches tall, with a light complexion, light hair and hazel eyes. He was born in Manchester, Vermont. Judkins received $25 as a bounty plus $2 and an advance of one month's pay of $13. He stated that he was from Kingston. Private Judkins's status was "not stated" for the month of August 1862. Judkins was "present" from September 1862 until March 31, 1864, when he reported as absent sick in General Hospital in Covington, Kentucky. Judkins was listed as wounded in action on September 17, 1862, on one form but not in his service record. He was wounded again on May 12, 1864, when he received a flesh wound of the right calf from a Minié ball at Spotsylvania. In the next two months, Judkins owed the government $22.36 for transportation. On September 30, 1864, Judkins was transferred to Company G, 6th Regiment Veteran Reserve Corps. He mustered out on June 10, 1865. He was due $75 for his bounty and pay from February 29, 1864. His clothing allowance shows he had drawn $41.87. After the war, Charles Judkins worked as a blacksmith and lived in Charlestown, Massachusetts.[215] He filed for a pension on August 1, 1887. Exactly when he died is not clear; in his pension file is the statement

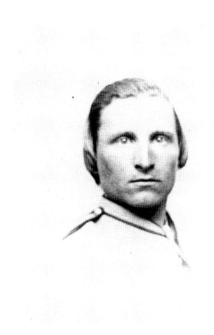

Left: Private Charles Judkins, 9th New Hampshire Infantry. *Right*: Back of Judkins's image.

that he was reported dead on September 4, 1902, but exact date of death is unknown.[216]

Private Charles Judkins is seen here wearing a variation of the Veteran Reserve Corps uniform. The uniform is the reverse of the standard-issue uniform, with sky-blue kersey wool making up the bulk of it and dark-blue trim.[217] Judkins was transferred to the Veteran Reserve Corps following his second wound and continued to serve his country in that capacity until the end of the war.

While the image unfortunately has no photographer's signature or location information, it was likely taken in or around Washington, D.C., in late 1864 or 1865. Private Judkins has cleaned himself up for this image, having combed his hair back, and looks directly into the camera. While the back of the image lacks the photography gallery information, it does have a touching inscription written for Judkins's brother: "may you remember me always when far a way remember me as your true and affectionate Brother Charles M. Judkins Co. A. 9th Reg N.H. Vol. 2nd Brigade 2nd Division 9th Army Corps." Beyond the inscription, the back of the image also has a two-cent tax stamp, meaning that this bust image cost Judkins less that twenty-five cents.[218]

51ˢᵗ PENNSYLVANIA INFANTRY

This regiment was recruited during the summer and fall of 1861 by Colonel John F. Hartranft for three years' service, most of the officers and men having already served a three-month term. Companies A, C, D, F and I were recruited in Montgomery County; E, H and K in Union and Snyder; G in Center; and B in Northampton. The place of rendezvous was Camp Curtin, Harrisburg, and the regimental organization was completed on November 16, 1861. At the end of the war, the 51ˢᵗ Pennsylvania marched in the Grand Review on May 23 and finally mustered out at Alexandria on July 27, 1865.[219]

The 51ˢᵗ Pennsylvania Infantry was about 335 officers and enlisted men strong at the time of the Battle of Antietam[220] and was active at South Mountain and Antietam, losing 21 killed and 99 wounded.[221] The regimental history says: "[S]ix men were the first to cross the bridge, but the remainder of the regiment followed close on their footsteps and so choked up the entrance to it that a halt was necessarily made on the stone structure. The enemy now deserted their works and scattered and scampered over the hills like a huge drove of scared sheep."[222]

John Van Lew mustered into Company K of the 51ˢᵗ Pennsylvania Infantry on November 12, 1861, as a private. Van Lew gave his age as eighteen, and he was described as five feet, eight inches tall, with blue eyes, brown hair and a fair complexion and worked as a farmer before enlisting. As was common, his status was "not stated" until the summer of 1862, when it was noted that he was assigned to the commissary. He seems to have been with the commissary until the November/December 1862 period, when he was "present." Van Lew was "present" until May or June 1864. He reenlisted on December 31, 1863, as a veteran volunteer. On May 6, 1864, Private Van Lew was promoted to corporal. The following month, on June 17, 1864, Van Lew was listed as wounded in action and was absent until September. He was also promoted on June 18 to sergeant. Van Lew was "present" until his muster out on July 27, 1865, after his final promotion, to second lieutenant, on April 18, 1865.[223] John Van Lew filed for a pension on March 25, 1878, with his last name spelled as Vaulen.[224] There is only limited information available about Sergeant John Van Lew (or possibly Vanlew, Vaulen or Vanloo depending on how the name was recorded). What is known is that he was most likely a private during the Battle of Antietam and mustered out at the end of the war as a second lieutenant. He was promoted to the officer ranks in April 1865, after

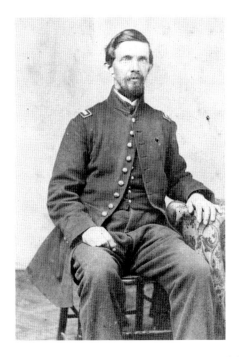

Left: Private John Van Lew, 51st Pennsylvania Infantry. *Right*: Back of Van Lew's image.

Lee's surrender, and it was sometime after that, perhaps even after he was mustered out, that he had this image taken for posterity.

Photographed in Harter's Gallery in Auburn, New York, Van Lew is seated on a stool and has on the dark-blue trousers of an officer, as well as an officer's dark-blue vest.[225] The single-breasted frock coat has the traditional nine Federal eagle buttons down the front, the topmost of which Van Lew has chosen to fasten for the image, along with three small eagle buttons on the cuffs. Neither the frock nor the trousers have the light-blue trim sometimes seen on infantry officers' uniforms. To signify his rank, the frock has a pair of second lieutenant's shoulder boards, while under the frock's high collar one can just make out a cravat and either a newly starched shirt or a paper collar. The cravat is actually a requirement for an officer.[226] Van Lew's neatly trimmed beard and combed hair show he wanted to look his best for the image.

The reverse of the CDV bares an advertisement and address for the photographer's gallery in Auburn within a stylized wreath. The image is unsigned by either the photographer or Van Lew, but more recently, someone has written in his name, company and regiment along with a note suggesting the image came from a family album.

51ST NEW YORK INFANTRY

The 51st New York Infantry Regiment contained six companies of the Shepard Rifles, two companies of the Scott Rifles and two companies of the Union Rifles and was organized in New York City, where it was mustered into the service of the United States between July 27 and October 23, 1861, for a three-year term of enlistment.[227]

The original members who did not reenlist were mustered out during the autumn of 1864 and the veterans at Alexandria on July 25, 1865. The total enrollment of the regiment was 3,050, and it received in June 1865 the veterans and recruits of the 109th New York. Its total loss in all its engagements was 925, while 202 died from wounds and 385 from accident, disease or imprisonment. Colonel William F. Fox, in "Regimental Losses," stated of the 51st, "Few regiments saw a more active service and none left a more honorable record."[228]

The 51st New York was about 335 officers and enlisted men strong at the time of the Battle of Antietam[229] and reported casualties of 18 killed, 68 wounded and no missing, for a total of 87 at Antietam.[230] Alongside its sister regiment, the 51st Pennsylvania, the 51st New York succeeded in taking the hotly contested Lower Bridge over the Antietam Creek. The 51st's approach to the bridge is described as follows: "Potter, at the head of the 51st New York, perceiving this movement and fearing that his exposed flank would lose very heavily, under the concentrated fire of the enemy, brought his regiment forward into line and then oblique to the left, down the road, on the edge of the stream below the bridge where a rail fence offered some cover."[231]

Serving in the 51st New York as assistant surgeon was William H. Leonard. Leonard enlisted into the regiment on September 28, 1861, at Worcester, New York, as a second lieutenant. He stated that he was twenty-six years old, five feet, eleven inches tall and had hazel eyes, brown hair and a light complexion according to his service records. Leonard was working as a clerk prior to the war. His commission was dated October 9, 1861, for three years. His status was "not stated" for October 1861. Lieutenant Leonard was, however, "present" until July/August 1862. On March 17, 1862, William Leonard was promoted to assistant surgeon, and surgeon on October 6, 1862. Leonard was "present" during the Battle of Antietam. There is a note that he was "absent" with the wounded in December. On December 30, 1862, Surgeon Leonard requested a furlough of twenty days. This was approved. Leonard returned and was "present" until August 15, 1863, when his resignation was accepted and he left the service. He stated that his wife's

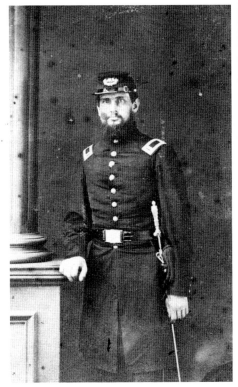

Left: Assistant Surgeon William H. Leonard, 51st New York Infantry. *Above*: Back of Leonard's image.

failing health prompted him to resign. Leonard seems to have never filed for a pension.[232]

Pictured here in his first lieutenant's uniform, Lieutenant William Leonard was a second lieutenant at the time of the Battle of Antietam. Initially with Company I, Leonard was made an assistant surgeon for the regiment six months prior to Antietam. Following the battle, on October 6, 1862, he was made the regimental surgeon. While his record does not specifically state this, it is possible that he was promoted to first lieutenant at that time.

The photographer was not identified on the image. The image itself is of the lieutenant in his full dress uniform, sash, sword and all. The front is signed, and the lieutenant's name and regiment have been included on the back, along with the regiment's nickname, the Shepard Rifles. There is no studio mark or information on the CDV, and that, along with similar props found in Lieutenant Gurney's image from chapter 1, suggests that these images may have been taken at the same location.

Lieutenant Leonard is wearing the dark-blue trousers and long frock coat of an infantry officer. The light-blue piping along the seam of the trouser

legs can just be made out along his left leg. The frock has the usual nine Federal eagle buttons along with the shoulder boards of a first lieutenant for his rank. Three small buttons can be seen on his left wrist. Around his waist he has a sash; one of the decorative finials can be seen near his sword hilt. Unlike infantry officers, who would have had a crimson sash, Lieutenant Leonard is likely wearing a green silk sash, as designated for officers of the medical department.[233] His sword belt is over top of the sash; its rectangular belt buckle is fastened across the stomach, the same as a noncommissioned officer's belt buckle.[234] Finally, the sword itself is prominently displayed for the image. The rounded finial, slightly bulbous hilt and rounded cross guard with what appears to be a Union shield emblem near the base of the blade—along with Lieutenant Leonard being in the medical department—all suggest that this is a medical staff sword.[235]

Lieutenant Leonard looks straight into the camera and sports a neatly trimmed beard and mustache. His forage cap appears to be a 1858 regulation cap,[236] with white metal roman lettering ornamentation often seen on officers' caps.[237] This was a common decoration, but the image is not clear if he has the *MS* lettering for Medical Service or the more common *US*—either is possible for a Union medical officer.

35TH MASSACHUSETTS INFANTRY

The 35th Regiment Massachusetts Volunteer Infantry was organized at Camp Stanton, Lynnfield, and was composed mostly of men enrolled from eastern Massachusetts. It was recruited during July and the early part of August 1862, and its members were mustered into the service largely between August 9 and 19.

At the end of the war, the 35th arrived in Alexandria, Virginia, on April 28, 1865, and remained as a part of the garrison of the District of Columbia until June 9, when it transferred its recruits to the 29th Massachusetts and was mustered out of the service. Returning to Readville, Massachusetts, on June 27, 1865, the men were paid off and discharged.

At Antietam, the regiment was under command of Lieutenant Colonel Sumner Carruth; the 35th Massachusetts had about 780 men under arms.[238] The regiment report lists 48 killed, 160 wounded and 6 missing, for a total of 214; most of these causalities were probably from the final attack, when the regiment was heavily engaged.[239] This action is detailed as "then charged

with a hurrah, on the double quick over the hill from which the 9th New York had charged, and down the slope, passing some broken commands, to the rail fences of Otto's lane, where it halted in a very exposed position, laid its rifles on the fence rails and opened fire."[240]

Frederick Grant mustered into Company F of the 35th Massachusetts Infantry on August 19, 1862—less than one month before the Battle of Antietam. He enlisted for three years and was paid a bounty of twenty-five dollars. Grant mustered in at Camp Stanton, Massachusetts, and stated that he was twenty-eight years old and working as a bookkeeper in Salem before enlisting. His rank was first sergeant. The service records report Grant as "absent" during the period of August 18 to October 31, 1862. However, a note says that Frederick Grant was "left with the sick men October 29, 1862." So, he was probably on the field at the Battle of Antietam, as he is listed as "present from November 1862 to April 1863." Sergeant Grant was granted a furlough of twenty days starting on June 21, 1863, by order of General Burnside. Here Grant's records become confused, as he is shown as "not returned to unit" until the May/June 1864 period. In the records of the 35th Massachusetts Infantry, he is reduced to private on January 1, 1864. Actually, Sergeant Grant received a commission as a second lieutenant in Company K of the 2nd Massachusetts Heavy Artillery on October 9, 1863, but no official notice had been sent to the 35th, so he was listed as a deserter. Frederick Grant was promoted to first lieutenant on January 17, 1865, and was mustered out of the 2nd Massachusetts Heavy Artillery on September 3, 1865, at Wilmington, North Carolina. On September 9, 1867, the charge of desertion was removed and his 35th Massachusetts record backdated to show a muster out date of November 29, 1863.[241] Frederick Grant died in 1888.[242] His widow filed for a pension on May 3, 1888, or 1889.[243]

Grant is pictured here in his second lieutenant's uniform following his commission in October 1863. During the Battle of Antietam, he served as the first sergeant of Company F, 35th Massachusetts Volunteer Infantry; his duty as an noncommissioned officer no doubt put him in a favorable light when the 2nd Massachusetts Heavy Artillery began recruiting in the summer of 1863. The heavy artillery was, to use a modern term, cross-trained to work the big guns, the "heavy artillery," of fortifications, while also knowing the infantry's manual of arms for musketry. This dual role meant that many heavy artillery regiments were broken up into battalions of several companies and sent to multiple locations. The 2nd Massachusetts was no different; most of its companies were sent to New Bern, North Carolina, following their mustering in, but Grant's Company K, along with

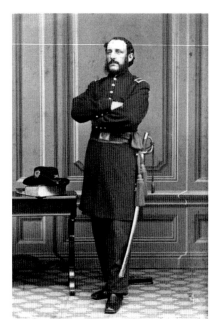

Left: First Sergeant Frederick Grant, 35th Massachusetts Infantry. *Right*: Back of Grant's image.

L and M, were sent to Fortress Monroe in the late fall of 1863.[244] The heavy artillery went on to play a major role in reinforcing the Army of the Potomac during the Overland Campaign in the spring of 1864, when many of these regiments were ordered to the front by the general in chief.

Likely photographed sometime in October 1863, near the date of his commission, Frederick Grant stands with arms folded in full dress uniform. According to the advertisement on the reverse, this image was taken in Salem, Massachusetts, in the gallery of photographer D.W. Bowdoin. Grant's dress uniform consists of dark-blue officers' trousers with no apparent piping along the seam. Being a heavy artillery officer, any piping would be red as opposed to the infantry sky blue.[245] Grant's frock coat has the traditional nine Federal eagle buttons running down the chest along with the long skirting around the waist; three small eagle buttons can also be seen on the cuffs. His shoulder boards are bare, indicating a second lieutenant's rank;[246] the color within the boards, however, would be red or scarlet for the artillery.[247]

Around his waist, Grant has an officer's sash of crimson, over which he has buckled his sword belt. The belt appears to be a model 1851, with an eagle belt plate. The wreath on the belt looks to be slightly lighter in color

and was probably applied after the rest of the buckle was forged. These applied wreathes were often picked out in silver.[248] As for the sword itself, the open guard, sword knot and pommel all suggest that this is a model 1860 light cavalry saber.[249] A cavalry saber being used by an artillery officer is not as out of place as it sounds; cavalry sabers were lighter than the model 1840 light artillery saber, and officers did have some leeway in what they carried.

On the table next to Grant, sitting on a large book, is his slouch hat, a more comfortable variation of the army hat than the regulation dress or Hardee hat. The right side of his hat has been pinned up using an officer's general service hat badge,[250] while the crossed cannons indicate the artillery branch of service. The image is not clear, but the regimental number of the 2nd Massachusetts Heavy Artillery may be within the wreath on the crossed cannons. The hat also has a black silk and gold twisted cord going around the crown of the hat, ending in acorn finials.[251] Finally, Frederick Grant has cleaned himself up for the image, combing back his hair and trimming his impressive mutton chops.

At about 1:00 p.m., the Lower Bridge over Antietam Creek, forever after known as Burnside's Bridge, was crossed by the Union forces described in this chapter. Several of them paid a price for their passage. Griffin Stedman was severely wounded here; though he recovered, he was later killed in action at Petersburg in 1864. Charles Judkins was also wounded here and was wounded again before the end of the war. He still managed to live into the twentieth century. Simon Griffin also survived the horrors of the war and lived into the twentieth century. John Van Lew was also wounded later in the war before returning to civilian life. Surgeon Leonard resigned in 1863 to return home to care for his sick wife, while Frederick Grant also survived the war and lived until 1888. Burnside's Bridge remained a significant crossing point over the Antietam until it was closed to traffic in 1964. Today, visitors to Antietam National Battlefield can still walk across the bridge, following in the footsteps of the Federal troops assaulting the high bluffs on the western side of the Antietam—though it is much quieter and safer than on that September day more than 150 years ago.

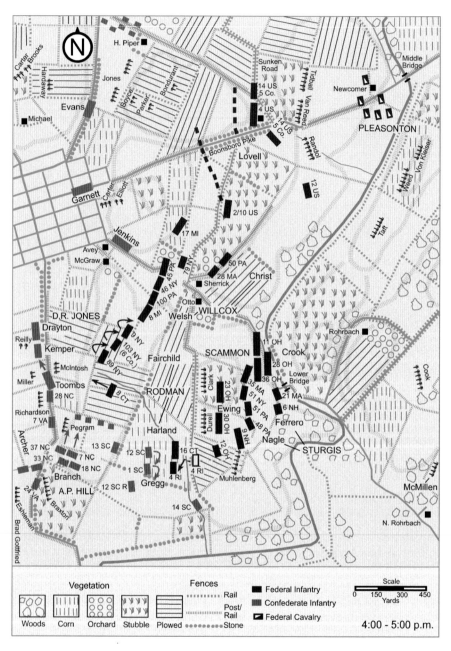

A.P. Hill's division arrives from Harpers Ferry, 4:00–5:00 p.m. *Courtesy Brad Gottfried.*

6

Final Attack

B etween 3:00 and 5:00 p.m. on the seventeenth, the final combat of the day took place on the ridges to the west of the Lower Bridge. On the right near the Sherrick farmhouse was the 50th Pennsylvania Infantry of Colonel Benjamin Christ's brigade. To the south and farther east was the 36th Ohio Infantry of Colonel George Crook's brigade. This unit was mainly in reserve and only suffered lightly. Advancing on the western edge of the attack was the 8th Connecticut Infantry of Colonel Edward Harland's brigade. During the fighting, the 8th approached the Harpers Ferry Road, the last line of Confederate resistance in the southern end of the battlefield. To its rear was the 12th Ohio Infantry from Colonel Hugh Ewing's brigade. In this position, the unit was in support. On the left of the line was the 4th Rhode Island Infantry, a veteran regiment in Colonel Edward Harland's brigade. Near the 4th was the brand-new 16th Connecticut Infantry. Their positions can be seen on the map as of about 4:00 p.m. in the afternoon. The following soldiers took part of that fighting and were members of those units.

50TH Pennsylvania Infantry

The 50th Regiment was recruited in the counties of Berks, Schuylkill, Bradford, Susquehanna, Lancaster and Luzerne and mustered into the U.S. service at Harrisburg on October 1, 1861, for three years.

About the middle of April 1865, it proceeded to Washington and remained there until June 30, when it was ordered to Gettysburg to represent the infantry of the Union army at the cornerstone ceremonies of the National Monument, July 4, and returned to camp at Georgetown, where it was mustered out on July 31, 1865.[252]

At Antietam, the 50th entered the fighting with 370 officers and enlisted men.[253] Its losses were reported to be 8 killed, 46 wounded and 3 missing, for a total of 57.[254] During the battle, the regiment attacked up toward the ridge south of where the National Cemetery is today. At that time, the combatants marched through a stubble field toward a rail fence, passing over what is now the tour road just north of the Sherrick farm.

Samuel Schwenk mustered into Company A of the 50th Pennsylvania Infantry on September 9, 1861, as a first lieutenant. He stated that he was twenty years old; five feet, eight inches tall, with blue eyes, dark hair and dark complexion; and working as a merchant before the war. Schwenk enlisted for three years and was born in Dauphin County, Pennsylvania, on May 8, 1842. Lieutenant Schwenk's service records show his status as "not stated" in November 1861. Later, he was listed as "present" for October and November, but in December, he was placed under arrest by order of Brigadier General Isaac Stevens and released on December 31, 1861. On February 7, 1862, Lieutenant Schwenk was ordered to recruiting duty and detached by order no. 68. He returned from recruiting duty on June 2, 1862, and on July 26, he was in command of the company. Schwenk was present for the Battle of Antietam, and on September 17, 1862, the same day as the battle, the lieutenant was promoted to captain.[255] Schwenk remained with his company until June 3, 1864, when he was wounded at the Battle of Cold Harbor; he was sent to USA General Hospital in Armory Square, Washington, D.C., as of June 8, 1864. Schwenk was discharged from that hospital for disability from a gunshot wound in the back on October 12, 1864. However, he seems to have recovered, as he enlisted again on February 28, 1865, as major of the regiment and was promoted again to lieutenant colonel on May 17, 1865. He returned to civilian life on July 30, 1865. On August 22, 1865, Schwenk was brevetted lieutenant colonel for gallantry before Petersburg and the attack on Fort Stedman. On October 14, 1865, he was brevetted again, this time to colonel, for meritorious service during the war to date from July 24, 1865. On June 22, 1867, Schwenk was again brevetted, to brigadier general, for the same reason as of the same date. Just before Samuel Schwenk mustered out, he was charged with 1) sending a horse that belonged to the government to his home; 2) he bought one horse that belonged to the U.S.

Left: First Lieutenant Samuel Schwenk, 50th Pennsylvania Infantry. *Right*: Back of Schwenk's image.

government from enlisted men and then appropriated it for his use; 3) he sold a mule belonging to the government to the clerk of the sutler of the 50th Pennsylvania, the mule having been captured by near Petersburg, and he kept the money. There is no other information in his records about these charges.[256] Schwenk filed for a pension on May 31, 1911; his index card states he passed away on April 10, 1915, in New York City.[257]

This photo was taken in February 1864, in Philadelphia by F. Gutekunst, possibly while Schwenk was on leave. The date and location of the image are noted on the back of the CDV along with the captain's signature and a three-cent tax stamp, indicating that the image cost upward of fifty cents to produce.[258] It is interesting that while the photo is marked as February 1864, the tax stamp did not come into effect until at least August 1864.[259] It is possible that this CDV is a reprint from an image taken earlier in the winter.

The image itself is a bust, but there are still several details that can be determined. The high collar and evenly spaced buttons running down the front of his coat are indicative of a frock. The buttons are undoubtedly Federal eagle buttons, while the shoulder boards, which can just be made out

on the edges of the CDV, should have two silver embroidered bars within them, indicating the rank of captain.[260] Captain Schwenk is looking his best for the image; his hair has been combed, possibly oiled, and his beard is neatly trimmed. Schwenk is described as having dark hair and blue eyes; both details can be made out in this CDV even though it is black and white.

36TH OHIO INFANTRY

The 36th Ohio Infantry Regiment was organized at Marietta between July 30 and August 31, 1861, to serve for three years. It first saw service in western Virginia and remained there until the spring of 1862. It was assigned to the Kanawha Division of Ohio Regiments. The regiment was mustered out at Wheeling, West Virginia, on July 27, 1865.[261]

During the Maryland Campaign, as the 36th Ohio entered Frederick, Maryland, in advance of the rest of the army, it had a brisk skirmish with Confederate cavalry, the rear guard of Lee's army. It was actively engaged in the Battle of South Mountain, where with the brigade, it made a memorable bayonet charge, by which the enemy was so scattered and routed that they never rallied on that part of the field again. It was actively engaged in the Battle of Antietam, but the loss there was small, the regiment's exposure being chiefly to artillery fire. During the battle, the 36th Ohio deployed across the Lower Bridge and moved toward the Otto farmhouse. The unit contained about 800 men.[262] It suffered 2 killed, 21 wounded and 2 missing, for a total of 25.[263] The light casualties are no doubt due to the 36th being mainly in reserve.

James H. Whitford served in the 36th Ohio from roughly the beginning of its formation. Whitford mustered in as assistant surgeon on August 27, 1861, for three years. His service records show him as "not stated" until January/February 1862. After this period, Whitford was listed as "present" until May/June, when he was detached to be at Gauly Bridge on June 26, 1862. He rejoined the regiment a month later, on July 25, and had been promoted to surgeon (major) on March 8, 1862. Whitford is listed as "Assistant Surgeon" in March 1863 and was discharged on the seventeenth to be appointed "Surgeon," so the records are confusing. Whitford gave his age at this time as thirty-eight. On July 14, 1863, Surgeon Whitford was given a leave of twenty days due to chronic diarrhea. Apparently, he recovered, as Whitford was back with the regiment in September/October 1863. Surgeon Whitford was "detached" to be "senior surgeon 1st Brigade,

Surgeon James H. Whitford, 36th Ohio Infantry. The reverse of Whitford's image is blank.

3rd Div, 14th Corps" until January 1864. He was with the regiment until February 24, 1865, when he went on leave. The surgeon mustered as a Veteran Volunteer on March 8, 1865, for three years; with the collapse of the Confederacy, however, this organization was disbanded. He mustered out of the service on July 27, 1865, at Wheeling, West Virginia; he had last been paid on June 30, 1865.[264] James Whitford filed for a pension on August 10, 1875. His date of death is not shown on his pension card.[265]

Surgeon James Whitford had this image taken likely to give it as a gift, as he has signed the bottom with the inscription "Truly Your Friend." Note the reverse of the image is blank, so the identity of the photographer is unknown. In this profile image, Whitford is wearing a dark-blue double-breasted frock with large general staff buttons.[266] His shoulder boards are hard to make out, so the specific rank cannot be determined, but his boards appear to have the dark blue or black interior of staff officers as opposed to the light blue of the infantry.[267]

Whitford's dark hair has been combed for the image, and his beard is nicely trimmed, adding to the idea that this was a gift and that he wanted to look his best.

8ᵀᴴ CONNECTICUT INFANTRY

The 8th Connecticut Infantry Regiment was organized at Camp Buckingham, Hartford, in September 1861. On April 3, 1865, the regiment was with the advance of the Union army when it made its entry into Richmond.[268]

The regiment mustered out on December 12, 1865, after four years and two months of service.

On September 8, 1862, the march commenced into western Maryland in pursuit of Lee's army, leading to the Battle of Antietam. The battle proved to be the bloodiest action in the history of the 8th Connecticut. That day, 9 officers were wounded, with total casualties being 194.[269] Conspicuous among the enlisted men killed were the brave color guard, who fell on the line of battle while defending their regiment's banners.[270] According to the report of Colonel Edward Harland of the 8th Connecticut, the brigade commander, on the afternoon of September 17, after crossing Antietam Creek, "I detached the Eighth Regiment Connecticut Volunteers, placed it in what I considered the strongest position for the defense of the battery."[271] Later in the afternoon,

> *When the order was given by General (Isaac P.) Rodman to advance, the Eighth Regiment Connecticut Volunteers, which was on the right of the line, started promptly. The Sixteen Regiment Connecticut Volunteers and the Fourth Regiment Rhode Island Volunteers, both of which regiments were in a corn-field, apparently did not hear my order. I therefore sent an aide-de-camp to order them forward. This delay on the left placed the Eighth Regiment Connecticut Volunteers considerably in the advance of the rest of the brigade.*

This was not a good position to be in, Colonel Harland later stated:

> *The Eighth Regiment Connecticut Volunteers, which had held their position until this time, now, by order of Major (J. Edward) Ward, commanding, moved more to the right, where they were sheltered in a measure from the fire in front, and changed front, so as to reply to the enemy on the left. After a few rounds, as most of the men were out of ammunition, the order was given to fall back.[272]*

Major Ward, in his brief report, states that "about 4 o'clock p. m. were ordered to advance to the support of General (Orlando B.) Willcox, on

our right, who had been repulsed. We did so, and held our position far in advance, until ordered to retire by General Rodman, but not until we had lost over 50 per cent of our regiment."[273] He ends his report thus: "Our loss was 34 killed, 139 wounded, and 21 missing; total, 194."[274] The regiment had seen the heaviest fighting of its career. At Antietam, the 8th Connecticut numbered about 421 officers and enlisted men.[275]

Albert Austin mustered into Company F of the 8th Connecticut Infantry on September 23, 1861, for three years as a corporal. He stated that he was twenty-eight and from Plainfield, Connecticut. Austin joined at Hartford and was described in the company descriptive book page as five feet, nine inches tall, with a fair complexion, hazel eyes and brown hair. Austin was born in Voluntown, Connecticut, and was working as a painter before the war. Corporal Austin's status was "not stated" from November 18, 1861, to February 1862, but he was "present" from March 1862 to December 1863—thus, Corporal Austin was present at the Battle of Antietam. On December 24, 1862, Corporal Austin was promoted to sergeant. On December 23, 1863, he reenlisted as a veteran volunteer, for which he received a bounty of $402 and a clothing allowance of $6.91. In the January/February 1864 period, Sergeant Austin was on furlough and then assigned to recruiting duty in Connecticut. He returned to the regiment in March/April 1864 with a note that he was due a difference in pay for being a sergeant. On May 7, 1864, Austin was wounded in action at Walthall Junction, Virginia. His right thumb was shot off, according to his records. Sergeant Austin was in the Central Park USA General Hospital in New York City on May 23, 1864. He had a deduction in his pay of $6.76 for transportation. Austin returned to duty the next month and remained on duty until May 12, 1865. He was discharged from the 8[th] to accept a promotion to second lieutenant in Company B of the 11[th] Connecticut Infantry. Lieutenant Austin was promoted again, to first lieutenant, on November 2, 1865, in Company K and on November 25 to quartermaster as part of the field and staff officers of the regiment. Albert Austin mustered out December 21, 1865.[276] He applied for a pension on January 3, 1866, and died almost twenty-one years later on December 3, 1886.[277]

A corporal at the Battle of Antietam, Albert Austin is seen here in his first lieutenant's uniform. The image itself was taken at the end of the war, likely just after he mustered out of service. The CDV was produced in Hartford, Connecticut, by the Kellogg Brothers and has an intricate border for the revenue stamp on the back. The revenue stamp itself is a three-cent stamp, meaning it was for images costing between twenty-six and fifty

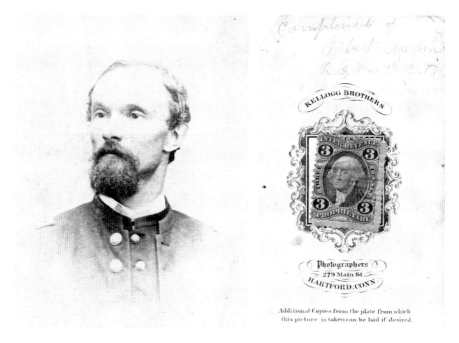

Left: Corporal Albert Austin, 8th Connecticut Infantry. *Right*: Back of Austin's image.

cents.[278] In addition to the revenue stamp and photographer's advertisement is the inscription "Compliments of Albert Austin R.Q.M. 11th Ct." Thus, this image was taken after Austin's promotion to quartermaster of the 11th Connecticut, which was a month before he mustered out of Federal service.

While a bust image, there are still numerous details that can be made out. The most obvious is his frock coat; the large, close-together buttons with a short standing collar give it away. The buttons themselves appear to be larger than the standard Federal eagles and may be staff buttons, which have a distinct ring like Austin's topmost button.[279] His shoulder boards can just barely be made out at the edges of the CDV. The right shoulder board is easier to make out, and a single bar within the board, designating a first lieutenant's rank, can just be seen.

Underneath his frock, Albert Austin has an officer's vest, the top three buttons being visible. His shirt collar can just be seen above the vest, with possible a cravat peeking out. The shirt collar itself is very clean, either freshly starched for the image or a new paper collar. Finally, Austin has a neatly trimmed beard and combed hair to look his best.

12ᵀᴴ Oʜɪᴏ Iɴꜰᴀɴᴛʀʏ

The 12th Ohio Infantry was organized at Camp Dennison between June 19 and 29, 1861, to serve for three years. At the end of its service, it was ordered to Columbus, Ohio, where it was mustered out on July 11, 1864.[280] At Antietam, the regiment consisted of about 200 engaged;[281] the Ohioans suffered 7 killed and 26 wounded and 0 missing for a total of 33 casualties.[282] In his report of the actions of the regiment, Colonel Carr B. White writes,

> *My regiment was then ordered to form a line at right angles with the main line, to advance and engage a flanking column of the enemy, which was promptly done under a shower of shell and canister that threatened the destruction of the regiment. With a view to a better position, the regiment was withdrawn to a fence 5 yards in the rear, and put in position. Finding this position equally exposed with the former, both to musketry and artillery, the regiment was ordered back to the position just abandoned, which was held in the face of a heavy fire until ordered back by Lieut. Kennedy, acting assistant adjutant-general of the Kanawha Division, to the brow of the hill in front of the bridge.*[283]

Private D. Kelley Ripley of Company G mustered into the unit on June 21, 1861, for three years at Camp Dennison in Ohio. Ripley gave his age as twenty-eight, and the company descriptive book page for him states that he had a light complexion, blue eyes, light hair and was five feet, five and three-quarters of an inch tall. At the time of his enlistment, he was working as a farmer. His records also note that he was born in Washington County, Maryland. Since Washington County is where the Battle of Antietam was fought, Kelley Ripley is one of the soldiers who "came home" to fight. According to Washington County Court House records, Kelley's father, Jacob, bought several acres on November 12, 1831, near Leitersburg. Jacob Ripley is listed on several documents involving horses. The family lived there until January 2, 1836, when the land was sold. So, Kelley Ripley spent the first three years of his life close to Antietam. His status was "not stated" for the early part of his service, as is common with the early records through November/December 1861. Ripley was listed as "present" starting in January/February 1862, through the rest of his service. However, there are notes that state that Private Ripley was assigned to the regimental hospital at various times as a "cook" or "nurse." So Ripley may have not been in the front lines

Left: Private D. Kelly Ripley, 12th Ohio Infantry. *Above*: Back of Ripley's image.

on September 17, but he certainly saw the results of the combat. Ripley mustered out on July 11, 1864, at Columbus, Ohio. He had last been paid on December 31, 1863, and he was due $100 bounty.[284] Ripley received a pension and died sometime in 1905, though the the exact date is not shown on his pension card.[285] One wonders if Ripley requested a furlough after the battle to visit his birthplace.

This image does not appear to be a wartime image of David Kelley Ripley; if it is, the CDV is probably from the earliest days of his enlistment, prior to his uniform being issued. Private Ripley appears to be wearing a civilian sack coat, with a cotton or muslin shirt underneath. Two tin or pewter buttons on his shirt can just be made out; a button on the coat can also be seen.

He looks directly into the camera with a determined gaze. While there is no inscription on the image, either front or back, his beard is kempt and his hair has been combed. With his signature and regimental information on the front, this was likely a gift for someone back home.

4ᵀᴴ RHODE ISLAND INFANTRY

The 4th Regiment of Rhode Island Volunteers was enlisted under General Orders No. 48, issued on August 15, 1861. On October 3, 1864, the regiment left for home and reached Providence on the morning of October 7. The Regiment numbered 189 officers and enlisted men and was under the command of Captain Walter A. Read. It was mustered out of service a little over a week later on October 15, 1864.[286]

During the Battle of Antietam, the regiment engaged with a valor second to no other on the field and closed the sanguinary day with the loss of 102 killed and wounded and 7 captured. Among the wounded was Colonel William H.P. Steere, who received a bullet in his left thigh; Captain Caleb T. Bowen, taken prisoner and paroled; Lieutenant George H. Watts, severely; Lieutenant J. Perry Clark, dangerously; and Acting Lieutenant George R. Buffum, mortally. The color bearer, Corporal Thomas B. Tanner, having carried his flag within twenty feet of the enemy, was killed, but the flag was saved from capture by Lieutenant George E. Curtis.[287] Assistant Surgeon Smalley was laboriously employed in rendering service to the wounded; Surgeon Millar was detailed to the general hospital, where his duties were arduous. Colonel Steere attempted to lead his men after being struck, but he fainted from the loss of blood and was carried to the division hospital. Lieutenant Colonel Joseph Curtis then assumed command of the unit.

At Antietam, the 4th Rhode Island entered the battle with 247 officers and enlisted men.[288] Its losses were 21 killed, 77 wounded and 2 missing for a total of 100 men.[289] The regimental history reports: "On our advance into that bloody corn field no one seemed to know the position of the rebel forces, whether in our front, flank, or rear. The Sixteenth Connecticut, as we were advancing to support them, broke, and came crowding in a confused mob upon our right, and confusion reigned preeminent for a while."[290]

Lieutenant Colonel Joseph Curtis wrote the after-action report for the Fourth Rhode Island Infantry; the following is taken from that report:

The order to commence firing was then given, and Col. Steere sent me to the Sixteenth Connecticut to see if they would support us in charge up the hill, but the corn being very thick and high, I could find no one to whom to apply. I returned to tell the colonel that we must depend upon ourselves. He then sent to the rear for support. Before they could arrive, the enemy outflanked us with a brigade of infantry, which descended the hill to our left in three lines, one firing over the other and enfilading us. The regiment on our right

now broke, a portion of them crowding on our line. Col. Steere ordered the regiment to move out of the gully, by the right flank, and I left him to carry the order to the left, of which wing I had charge, the colonel taking the right (the major being sick, and no adjutant, here were only two field officers to handle the regiment.)

The regiment commenced the movement in an orderly manner, but, under the difficulty of keeping closed up in a corn-field, the misconception of their order on the left, and the tremendous fire of the enemy, consisting of musketry, shell, and grape, the regiment broke. Col. Steere, as I afterward learned, was severely wounded in the left thigh, immediately after I left him to repeat on the left the order to leave the corn-field. An attempt was made rally the regiment to the support of a battery at some distance back from the corn-field, but before many had been collected the battery retired, when the efforts became unavailing.

Col. Steere commends in the highest terms the conduct of the regiment upon that day. I can only add that throughout the day I never saw an officer but that he was encouraging and directing his men.

The men fought well, as is proved by the fact that they were engaged constantly with the enemy during nine or ten hours, all of which time they were under arms; that they finally broke, under such a very severe fire, and the pressure of a broken regiment, is not surprising, although much to be regretted. Of the present state of the regiment I have only the most favorable report to give.

By direction of Col. Steere, I have organized the regiment into eight companies, the members of Companies I and K being divided among the others temporarily, although in all reports and musters they will brew borne upon their own rolls. In this way officers are gained to officer the other companies, and the companies are made practically larger. The three days just spent in camp alt rough broken by marching orders, have in part rested the men from the fatigues of the two battles and constant marches to which they have been subjected since the 4th of this month.

The temporary loss of its commanding officer at the time when his experience can be of so much use is a severe blow to the regiment.

I have the honor to be, sir, very respectfully, your obedient servant,

Joseph B. Curtis,

Lieut.-Col., Commanding Fourth Rhode Island.

His Excellency William Sprague

Governor State of Rhode Island.[291]

W. L. Germon's
Atelier,
No. 702 Chestnut St
Philada.

Left: Colonel William H.P. Steele, 4th Rhode Island Infantry. *Above*: Back of Steele's image.

Colonel William Steere was originally mustered into the 2nd Rhode Island Infantry on June 5, 1861, as a captain. He stated that he was forty-four years old and living in Providence. Steere was promoted to lieutenant colonel on July 22, 1861. Eleven months later, on June 12, 1862, Lieutenant Colonel Steere was transferred to the 4th Rhode Island Infantry and promoted to colonel of the regiment. His service records for the 4th list him as "present" starting in July/August 1862. As he was severely wounded at Antietam, Colonel Steere was "absent" until his return about May 15, 1863. In the next two months, Colonel Steere was placed in command of the 3rd Brigade of the 2nd Division of the 9th Corps. On September 13, 1863, Steere requested a twenty-day leave to return home to see his daughter, who died on September 12, 1863. He remained in command of a brigade for the rest of his service. Steere mustered out on October 15, 1864, upon completion of the three years. He had last been paid on July 31, 1864. On October 9, 1867, he was breveted brigadier general to date from March 13, 1865.[292] William Steere applied for a pension on August 25, 1865.[293] Born on May 5, 1817, he passed away on August 25, 1882, in Johnston, Rhode Island.[294]

Pictured here in his 2nd Rhode Island Volunteer Infantry captain's uniform, William Steere had this image taken early in the war while in Philadelphia, likely while the 2nd Rhode Island was on its way to Washington, D.C. Like a

number of images that have been examined, this CDV uses several props. A chair has been provided for the soon-to-be colonel, while the heavy drapery and column are reminiscent of other images of the period.

While he is seated, there are still numerous details that can be made out in this image. William Steere wears the dark-blue trousers of an officer, and on the side of his right leg, one can just make out the light-blue stripe signifying the infantry.[295] His frock coat is open, showing his nine-button officer's vest, with the braided cord of a pocket watch hooked into the fifth buttonhole. Steere's double-breasted frock coat has a double row of seven Federal eagle buttons, with three small eagle buttons on the cuffs. The uppermost button on Steere's coat is interesting, as it appears to be a different button from the others. The detail on the button cannot be made out, but it could be a Rhode Island state seal button. Steere's shoulder boards are washed out in the image and make them difficult to read—they should be the double bars of a captain.[296] The frock that he wears is a private purchase; he likely paid a little extra for the velvet collar. A white shirt and a cravat can also be seen peeking from the frock's collar and under Steere's beard.

William Steere's forage cap is in his left hand. The cap is an 1858 regulation forage cap, better known today as a McDowell, and is distinctive due to its rounded brim.[297] The front of his forage cap is decorated with the infantry's hunter's horn insignia and a brass *2* within the loop of the horn for the 2nd Rhode Island Infantry.[298] To finish off this CDV, Steere has his beard trimmed nicely and has oiled and combed back his hair.

16th Connecticut Infantry

Raised in Hartford County and organized in August 1862, the 16th Connecticut Infantry was mustered into the U.S. service for three years on August 24, 1862. Immediately assigned to the Army of the Potomac's 9th Corps, the unit had barely any training prior to entering combat at Antietam, where it suffered heavily. Transferred south in the winter of 1863, the 16th was nearly captured in its entirety on April 20, 1864, at Plymouth. The sadly depleted regiment was stationed at Roanoke Island, North Carolina, until March 4, 1865. It remained at New Bern, North Carolina until its mustering out on June 24, 1865.[299]

Even though the 16th was a new regiment, a number of men probably dropped out on the march to the battlefield, so it consisted of about 750

officers and men on the field.[300] The 16th suffered 42 killed, 143 wounded and 0 missing for a total of 185 men.[301] In his short history, B.F. Blakeslee notes, "After resting awhile we loaded our muskets for the first time, and marched over a hill."[302] This was on September 16, the day before Antietam. This shows just how green the unit was as it entered combat for the first time. "The Sixteenth sprang up and returned the fire with good effect; some fixed bayonets, advanced, and were captured. The most helpless confusion ensued. Our men fell by scores on every side. Still our position was obstinately maintained, until ordered to fall back. The rebels discovered the disorder and came on us in heavy column."[303]

Herbert Landon mustered into Company B of the 16th Connecticut Infantry on August 24, 1862, for three years. He stated he was eighteen and was paid a bounty of $25. Landon mustered in as a sergeant; he was five feet, eight inches tall, had a florid complexion, black eyes and black hair and was born in Guilford, Connecticut, according to the company muster book page. He was working as a clerk before the war. His service records show him "present" from August 24, 1862, to March 17, 1864. On October 15, 1862, Landon was promoted to third sergeant. On January 13, 1863, he was promoted again to sergeant major and assigned to the "Field and Staff" of the regiment. In December 1863, Landon accepted a promotion to second lieutenant in Company D. His service records show that on April 20, 1864, he was taken prisoner at Plymouth, North Carolina. He was confined at Camp Asylum in South Carolina, from which he eventually escaped in the spring of 1865. Landon was ordered to return to his regiment after his escape on March 20, 1865, but he received a thirty-day leave before reporting back to the regiment. On June 15, 1865, Herbert Landon was promoted for the last time, to first lieutenant and acting adjutant, and he owed the sutler $11.46. Lieutenant Landon mustered out on June 24, 1865. He had last been paid on February 28, 1865, and he owed the government $7.60 for his clothing allowance as a sergeant major; however, he was also due pay for one month and six days as sergeant major.[304] Landon filed for a pension on September 7, 1889, and passed away on March 5, 1928, in San Jose, California, according to his pension card.[305]

A sergeant at the Battle of Antietam, Herbert Landon is seen here as a second lieutenant, the rank he gained in December 1863. As he was a prisoner of war for almost a year, this picture was probably taken after his escape. It seems likely that this image, which was taken in New York by Jas. L.Warner Acf., was taken while Landon was on his thirty-day furlough home, or when he was on his way back to his unit. The back of the image has

Left: Sergeant Herbert Landon, 16th Connecticut Infantry. *Right*: Back of Landon's image.

the photographer's advertisement and has been signed by Landon, giving his name and rank at that point. Sadly, the image also had a revenue stamp at some point, but the stamp has been removed, likely by a collector, taking away most of the photographer's cancellation on the revenue stamp as well.

Landon is seated for this image; his Federal sky-blue pants can just be made out in his lap. He is also holding his forage cap, though the type is indeterminate due to where the image cuts off. His nine-button officer's vest can be seen under his coat; the coat itself is a frock and open because of the vest. Landon's frock is in very good shape; it may be a new coat following his time as a prisoner. Eight of the nine Federal eagle buttons can be clearly seen and are very bright. His shoulder boards are also visible and bare, indicating a second lieutenant's rank.[306] His shirt can just be seen peeking out of his collar.

Landon has the beginnings of a beard and has attempted to comb his unruly hair for the image. He also may have oiled his hair, a common practice at the time.

So ended the bloodiest day in American history. These six soldiers experienced the terrible but often overlooked fighting on the south end of the field, fighting that was five times more destructive than the better-known action at Burnside's Bridge. Samuel Klinger Schwenk survived Antietam but was wounded in 1864 at Cold Harbor. He lived into the twentieth century. As an assistant surgeon, James H. Whitford was probably not on the front line, but he certainly saw the results of the combat. His widow was granted a pension after the war. Albert Austin was among the men who advanced the farthest toward the Harpers Ferry Road. Austin lost a thumb later in the war and survived into the 1880s. To the east was D. Kelley Ripley, who was born in Washington County. He survived into the twentieth century. William Henry Peck Steele was severely wounded at Antietam while in command of the 4th Rhode Island. Following his recuperation, Steele, returned to serve the rest of his three years' enlistment. He passed away in 1882. The final soldier was a member of the brand-new 16th Connecticut, Herbert Landon. Herbert was a prisoner of war later in the conflict and eventually returned to the regiment. He lived into the twentieth century. As with the other soldiers, these men saw and heard much that September day, but all of them returned to civilian life.

Epilogue

When the sun set on the evening of September 17, 1862, the bloodiest twelve hours in American military history came to an end. Of the approximately 100,000 combatants, 23,110 had become causalities—either killed, wounded or missing in action. The 36 soldiers you have just read about experienced this tragic day in different ways. What they saw, heard, smelled and felt during the Battle of Antietam is difficult for us to imagine, if not impossible. These soldiers carried their experiences from these fields and for the rest of their days. Some were slain or physically scarred due to the fighting—who knows how many were mentally or emotionally scarred—all were changed.

Following the bloodletting on September 17, the contending armies consolidated their forces. Lee and McClellan spent September 18 in preparation; both realized the extent of the previous day's battle, but neither was sure of the other's intentions. Lee withdrew his lines on the eighteenth out of range of Federal batteries on the east side of Antietam Creek, brought up his stragglers and began the process of removing the wounded who could travel back to Virginia.[307]

Union efforts were much the same on September 18, bringing up elements of the Army of the Potomac that had yet to arrive on the seventeenth and rearming long-range ordinance. Federal commanders were ordered to prepare their forces to move in any direction, either to attack or defend against the Confederates the next day.[308]

The Confederate retreat from Sharpsburg began on the afternoon of the eighteenth, with supply trains and the wounded being sent over the Potomac River at Blackford's (Boteler's) Ford, just south of Shepherdstown (West) Virginia. The last of the Confederate cavalry was over the ford by 10:00 a.m. on the nineteenth. At this point, Federal cavalry were already in pursuit, overtaking Confederate stragglers. They opened a brisk artillery exchange with Confederate guns posted on the Virginia side of the Potomac. By noon, Federal infantry from the 5th Corps had come up, and more Union batteries were put into action. That evening, Federal infantry were pushed across the ford, the Union guns having driven many of the Confederate artillerymen from their pieces. The Union troops succeeded in capturing several cannons on the bluffs above the river before withdrawing back to the Maryland side.[309]

The aggressive Federal response to his retreat forced General Robert E. Lee to order his rear guard, under Major General A.P. Hill, to return to Shepherdstown. The Battle of Shepherdstown, fought on September 20, was the bloody exclamation point at the end of the Maryland Campaign, resulting in the repulse of advancing Federal troops who had returned to the Virginia side of the Potomac that morning.

With this, the campaign came to an end, as both sides withdrew to tend to the needs of their armies and the wounded. What became known as the First Confederate Invasion of the North had been turned back and proved to be the catalyst for President Abraham Lincoln to issue his preliminary Emancipation Proclamation on September 22, 1862. From this point on, the American Civil War was not only fought to preserve the Union but to end the institution of slavery in the United States as well.

It is unknown how the soldiers profiled here felt about emancipation, but they fought and continued to fight to see the war through. The battlefield landscape would be visited again by many of these soldiers during future campaigns and long after the war, when the boys in blue returned to these fields as members of veteran and memorial organizations. It was during this period, between 1880 and 1910, that the majority of the Union regimental monuments were erected on the battlefield and the first talk of preserving these fields for the future began.[310]

Antietam National Battlefield continues to be one of the best-preserved Civil War landscapes in America. The National Park Service and its preservation partners strive to maintain the battlefield as close to its September 1862 appearance as possible. This allows us to get that much closer to the fighting men of that era by walking the fields of this great

conflict and seeing the landscape much as they did. At the same time, the peaceful fields and woods of today stand out in sharp contrast to that terrible Wednesday in September over 150 years ago and the days and weeks that followed as the dead and wounded were cared for—many on, or near, the fields where they fell.

We hope that this work has given you insight into some of the men who fought here and that you will be inspired to take your own trip to Antietam National Battlefield, walking the same trails and approaches of these and many thousands of other soldiers in both Union blue and Confederate gray.

Appendix

Included here are the official reports from those regiments that have reports published in the *Official Records*. Many units did not submit reports. The order here is the order the units are referenced in the book.

Report of Captain Albert Moore, First Rhode Island Light Artillery, Chief of Artillery First Division, of the Battle of Antietam

Hdqrs. Artillery, First Div., First Army Corps, Camp near Sharpsburg, Md., September 26, 1862.

Sir: I have the honor to submit the following report of the part the light batteries of this division took in the engagement of the 17th instant:

Early in the morning the enemy opened upon us an exceedingly brisk fire. In an extraordinarily short time all the division batteries except Company B, Fourth Artillery, were in position on the ridge upon which they had been during the night, and which ran nearly parallel with the position occupied by the enemy's guns, and about 800 or 1,000 yards from it. Before the enemy's batteries were silenced, which was done in about one hour and a quarter, Company L, First New York Artillery, was ordered through the wood at the

left into the plowed land beyond, leaving in the position but Company D, Rhode Island Artillery, commanded by myself, and the First New Hampshire Battery, Lieutenant Edgell. But two batteries from another division came up and took position on the right.

Company B, Fourth Artillery, Captain J.B. Campbell, accompanied General Gibbon's brigade through the wood to the open ground beyond, where Lieutenant Stewart's section was detached from the battery, and ordered to a position near the turnpike, to shell the woods beyond. Here the section suffered severely in men and horses, but it did excellent service, throwing a body of the enemy, 400 or 500 strong, into considerable confusion, so that they partially broke and ran through a hollow, gaining the cover of some fence-rails.

About this time Captain Campbell placed his other four guns in position on the left of Lieutenant Stewart's section. In the mean time the enemy had crept into a corn-field near the battery and on the left of the turnpike, and opened a murderous fire, which was replied to with canister with good effect. Captain Campbell was here severely wounded in the shoulder, and the command of the company devolved upon Lieutenant Stewart. The battery was supported by General Gibbon's brigade and the Twentieth New York. . Being very much weakened, General Gibbon directed Lieutenant Stewart to change position to the right, out of range of the enemy's musketry, and to shell the woods in front; but only one section went into position, on account of the great number of wounded men and horses in the other two sections. Company L, First New York Artillery, Captain J.A. Reynolds, after moving through the woods, was ordered to move forward into the plowed ground, where it took position and opened upon one of the enemy's batteries in the field beyond the turnpike, silencing it after a sharp fire of some time.

From this position Captain Reynolds was ordered by General Gibbon to move to the right and shell the woods in front. Company L and the section of Company B took this position about the same time, the section of Company B on the left of Company L. Soon after both of these batteries were ordered to the rear. Captain Reynolds went back to the ordnance train to obtain a supply of ammunition, and upon his return was ordered to the extreme right, where he had no opportunity to use his guns. Lieutenant Stewart retired to the rear of the wood through which he had advanced, removed his disabled horses, and regulated his men and horses throughout.

Shortly after the enemy's batteries upon the hill were silenced, and about the time Company B, Fourth Artillery, and Company L, New York Artillery, were ordered to the rear, Company D, Rhode Island Artillery, commanded by myself, was ordered through the wood, and immediately after the First Hampshire Battery, Lieutenant Edgell, was ordered to follow. General Hooker directed me to move forward beyond the second corn-field, if possible, and take position as near the wood as the ground would admit. I advanced, followed by Lieutenant Edgell, First New Hampshire Battery, and went into battery about 50 yards from the wood, the New Hampshire battery taking position, and about 100 yards to the rear.

A battery of the enemy here opened upon me, but no attention was paid to it, and its fire was perfectly ineffective; but the battery with one section opened upon a body of the enemy, who was seen retreating at the left of their front, and about 125 yards distant, throwing them into great confusion. The other four guns opened with canister and case upon a large force advancing through the woods in front, which were very open, and, with the assistance of the other section, which had accomplished its object by a few shots, and the First New Hampshire Battery, checked the enemy, and he retired out of sight.

While engaged forcing back the enemy in the wood, a body of sharpshooters had, unobserved, crept along under a little ridge that ran diagonally to the front of the Rhode Island battery, and opened a most unerring fire upon it, killing and disabling many horses and men. As quick as possible, a section was directed to open upon them with canister, which, though it caused them no injury, they lying down under the ridge, kept them almost silent, they firing but an occasional shot, but without effect.

While this section was keeping the sharpshooters silent, the other four guns, with the guns of Lieutenant Edgell, opened upon the battery that was still firing, and soon silenced it. I then ordered my battery to limber to the rear. The sharpshooters took advantage of the opportunity thus afforded, and opened most briskly, severely wounding a number of men and killing and disabling a large number of horses. My own horse was pierced by six bullets. All the horses but one lead horse of one piece were either killed, or disabled, and the piece had to be drawn away by hand by means of a prolong. The limber was left, but was subsequently recovered. The New

Hampshire battery left its position at the same time, and went back to its original position.

After securing the piece that was drawn away by hand to its caisson, I moved my battery into the lot between the second corn-field and the plowed land beyond the first corn-field, and went into position with five guns, and shelled the woods beyond the turnpike. After firing a short time, I retired to my original position, when the disabled piece was sent to the rear. Soon after taking this position, the enemy's artillery opened from the same hill that it did in the early morning, but they were soon silenced by the New Hampshire and the Rhode Island batteries, with the assistance of the two other batteries that were still there. Lieutenant Stewart, after rearranging his horses, harness, and men, took position upon the same hill. There the batteries remained inactive until about 5 o'clock, when the enemy again opened a brisk fire upon the opposite hill, which was immediately replied to by all the guns we had in position on the hill, silencing the enemy in about ten minutes.

Lieutenant Stewart, Company B, Fourth Artillery, speaks with high praise of the following non-commissioned officers and privates of his company, and desires their names may be brought to the favorable notice of the general commanding: First Sergt. John Mitchell, Company B, Fourth Artillery; Sergt. Andrew McBride, Company B, Fourth Artillery; Sergt. William West, Company B, Fourth Artillery; Corp. Frederick A. Chapin, Company B, Fourth Artillery; Lance Corp. Alonzo Priest, Sixth Wisconsin Volunteers; Lance Corp. Henry G. McDougal, Sixth Wisconsin Volunteers; Privates Henry A. Childs, Sixth Wisconsin Volunteers; James Cahoo, Company B, Fourth Artillery; William Kelly, Company B, Fourth Artillery; John B. Lackey, Company B, Fourth Artillery; William Green, Company B, Fourth Artillery; Jeremiah Murphy, Sixth Wisconsin Volunteers; Charles Harris, Seventh Wisconsin Volunteers; Elbridge E. Packard, Second Wisconsin Volunteers.

Very respectfully,

J. ALBERT MONROE, Captain, Commanding Artillery, First Div., First Army Corps.[311]

Report of Captain James MacThompson, 107th Pennsylvania Infantry, 1st Brigade, of the Battles of South Mountain and Antietam

HDQRS. ONE HUNDRED AND SEVENTH PENNSYLVANIA VOLS., Camp near Mercerville, Md., October 7, 1862.

SIR: I have the honor to make the following report respecting the One hundred and seventh Regiment Pennsylvania Volunteers in the two actions, September 14 and 17, at South Mountain and Antietam:

Arriving at the base of South Mountain, after a wearisome march of 17 miles, on September 14, at about 5,30 o'clock p. m., we found the enemy fiercely engaged with the Pennsylvania Reserves. Immediately, in compliance with orders from Gen. Duryea, formed in line of battle near the foot of the hill, and gave orders to move forward with fixed bayonets. Nothing could exceed the promptness of both officers and men in the execution of this order; with enthusiastic cheers they dashed forward, and soon the enemy were scattered, and in much confusion were flying before us. Several times they rallied, and once in particular, having gained an admirable position behind a stone fence, they appeared determined to hold on to the last. Here it was they sustained their greatest loss. Col. Gayle, Twelfth Alabama, fell dead, and the lieutenant-colonel Fifth South Carolina wounded and taken prisoner.

Their stand at this point delayed not the on ward movement of the One hundred and seventh a moment, but in a little while we were over the fence and among them, taking 68 prisoners, killing and wounding quite a number and causing the remainder to fly precipitately to the top of the mountain. Following, we drove them across the narrow plain on the summit and part way down the other side. Night ended the pursuit; but, fearing a surprise, I directed officers and men to rest in line during the night, prepared for any emergency, and threw 200 yards in advance a volunteer picket of 10 men. About 1 o'clock a. m. one of these pickets brought in a rebel adjutant-general, who had the temerity to venture close to our lines. In this engagement we lost 3 men killed and 18 wounded. This small loss is accounted for by the fact that the rebels, being all the while located above us, shot too high. In evidence of the truth of this statement, our colors were completely riddled, while the color-bearer was in nowise injured. The next morning, September

15, we moved forward, and at high crossed the Antietam near Keedysville, bivouacking on the opposite side. On Tuesday afternoon we again moved forward, and, after a few miles' march, the advance of our corps engaged the enemy, who, located in a favorable position in the woods, made a stubborn resistance, but finally gave way, falling back, however, but a short distance.

The coveted ground gained by our force, and night coming on, no farther advance was made, and both armies lay on their arms, ready for the fierce fight of tomorrow, our brigade having reached a point less than half a mile in rear of the outer pickets.

At early dawn, agreeably to orders, I moved the One hundred and seventh Regiment by the flank to the field on the right. Here, forming column by divisions, we moved forward through a narrow strip of timber, gained the night previous, into a plowed field, in which, opposite side, Thompson's Pennsylvania battery had just gotten into position. Advancing half way across the field to within easy supporting distance of the battery, we halted for about five minutes, the enemy's shell and round shot haying about us like hail, killing and wounding some of our poor fellows, but not injuring the morale of the regiment in the least. Shortly we were again advancing and passing the battery, and over a clover field reached the spot so frequently mentioned in the reports of this battle—the corn field. Deploying into line, we entered the field and pushed rapidly through to the other side. Here we found, in different positions, three full brigades of the enemy. We opened fire immediately upon those in front, and in fifteen minutes compelled them to fall back. Receiving re-enforcements, however, he soon regained his position, and an unequal conflict of nearly three-quarters of an hour resulted in forcing us back through the corn-field. Our brigade had, however, done its work. We had held at bay a force of the enemy numerically five time our superior for considerably more than an hour, and at one time driving them. We were now relieved by re-enforcements coming up, and retired to the rear. During the balance of the day we were constantly on the qui vive, but were not again called into action save to support batteries.

In the battle of Antietam the One hundred and seventh Regiment had 190 men engaged, and lost 19 men killed and 45 wounded, a total loss of 85 killed and wounded in both engagements. Too much cannot be said of the dashing bravery of both officers and men at South Mountain or of their heroic firmness and cool bearing when standing still in line of battle at

Antietam. They, for more than an four, received [and returned] the fire of a force infinitely superior.

With much respect, I am, sir, your obedient servant,

James MacThompson, Capt., Comdg. One hundred and seventh Regt. Pennsylvania Vols., in the engagements of September 14 and 17, 1862. Lieut. Kenny, Acting Assistant Adjutant-Gen.[312]

Headquarters Twenty-Sixth New York Volunteers, Camp near Sharpsburg, Md., September 19, 1862.

Sir: In compliance with orders, this regiment marched from camp near Frederick at 6 o'clock a.m. Sunday, September 14, 1862, 12 miles to the gap, near Boonsborough, arriving on the battle-ground at 6 o'clock p.m., and formed in line of battle on the right of the brigade, and advanced up the slope toward the enemy, who occupied the cornfield and brush at the top of the hill. In going up we marched by the left flank, as ordered, for the purpose of gaining ground to the left and relieving regiments then engaged.

On reaching the fence along the timber at the hill top, we halted, and commenced firing from the left of the battalion, the right reserving their fire, not being in range of the enemy, until after some moments later. The left wing of the regiment fired some 20 rounds and right wing 4 rounds, when the order was given to cease firing, and lay on our arms in the same position until morning, with skirmishers advance.

I would further report as casualties: Killed, none; wounded, 2.

Marched from camp near Keedysville about 3 o'clock p. m. September 16 to the battle-ground, near Sharpsburg, and took position in line arms until morning, posting pickets as order. Marched at daylight September 17, under orders, across the fields, formed line of battle, occupying the left of the brigade, and halted some 400 or 500 yards from the wood, beyond which the enemy lay in position. I was directed to deploy in column by division, which I did, and advanced obliquely toward the wood under a heavy fire of shot and shell, and halted, as directed, 100 yards in rear of the brigade of Gen. Duryea, that brigade moving to the right. I was ordered to advance in support of Gen. Hartsuff, and did so Under direction of Gen. Seymour we

deployed in line of battle along the fence, the left of the battalion connecting with the right of another regiment, the right with the left of the Ninety-fourth New York Volunteers.

The enemy were in sight, about 350 yards, engaged with Hartsuff's brigade. I gave the command to commence firing by file, and the battalion continued firing evenly and carefully for some 30 rounds, average, when the command ceased firing, saving ammunition. This cessation brought the enemy out more plainly in view on the open ground, and we again opened fire, driving the enemy again behind the fence, and under cover of the corn-field. I again gave orders to cease firing, being nearly out of ammunition, and sent word twice to the colonel commanding the brigade for ammunition or relief. We resumed our firing until every round of cartridge was expended, when, the relieving column advancing, we retired in good order to the point indicated for supplying the men.

Without particularizing, I can but say that every officer and man in the command performed his duty in the coolest manner, obeying every order with alacrity, and executing with determination, under fire, two hours and a quarter.

Casualties: 5 killed, 41 wounded, 20 missing; total, 66.

All of which is respectfully submitted.

I have the honor to be, colonel, most respectfully, your obedient servant,

R.H. RICHARDSON ,
Lieut.-Col., Comdg. Twenty-sixth New York Volunteers.

Lieut. DAVID P. WEAVER,
Acting Assistant Adjutant-Gen., Second Brigade.[313]

Report of Lieutenant Colonel Joseph M. Sudburg, 3rd Maryland Infantry, of the Battle of Antietam

NEAR SANDY HOOK, MD., September 22, 1862.

SIR: I hereby respectfully submit to you the following report concerning the action of the Third Maryland Regiment in the battle near Sharpsburg on the 17th of this month:

We rested from 3 o'clock a.m. in a field about 1 mile from the bridge over the Antietam. At 6.30 o'clock in the morning Gen. Greene, commanding the division, marched us from this field in column by companies, and, advancing in a southerly direction, we reached a point about 1 mile from our starting place. We here met the enemy, who was in possession of a piece of woods. Deploying in line of battle, we here met our first loss; 3 of our men fell. After a short but severe contest, we drove the enemy out of this wood and across a newly plowed field. This woods was filled with the wounded and dead of the enemy, who had taken refuge behind one of the batteries in front and toward our left. Arriving at the farther end of this field, we halted for some minutes, in order to form again in line. Our left rested on a burning farm-house, said to have been the commissary store-house of the enemy, who had, before leaving, set fire to the same and thrown his salt in the will.

After again being formed, we advanced over a meadow toward the battery of the enemy, who had vigorously shelled us during our advance from the woods. Arriving behind the crest of a little elevation, we been ordered tour support, and of which a section shortly came up and unlimbered. A full battery, said to have been Knap's, came up soon after and went directly into action. The enemy's infantry advanced from the right, apparently designing to take our battery. We were ordered up, fixed bayonets, and charged forward past the battery, which in the mean time had given the enemy the benefit of two rounds and across the road leading from Bakersville to Sharpsburg. On the other side of the road is a church or school-house, surrounded by woods. Charging through this piece of woods, we drove the enemy out, and held possession nearly two hours. The enemy occupied a corn-field in front of us, and, judging from his fire, must have been in strong force. In this woods I lost most of my men. I took 148

men into action. Our casualties amount to 1 killed and 25 wounded, some of who have since died. Four were missing.

Very respectfully, your obedient servant,

J.M. SUDSBURG,
Commanding Third Regiment Maryland Volunteers.

Lieut.-Col. LANE,
Commanding Second Brigade.[314]

Report of Colonel James A. Sutter, 34th New York Infantry, of the Battle of Antietam

HDQRS. THIRTY-FOURTH REGIMENT NEW YORK VOLS.
Battle-field near Sharpsburg, Md., September 20, 1862.

SIR: I would most respectfully make the following report of the battle of the 17th instant:

We lay in camp near Keedysville, Md., on the 16th instant. In the evening of that day I received an order to be prepared to march at daylight on the morning of the 17th instant. In obedience to said order, I was under arms with my command, and so remained until the order was given to move, which was about 7.30 o'clock a.m. We moved in a northwesterly direction. Having arrived within about 1 1/2 miles of the battle-field, where Gen. Hooker's forces had been engaged with the enemy, we were formed in line of battle by brigades, Gorman's to the front, First Minnesota Regiment on the right, Eighty-second Regiment New York Volunteers second, Fifteenth Regiment Massachusetts Volunteers third, and my command, Thirty-fourth Regiment New York Volunteers, on the left. Gen. Dan's brigade formed the second line, and Gen. Howard's brigade formed the third line. We were moved at double-quick. Arriving near the battle-field, we were moved by the right flank through a piece of timber-land in three columns. At this point we were considerably crowded, the three columns occupying an extent of not more than 40 paces from our left to the right flank of Gen. Howard's brigade, the Seventh Regiment Michigan Volunteers being crowded in my ranks, causing considerable confusion.

Arriving at the open field, we were again ordered in line of battle, being still at double-quick. We moved over this field to the pike road leading to Sharpsburg. Fronting this was a piece of timber land, into which I moved my command, still at double-quick, arriving at about 20 yards in rear of a school-house, when I discovered the enemy under the hill. I immediately ordered my command to fire, which they did in gallant order.

From some cause to me unknown, I had become detached from my brigade, the one hundred and twenty-fifth Regiment Pennsylvania Volunteers being on my right. On my left and rear I was entirely unsupported by infantry or artillery. The enemy were in strong force at this point, and poured a tremendous fire of musketry and artillery upon me. At this time I discovered that the enemy were making a move to flank me on the left. Lieut. Howe arriving at this time, I informed him of my suspicions. He replied that he thought they were our friends. Lieut. Wallace, of Company C, proposed going to the front, to make what discovery he could, which I granted. He returned, saying that the enemy were moving upon my left flank with a strong force. I turned and discovered Lieut. Richard Gorman, of Gen. Gorman's staff, and requested him to inform the general that the enemy were flanking me. He immediately returned for that purpose. Presently Gen. Sedgwick arrived upon the ground. Moving down my line, he discovered the situation of my command, and that the point could not be held by me, and gave the order for me to retire, which I did. Rallying my command, I formed them in line of battle, supporting a battery some 400 yards in rear of the battle-field.

In this engagement the casualties were as follows, viz: 32 killed, 109 wounded, and 9 missing. Commissioned officers: 1 killed, 2f wounded, 1 taken prisoner.

In connection with this I cannot speak in too great praise of my officers. When all acted gallantly it is impossible to single out any. I would therefore say that all did well and behaved in the most gallant manner. Of Maj. Beverly I would say that he was invaluable to me in assisting me on the left of my line in the most trying time. Of my color sergeant I cannot speak in too high terms. He (Sergt. Charles Burton) had carried the banner through all of the battles in which we had been engaged while on the Peninsula without receiving a wound. Here it was his fate to be struck five times, and when he

was compelled to drop his colors he called upon his comrades to seize them and not to let them fall into the hands of the enemy. This was done by Corpl. G. S. Haskins, who nobly bore them from the field.

All of which is respectfully submitted.

JAMES A. SUTTER,
Col., Commanding.

Capt. J.W. GORMAN,
Assistant Adjutant-Gen.[315]

Report of Lieutenant Colonel John W. Kimball, 15th Massachusetts Infantry, of the Battle of Antietam

HEADQUARTERS FIFTEENTH REGIMENT, MASS, VOLS.
Camp near Sharpsburg, September 20, 1862.

CAPT.: I have the honor to report that on Wednesday, 17th instant, at 7 o'clock a.m., I was ordered to hold my command in readiness to move at a moment's notice. At 7.30 o'clock we took up our line of march with 582 muskets, including First Company Andrew Sharpshooters, Capt. J. Saunders, attached to this command, being the third regiment in the brigade line. We moved in a direct line toward the ground held by the forces under command of Gen. Hooker, fording, in the march, Antietam Creek.

On reaching the field, a line of battle was formed, in which my command occupied the position of third regiment of the first line. We then moved forward in line under a severe artillery fire about one mile over the ground gained by Gen. Hooker, passing fences, fields, and obstacles of various descriptions, eventually occupying a piece of woods, directly in front of which, and well covered by the nature of the ground, field of grain, haystacks, buildings, and a thick orchard, were the enemy in strong force.

At this time we were marching by the right-oblique, in order to close an interval between my command and that of Col. Hudson, Eighty-second New York Volunteers, and as we gained the summit of a slight elevation my left became hotly engaged with the enemy, covered as before mentioned, at a distance of not more than 15 yards. A section of the enemy's artillery

was planted upon a knoll immediately in front of and not more than 600 yards distant from my right wing. This was twice silenced and driven back by the fire of my right wing, concentrated upon it. The engagement lasted between twenty and thirty minutes, my line remaining unbroken, the left wing advancing some 10 yards under a most terrific infantry fire.

Meanwhile the second line of the division, which had been halted some 30 or 40 yards in our rear, advanced until a portion of the Fifty-ninth Regiment New York Volunteers, Col. Tidball, had closed upon and commenced firing through my left wing on the enemy. Many of my men were by this maneuver killed by our own forces, and my most strenuous exertions were of no avail either in stopping this murderous fire or in causing the second line to advance to the front. At this juncture Gen. Sumner came up, and his attention was immediately called by myself to this terrible mistake. He immediately rode to the right of the Fifty-ninth Regiment, ordered the firing to cease and the line to retire, which order was executed in considerable confusion.

The enemy soon appeared in heavy columns, advancing upon my left and rear, pouring in a deadly cross-fire on my left. I immediately and without orders ordered my command to retire, having first wit nested the same movement on the part of both the second and third lines. We retired slowly and in good order, bringing off our color stand a battle-flag captured from the enemy, reforming by the orders of Gen. Gorman in a piece of woods some 500 yards to the rear, under cover of our artillery. This position was held until I was ordered to support a battery planted upon the brow of a hill immediately in our rear, the enemy having opened again with artillery. His fire being silenced, the position was held throughout the day. I desire to say that my entire regiment behaved most gallantly during the engagement, evincing great coolness and bravery, as my list of casualties will show. Although suffering terribly from the fire of the enemy, it was with great surprise that received the order to retire, never entertaining for a moment any idea but that of complete success, although purchased at the cost of their lives. The order forbidding the carrying wounded men to the rear was obeyed to the very letter.

Of my line officers, without exception, I cannot speak in too high praise. They were all at their posts, bravely and manfully urging on their men, and equally exposed with them. Those wounded refused all assistance, ordering their men to return to the ranks and do their duty.

I desire to call your particular attention to Maj. Philbrick and Adjutant Hooper. They were with me during the entire engagement in the thickest of the fight, receiving and executing my orders with great coolness and promptitude.

I herewith append a list of the casualties in the late engagement.

Officers killed: Capt. C.S. Simonds, Capt. J. Saunders, First Lieut. R. Derby, First Lieut. William Berry, First Lieut. F.S. Corbin. Officers wounded: Capt. W. Forehand, slight; Capt. G.C. Joslin, severe; Capt. A. Bartlett, slight; First Lieut. Thomas J. Spurr, severe; First Lieut. L.H. Ellingwood, severe; Second Lieut. W. Gale, slight; Second Lieut. A.J. Bradley, slight. Enlisted men killed, 60; wounded, 238; missing, 38. Officers killed and wounded, 12. Enlisted men killed, wounded, and missing, 336. Total, 348.

I have the honor to be, very respectfully, your obedient servant,

John W. Kimball,
Lieut.-Col., Commanding.

Capt. J. Gorman,
Assistant Adjutant-Gen.[316]

Report of Captain H.G.O. Weymouth, 19th Massachusetts Infantry, of the Battle of Antietam

Hdqrs. Nineteenth Massachusetts Volunteers,
Bolivar, Va., September 29, 1862.

Col.: At your request I forward to you the following report of the part taken by this regiment, in connection with the First Minnesota, during the engagement of Sedgwick's division on the 17th instant: The Nineteenth Regiment was on the extreme right of the second line of battle, the Minnesota regiment being on the right of the first line, when the Minnesota was the last regiment in its line to leave the position, and was immediately followed by the Nineteenth. A stand was made by the latter regiment, at the command of Col. Hinks, on a slight elevation, where it was directly

joined by the former. Soon slight elevation, where it was directly joined by the former. Soon Col. Hinks gave the order to fall back still farther, and immediately fell, severely wounded. The command then devolved upon Lieut.-Col. Devereux, who reported to Col. Sully, as the superior officer then on the field, informing him of the wound of Col. Hinks. Under command of Col. Sully, both regiments were withdrawn to a close stone wall, where preparations were made to receive the enemy should he attempt an attack. Col. Sully remained in command until the troops were withdrawn by command of Gen. McClellan.

Believing the above statement to be correct, I remain, sir, respectfully, yours,

H.G.O. Weymouth,
Capt., Commanding Nineteenth Massachusetts Volunteers.

Col. Alfred Sully,
First Minnesota Volunteers.[317]

Report of Lieutenant Colonel Charles R. Brundage, 60th New York Infantry, of the Battle of Antietam

Hdqrs. Sixtieth New York State Volunteers,
Camp on Loudoun Heights, Va., September 27, 1862.

I have the honor to report that, on the morning of the 17th of September, 1862, the Sixtieth Regiment New York State Volunteers went into action with 217 enlisted men and 9 commissioned officers, and that with his company (Company C) to skirmish, which he did with admirable skill and effect, clearing the woods to the right of the enemy's sharpshooters. After being in action between two and three hours, a brigade fell back on us, breaking our line and scattering our men, making a delay of an hour or more in our rejoining our brigade, then formed in line about half a mile to the rear of their position in action. The regiment remained with the brigade during the remainder of the day, and moved with it at dark to rejoin the division.

I take pleasure in reporting that the officers and men behaved well under fire, promptly obeying all orders. For an account of our losses I beg leave to refer you to official report of casualties.
Very respectfully submitted.

CHAS R. BRUNDAGE,
Lieut.-Col., Sixtieth New York State Volunteers.

Col. W.O. REDDEN,
Commanding Third Brigade.[318]

Report of Lieutenant Colonel Sanford H. Perkins, 14th Connecticut Infantry, of the Battle of Antietam

HEADQUARTERS FOURTEENTH REGIMENT CONN. VOLS.,
Sharpsburg, Md., September 19, 1862.

We broke bivouac at camp near Keedysville, Md., on the morning of the 17th of September, taking position on the right of your command according to order, and marched about two hours by flank, when we formed line of battle and moved forward a distance of about one-half mile, where we became engaged, our position being in a corn-field west of William Roulette's farm-house, the enemy occupying a position on the summit of a hill to our front. The Fifth Maryland Regiment being slightly in our advance, I reserved my fire until they broke, which threw three companies of my right wing into confusion, when we opened fire from the left and immediately proceeded to rally the right, which having been effected, we held our position under a severe cross-fire for nearly three hours, during which time, my horse being disabled, I was obliged to continue with my command on foot.

I cannot omit saying that during the time above mentioned my right and center were broken twice, but rallied on the colors and formed in good order, and when ordered to retire, moved from the field with precision, after which we accompanied you to support Gen. Kimball, who was retiring for ammunition, and took position near a stone wall east of the farm-house, holding the same until ordered to support Col. Brooke.

During this movement, while marching by flank, a shell was thrown into our ranks, killing several of our men. The ranks were at once closed, the regiment moving forward at quick time and in good order. At this time and during the remaining thirty-six hours, being under your immediate command, requires no further detail.

Where all behaved so well it may seem invidious to particularize, but I feel bound to mention Capt. Blinn, of Company F, and Capt. Willard, of Company G, who fell at their posts gallantly cheering their commands. Also First Lieut. Coit, commanding Company K, and Lieut. Crosby, of the same company, were dangerously wounded, leaving that company without a commissioned officer. Acting Adjutant Lucas, Assistant Adjutant-Gen. Ellis was disabled. Sergeant Mills, color-bearer, was severely, if not mortally, wounded while bearing and waving aloft our standard, and his place was filled by Lieut. Comstock, Company H, who with Sergeant Foote, of Company I, retained them until the close of the action. Our colors are riddled with shot and shell, and the staff broken.

Capt. Gibbons, of Company B, deserves notice, who, finding the farmhouse occupied by a large force of the enemy, ordered his company to advance and fire, scattering them and driving a portion of them into the cellar, where, by closing the door, a large number of them were captured.

As you are aware, our men, hastily raised and without drill, behaved like veterans, and fully maintained the honor of the Union and our native State.

Total killed, wounded, and missing, 156. I have the honor to be, your obedient servant,

Sanford H. Perkins,
Lieut. Col., Commanding Fourteenth Regiment Conn. Vols.

Col. Dwight Morris,
Commanding Second Brigade, Gen. French's Division.[319]

Report of Major James Cavanagh, 69th Infantry, of the Battle of Antietam

HQRS. 69TH REGT. N.Y.S. VOLS., IRISH BRIG., Camp on the Field, near Sharpsburg, Md., September 21, 1862.

Brigadier General THOMAS FRANCIS MEAGHER, Commanding Irish Brigade, Sumner's Corps.

GENERAL: Agreeably to request, I herewith transmit to you the following report of our participation in the late battle of the 17th instant:

As you are aware, Lieutenant Colonel James Kelly had command of our regiment up to the time he was wounded and borne from the field, which I deeply regret happened to so brave an officer, the fight being yet, so far as our regiment was concerned, only a short time in progress. The command thus devolving upon your humble servant, the control of the regiment was in the hands of myself, ably assisted by the adjutant, Lieutenant James J. Smith. I may here mention the sorrow I felt, which extended to the whole of my command, when I heard that our acting major, Captain Felix Duffy, had been mortally wounded in the early part of the engagement. Ably assisted by such of my line officers as had been spared me, we used our best endeavors to maintain our reputation and uphold the prestige of our flag. We remained upon the field in the front line until we had expended the last round of cartridges, and only left it when the fire of the enemy had ceased and the brigade was relieved by that of General Caldwell.

I hardly know in what terms to express my appreciation of our regiment, both officers and men, and in making any particular mention of bravery on the field, I speak of those who actually came under my own observation. Captain James E. McGee, of Company F, most particularly distinguished himself by his coolness and bravery during the whole engagement, and while in the heat of battle, after his command had been almost entirely decimated, picking up the green flag, the bearer of which had been carried from the field wounded, and bearing its folds aloft throughout the battle. Captain James Saunders, of Company A, and Captain Richard Moroney, Company I, I am proud to say, acted most bravely, cheering on their men, and encouraging them throughout the battle. Lieutenant Terrance Duffey, of Company G, and First Lieutenant John T. Toal, of Company H, I am also happy to say, throughout that trying hour did all that could

be expected in rallying their commands, which had become so greatly reduced in numbers. Of the many officers who entered the field, the above whom I have mentioned are all that were left me, the remainder having been either killed or wounded during the engagement.

I cannot forbear mentioning the deep sorrow that has been cast over our regiment by our great loss in officers and men. Those that were of us, and who are now numbered among the gallant dead, I can speak of as having been good soldiers, and an honor to our race—Captain Felix Duffy, Lieutenant Patrick J. Kelly, Lieutenant Charles Williams, and Lieutenant John Conway. I feel that our regiment has sustained a great loss, and one the recollection of which will be ever green in my memory. For those officers who have been wounded, and are for a time prevented from rejoining their commands, I can only speak as I have of the few that are left with me. Good soldiers, brave men, I cheerfully recommend for your consideration all of them, who in this fight stood nobly up for their country, and only left the field when borne away wounded. Among them I will mention the brave Captains Shanley and Whitty, both disabled for the second time, and Lieutenants Nagle and Patrick Kearney, who, until wounded, did the regiment good service by their gallant conduct.

Among the non-commissioned officers who particularly distinguished themselves on the field, I take occasion to mention the following as being most worthy of your consideration for promotion to a commission, viz: First Sergts. Murtha Murphy, Company C; Michael Brennan, Company B; Bernard O'Neil, Company C, and Soucoth Mansergh, Company H. Among the privates who also distinguished themselves during the action, I also recommend Patrick O'Neil, of Company C, and John Kelly, of Company; and of the non-commissioned staff, Sergt. Major Patrick Callahan, who on the field behaved with great gallantry.

In conclusion, I beg to call your attention to the fact that we had with us in the battle some forty-odd new recruits, who, considering all things, behaved well, and were of great assistance to us.

Congratulating you on your many narrow escapes from time to time during that memorable day, I have the honor to be, respectfully, yours,

JAMES CAVANAGH, Major, Commanding Sixty-ninth Regiment New York State Vols.[320]

APPENDIX

Report of Brigadier General Winfield S. Hancock, U.S. Army, commanding First Division, Second Army Corps, of the Battle of Antietam

HEADQUARTERS FIRST DIVISION, SECOND CORPS D'ARMEE Harper's Ferry, September 29, 1862

Lieut. Col. J.H. TAYLOR, Chief of Staff, Assistant Adjutant-General, Hdqrs. Second Corps d'Armee, Harper's Ferry, Va.

COLONEL: In obedience to instructions from the major-general commanding the corps, I have the honor to submit a narrative of the operations of this (Richardson's) division during the battle of Antietam, and the time subsequent thereto, until the enemy had retreated from the field, Major-General Richardson's wound being of such a nature as to render it impracticable for him to make the report as to the period during which he exercised the command....The staff officers of Major General Richardson, Maj. J.M. Norvell, assistant adjutant general; Capt. James P. McMahon, of the Sixty-ninth New York Volunteers; First Lieut. D.W. Miller, First Lieut. Wilber L. Hurlbut, First Lieut. C.S. Draper, badly wounded, acted with heroism. After General Richardson was wounded, Captain McMahon, Lieutenant Miller, and Lieutenant Hurlbut joined me, and were very efficient, and deserve the highest commendations for their good conduct.

am, sir, very respectfully, your obedient servant,
WINF'D S. HANCOCK,
Brigadier-General, Commanding Division[321]

Report of Major Alfred B. Chapman, 57th New York Infantry of the Battle of Antietam

CAMP ON BOLIVAR HEIGHTS September 24, 1862.
Lieutenant CHARLES P. HATCH, Acting Assistant Adjutant-General.

LIEUTENANT: I have the honor to submit the following report of the movements of my command during the action of the 17th instant near Sharpsburg:

146

About noon of that day we became actively engaged with the enemy, our brigade having relieved that of General Meagher.

It is with gratification that I have to speak of the general conduct of my command, both officers and men. They acted nobly throughout. I would especially mention Captain N. Grarrow Throop (severely wounded); Captain James W. Britt (who, although wounded, refused to leave the field); Captains Kirk, Curtiss, and Mott; Lieutenant John H. Bell (severely wounded), Lieutenants Jones, Wright, Higbee (killed), and Folger (killed). The medical officers of the regiment, Surgs. Robert V. McKim and Asst. Surgs. Henry C. Dean and Nelson Neely, are deserving of all praise for their care and attention to the wounded, and the promptness with which they caused them to be removed from the field.

We took into the battle 309 officers and men, and lost during the day 97 killed and wounded and 3 missing. A detailed list of casualties has already been sent in.

I am, sir, with much respect, your obedient servant,
A.B. Chapman, Major, Commanding Fifty-seventh New York Volunteers[322]

Reports of Colonel Edward E. Cross,
5th New Hampshire Infantry, of Skirmish at Boonsborough
and the Battle of Antietam

Headquarters Fifth New Hampshire Volunteers,
On the Battle-field, September 18, 1862.

Capt.: In reference to the part taken by my regiment in the battle of the 17th instant, I have the honor to report that, on arriving at the scene of action, I was ordered forward to relieve on of the regiments of the Irish Brigade, which was done under fire. We then advanced in line of battle several hundred yards and entered a corn-field. While marching by the right flank to gain our position in line of battle, we received a heavy fire of shell and canister-shot, which killed and wounded quite a number of officers and men, a single shell wounding 8 men and passing through the State colors of my regiment.

I had scarcely reached my position on the left of the first line of battle and opened fire, when it was reported that the enemy were cautiously

attempting to outflank the entire division with a strong force concealed behind a ridge, and in the same corn-field in which I was posted. They had, in fact, advanced within 200 yards of the left of our lines, and were preparing to charge. I instantly ordered a change of front to the rear, which was executed in time to confront the advancing line of the enemy in their center with a volley at very short range, which staggered and hurled them back. They rallied and attempted to gain my left, but were again confronted and held until, assistance being received, they were driven back with dreadful loss. In this severe conflict my regiment captured the State colors of the Fourth North Carolina Regiment, Corpl. George Nettleton, of Company G, although wounded, bringing them off the field, displaying great bravery and endurance.

My regiment remained on the battle-field all the remainder of the day, under fire of shot and shell, and picketed the field at night. Throughout the whole time my officers and men exhibited all the qualities of good soldiers, steady brave, and prompt in action, although the forces of the enemy were more than three to one.

Maj. Sturtevant, Adjutant Dodd, Capts. Pierce, Long, Murray, Cross, Perry, Randlett, and Crafts deserve especial mention for their gallant conduct; also Lieuts. Graves, George, and Bean, each commanding companies, and Lieuts. Livermore, Ricker, and Goodwin.

The following officers were wounded: Col. Cross (slightly); Capts. Long and Randlett; First Lieuts. Graves and Parks; Second Lieuts. Bean, George, Twitchell, Little, and Hurd. Lieut. George A. Gay, a gallant young officer, was killed. Sergeant-Maj. Liscomb was also wounded. Of enlisted men, as far as can be ascertained, 107 were killed and wounded. Our wounded were attended to by Drs. Knight, Davis, and Childs as rapidly and as well as possible, and were all made very comfortable.

Very truly,

Edward E. Cross,
Col. Fifth New Hampshire Volunteers.

Capt. Caldwell[323]

Report of Lieutenant Colonel Richards McMichael, 53rd Pennsylvania Infantry, of the Battle of Antietam

HEADQUARTERS FIFTY-THIRD PENNSYLVANIA,
Camp of Richardson's Division, September 21, 1862

SIR: I have the honor to make the following report of this regiment in the several engagements near this place:

On Monday, the 15th ultimo, we arrived in sight of the enemy near Antietam Creek. My command being on the left of the brigade. I was ordered by Col. Brooke, commanding the brigade, to halt in a corn-field, being then in rear of the Fifty-seventh New York. We were considerably exposed to the shells from the enemy's batteries while in that position. Some time afterward I was ordered to march by the right flank and follow the Fifty-seventh New York. My command was then placed in the second line, in rear of the 69th New York, of Gen. Meagher's brigade. I remained in that position until the morning of the 17th ultimo, when I was ordered to march by the right flank on left of the brigade.

After crossing Antietam Creek, I was ordered to halt in front of the Fifty-seventh New York, and have my men load and prime their pieces. Shortly afterward we were again advancing in same order as before, until we came near the scene of action. I was then ordered to form in line of battle on the left of the Sixty-sixth New York, which was done speedily and in good order. We Were then in the second line. While in this position, Gen. Caldwell's brigade passed through the line of this brigade on the right of my regiment. Shortly afterward we were ordered to advance to the front and take position on the left of that brigade. On arriving there however, found the enemy, after repeated efforts, had succeeded in piercing the line of the division immediately on our right, leaving us in imminent danger of being flanked. Col. Brooke at once saw that they must be held at bay at all hazards. Ordering the Fifty-third to file to the right, my regiment passed down the enemy's line to the right in perfect order, receiving their fire with entire composure. Gen. Richardson ordered Col. Brooke to send the Fifty-third Regiment forward, and hold in check the rebel brigade now on our right and in front; also to hold at all hazard the barn and orchard a short distance in front, the barn being used as a hospital. Steadily, under a shower of musketry, my regiment advanced to the orchard and gained the barn about 100 yards in front of

the main line, and, still pressing onward, reached the crest of the hill and drove back the enemy. We moved forward until we formed a connection with Gen. French's division, and held that position until ordered by Col. Brooke to support a battery.

While in this position, First Lieut. John D. Weaver, acting adjutant of the regiment, was mortally wounded when nobly cheering the men on to victory. It was here, also that First Lieut. Philip H. Schreyer was wounded. We were exposed to a murderous fire from the enemy's batteries during the whole time we were in this position. After we had supported the battery for some time, I was ordered to move my regiment and occupy the ground vacated by the Fifth New Hampshire Regiment, in front line, on right of the brigade. I moved my regiment there under a heavy fire from the enemy's batteries, yet my men behaved splendidly and never once flinched. I sent out my left company (B), commanded by Capt. Eicholtz, as skirmishers, to a corn-field some distance in the front. During the balance of the day my regiment was continually exposed to the destructive fire from the enemy's batteries, yet I had not a man who left his post or went to the rear. My regiment remained in front line until the 19th ultimo, when I was ordered to be in readiness to march, the enemy having retreated.

My loss in killed is 6, including Acting Adjt. J.D. Weaver, who died on the 18th ultimo; wounded, 18; missing, 1. I cannot particularize any of my officers, from the fact that they all did nobly. Capt. S.O. Bull, acting major, ably assisted me during the whole engagement, as also did all the officers of the regiment.

Very respectfully,

R. McMichael,
Lieut.-Col., Comdg. Fifty-third Regt. Pa. Vols.

Lieut. Charles P. Hatch,
Acting Assistant Adjutant-Gen., Third Brigade[324]

Reports of Colonel George Crook, 36ᵗʰ Ohio Infantry, Commanding, Second Brigade, of South Mountain and Antietam

HEADQUARTERS SECOND BRIGADE, KANAWHA DIVISION, Mouth of Antietam Creek, Md., September 20, 1862.

Lieutenant KENNEDY, Acting Assistant Adjutant-General, Kanawha Division.

CAPTAIN: I have the honor the report that on the morning of the 17th instant I received orders from the general commanding corps to cross the bridge over Antietam Creek after General Sturgis had taken the bridge; but upon my arrival in the vicinity of the bridge I found that General Sturgis' command had not arrived; so I sent the Eleventh Regiment ahead as skirmishers in the direction of the bridge, and conducted the Twenty-eighth Regiment above the bridge to reconnoiter the enemy's position, leaving the Thirty-sixth Regiment as reserve. After a labor of two hours, I succeeded in establishing two pieces of Simmonds' battery in a position to command the bridge and getting five companies of the Twenty-eighth across the stream. I then intended taking the bridge with the Thirty-sixth Regiment, but soon after my battery opened on the bridge General Sturgis' command crossed the bridge. The brigade also participated in the charge on the enemy.

I regret to have to report the death of Lieutenant-Colonel Clarke, of the Thirty-sixth Regiment, and Lieutenant-Colonel Coleman, of the Eleventh. These gallant officers fell while gallantly leading their men.

The following is a list of the killed, wounded, and missing during the engagement, viz: Eleventh Regiment-4 killed, 12 wounded, and 5 missing; Twenty-eighth Regiment-1 killed, and 19 wounded; Thirty sixth Regiment-3 killed and 21 wounded. Total, killed, 8; wounded 52, and missing, 5.

I am, sir, very respectfully, your obedient, servant,

GEORGE CROOK, Colonel, Commanding Second Brigade, Kanawha Division[325]

Reports of Colonel Carr B. White, 12*th* Ohio Infantry, of the Battles of South Mountain and Antietam

HDQRS. TWELFTH REGIMENT OHIO VOLUNTEER INFANTRY,
Camp at Mouth of Antietam Creek, Md., September 22, 1862.

SIR: I have the honor to forward the following report of the movements of the Twelfth Regiment Ohio Volunteers Infantry, under my command, in the late actions along the Antietam:

Late in the evening of the 16th of September the regiment was placed in line of battle on the Miller farm, to support Lieut. Benjamin's battery. At a.m. of the 17th I moved the regiment to the left and front of the bridge over Antietam, and in line with the Twenty-third and Thirtieth, and in supporting distance of McMullin's battery. We occupied this position from one to two hours, when we moved with the brigade, under command of Col. Ewing, to a ford about 1 mile down the stream. While fording the stream the enemy opened on the column with artillery, fortunately inflicting but little injury. After crossing the stream, we moved up along its bank to the left and front of the bridge over Antietam, to within supporting distance of Gen. Rodman's division. While lying in this position the enemy shelled us severely for about two hours.

By order of Col. Ewing, we were then moved forward and put in line of battle with the brigade, to charge the enemy's lines posted on and beyond the hill. Before the line moved forward to the charge, it was discovered that the enemy was moving two columns our left flank. My regiment was then ordered to form a line at right angles with the main line, to advance and engage a flanking column of the enemy, which was promptly done under a shower of shell and canister that threatened the destruction of the regiment. With a view to a better position, the regiment was withdrawn to a fence 5 yards in the rear, and put in position. Finding this position equally exposed with the former, both to musketry and artillery, the regiment was ordered back to the position just abandoned, which was held in the face of a heavy fire until ordered back by Lieut. Kennedy, acting assistant adjutant-general of the Kanawha Division, to the brow of the hill in front of the bridge, where it remained by your order during the night.

Our loss on this day was 6 killed and 24 wounded out of about 200 engaged, and occurred mainly from the enemy's artillery while engaged in holding in check the force endeavoring to turn our left.

On the 18th we were advanced to a hill in front, and threw forward a heavy line of pickets, which kept up a fire all day on the enemy's skirmishers. Our loss on this day was 1 man killed and 2 men wounded.

Among so many officers who did their whole duty it might seem invidious to particularize, but I cannot refrain making honorable mention of Lieut. Col. J.D. Hines, to whose aid I am so much indebted for the conduct of the regiment also of William B. Nesbitt, my adjutant, and Sergt. Maj. James H. Palmer. And though it may swell this report beyond a reasonable limit, I must bear testimony to the good conduct of Capts. Joseph L. Hilt, W.B. Smith, and John Lewis; of Lieuts. John Wise, J.W. Ross, T.J. Atkinson, W.A. Ludlum, H.F. Hawkes, J.A. Yordy, W.H. Glotfelter, and H.G. Tibbals; also of Sergts. W.B. Redmon, Maurice Watkins, Jonathan McMillen, and M.B. Mahoney, with others whose names cannot at present be mentioned for want of space, whom I recommend as deserving promotion. Capts. Wilson, Williams, and Pauley were absent. The first named was wounded at South Mountain. The last two were sick and in hospital.

I am, sir, very respectfully, your obedient servant,

C.B. White,
Col. Twelfth Regiment Ohio Volunteer Infantry.

Lieut. G. Lofland,
Lieut. and A.A.A.G., First Provisional Brig., Kanawha Div[326]

Report of Major J. Edward Ward, 8th Connecticut Infantry, of the Battle of Antietam

Headquarters Eighth Connecticut Volunteers,
Mouth of Antietam, Md., September 19, 1862.

Sir: I have the honor to submit the report of the proceedings of the Eight Regiment Connecticut Volunteers during the late engagement near Sharpsburg:

Lieut.-Col. Appelman having been wounded in the engagement, I am unable to state what orders he may have received, but can speak only from

the time I took command. The Second Brigade, Third Division, Ninth Army Corps, with which we were connected, held the extreme left of our line, and about 4 o'clock p. m. were ordered to advance to the support of Gen. Willcox on our right, who had been repulsed. We did so, and held our position far in advance, until ordered to retire by Gen. Rodman but not until we had lost over 50 percent, of our regiment. The fire from artillery and musketry was very severe, the regiment receiving fire in front and on both flanks. The conduct of both officers and men was all that could be asked for, and have to thank the officers for their active co-operation with me in the performance of their several duties. I will notice particularly the conduct of Private Charles Walker, of Company D, who brought the national colors off the field after the sergeant and every corporal of the color-guard were either killed or wounded.

Our loss was 34 killed, 139 wounded, and 21 missing; total, 194.

I have the honor to be, very respectfully, your obedient servant,
J. EDWARD WARD,
Maj., Commanding Eighth Connecticut Volunteers[327]

Report of Colonel Edward Harland, 8th Connecticut Infantry, commanding Second Brigade, Third Division of the Battle of Antietam

HEADQUARTERS SECOND BRIGADE, RODMAN'S DIVISION, Mouth of Antietam Creek, Md., September 22, 1862.
Captain CHARLES T. GARDNER, Assistant Adjutant-General.

CAPTAIN: I have the honor to submit the following report of the movements of the Second Brigade, of General Rodman's division of the Ninth Army Corps, during the engagement with the enemy on the 17th instant:
About sunset on the 16th brigade was placed in line of battle by order of General Rodman on the left of Colonel Scammon's division, supported on the left by the First Brigade, of General Rodman's division. The line was formed behind a range of hills running nearly parallel with Antietam Creek and about one-quarter of a mile directly back from the bridge across the creek. Strong pickets were placed at the distance of 300 yards in front of the

line, and in this position we remained until morning. At daylight the enemy commenced shelling the position, and as they had obtained the exact range our loss was considerable.

About 7 o'clock, in accordance with an order received from General Rodman, I moved the brigade into a position to the rear and to the left of the one formerly occupied, facing to the left, the new line of battle forming nearly a right angle with the old one. In this position we remained between and two hours. Our next movement was a change of front formed on first battalion. This brought the line of battle in a position parallel to the one occupied at first, the right resting about 200 yards in the rear of the first position to the left. Shortly afterward I received orders from General Rodman to move the brigade, with the exception of the Eleventh Regiment Connecticut Volunteers, which was left to support a battery, to the left, forming a line of battle on the prolongation of the old line. I then sent out two companies of skirmishers from the Eighth Regiment Connecticut Volunteers to discover, if possible, a ford by which the creek could be crossed. After the ford was found, I followed in the rear of the First Brigade for the purpose of crossing the creek. I sent an aide-de-camp to bring the Eleventh Regiment Connecticut Volunteers to join the rest of the brigade, who reported that the regiment was not in the position in which it was left, and that he was unable to find it. I saw nothing more of the Eleventh Regiment Connecticut Volunteers until about sunset, when I met the remnant of the regiment near the bridge.

General-Rodman ordered me to detach one regiment for the support of the battery belonging to the Ninth New York Volunteers, and to send the remaining regiments of the brigade across the creek in rear of the First Brigade, and, when I had placed the regiment in proper position, to join the balance of the brigade. I found the battery on the hill just below the ford. I detached the Eighth Regiment Connecticut Volunteers, placed it in what I considered the strongest position for the defense of the battery, and then crossed the ford. I found the rest of my command placed behind a stone wall, with orders from General Rodman to wait there for orders.

Shortly after my arrival the enemy opened an enfilading fire from a section of a battery which had been placed on our left flank. In order to protect the men, I moved the command more to the right, behind the crest of a hill, and awaited in that position the orders of General Rodman. While in this position the Eighth Regiment Connecticut Volunteers rejoined the brigade, and I moved still more to the right, in the direction of the bridge, and halted in the woods, just under the brow of the hill. From this point I was conducted by an aide of General Rodman, and placed in the rear of

the First Brigade. Shortly after, General Rodman ordered me to form on the left of the First Brigade, ready for an advance on the enemy. Major Lion, acting aide-de-camp, who went to the left of the line to carry my orders, on his return reported a brigade of the enemy's infantry was forming on the left, which fact I reported to General Rodman. When the order was given by General Rodman to advance, the Eighth Regiment Connecticut Volunteers, which was on the right of the line, started promptly. The Sixteenth Regiment Connecticut Volunteers, and the Fourth Regiment Rhode Island Volunteers and the Fourth Regiment Rhode Island Volunteers, both of which regiments were in a cornfield, apparently did not hear my order. I therefore sent an aide-de-camp to order them forward. This delay on the left placed the Eighth Regiment Connecticut Volunteers considerably in the advance of the rest of the brigade. I asked General Rodman if I should halt the Eighth Regiment Connecticut Volunteers and wait for the rest of the brigade to come up. He ordered me to advance the Eighth Regiment Connecticut Volunteers, and he would hurry up the Sixteenth Regiment Connecticut Volunteers and the Fourth Regiment Rhode Island Volunteers. I advanced with the Eighth Regiment Connecticut Volunteers and commenced firing. The Sixteenth Regiment Connecticut Volunteers and the Fourth Regiment Rhode Island Volunteers not coming up, I turned to see if they were advancing, and saw some infantry belonging to the enemy advancing upon our left flank. Knowing that if they were not checked it would be impossible to hold this part of the field, without waiting for orders, I put the spurs to my horse to hasten the arrival of the Sixteenth Regiment Connecticut Volunteers. My horse was almost immediately shot under me, which delayed my arrival. I found that the Sixteenth Regiment Connecticut Volunteers had changed their front, by order of General Rodman. The line was formed facing to the left, and was nearly a prolongation of the enemy's lines, except that they faced in opposite directions. I immediately ordered Colonel Beach to change his front, so as to attack the enemy on the right flank. This change was effected, though with some difficulty, owing to the fact that the regiment had been in service but three weeks, and the impossibility of seeing but a small portion of the line at once.

Almost as soon as the change was effected, the right of the enemy's lines, which was concealed in the edge of the corn-field, opened fire. Our men returned the fire and advanced, but were forced to fall back. Colonel Beach rallied them and returned to the attack, but they were again driven back, this time out of the corn-field, beyond the fence. Here they were again rallied, but as it was impossible to see the enemy; and the men were under fire for

the first time, they could not be held. The Eighth Regiment Connecticut Volunteers, which had held their position until this time, now by order of Major Ward, commanding, moved more to the right, they were sheltered in a measure from the fire in front, and changed front, so as to reply to the enemy on the left. After a few rounds, as most of the men were out of ammunition, the order was given to fall back. On the road leading to the bridge I found part of the Eleventh Regiment Volunteers. At the bridge I collected the shattered remnants of the brigade, in hopes of making a stand, but owing to the large loss of officers and the failure of ammunition, it was impossible to render the men of any material service. I therefore conducted the brigade across the bridge, and bivouacked for the night in front the position held by a portion of General Sykes' command.

Battery A, Fifth Artillery, was assigned to my brigade. General Rodman, however, assumed the immediate command the night before the action, and the battery did not report to me again until after the battle.

The regimental reports not being in, it is impossible to give a more detailed account of the movements of the different regiments composing the command.

I append a list of casualties, with the strength of the brigade before going into action.

Very respectfully, your obedient servant,
EDWARD HARLAND, Colonel, Commanding Second Brigadier, Third Div., Ninth Army Corps[328]

Report of Lieutenant Colonel Joseph B. Curtis, U.S. Army, 4th Rhode Island Infantry, of the Battle of Antietam

HDQRS. FOURTH REGIMENT RHODE ISLAND VOLUNTEERS, Mouth of Antietam Creek, September 22, 1862.

His Excellency WILLIAM SPRAGUE, Governor State of Rhode Island.

SIR: I have the honor to submit the following report of the part taken by this regiment in the battle of Sharpsburg on the 17th instant:
On the afternoon of the 16th, Harland's brigade, consisting of the Eighth, Eleventh, and Sixteenth Connecticut and Fourth Rhode Island, left the

bivouac it had occupied on the left of the Sharpsburg road, and proceeded in a southwesterly direction, following the general course of the Antietam Creek, for 3 or 4 miles, and took up a position behind a range of hills covering a stone bridge which crossed the creek. The regiment lay upon its arms all night, having its front covered by its own pickets. The Fourth had the left of the brigade line and upon its left lay Fairchild's brigade of Rodman's division. About an hour after light on the morning of the 17th, the enemy's pickets commenced firing upon those of the regiments upon our left, and shortly after they began shelling the whole division line, their range being very accurate. As soon as the firing commenced, the ranks were dressed and the men directed to lie down in their places. The three left companies, being in a more exposed position, were brought in rear of the rest of the battalion.

Orders were received from Colonel Harland to follow the other brigade to the left, but before that brigade could move, the enemy opened another battery on our right, enfilading our position with a fire of round shot, and completely commanding a little rise of ground on our left, which we should have been obliged to cross to roach the ground occupied by the other brigade. This fact was reported to Colonel Harland by an officer, who returned with orders for the regiment to move to the left and rear, thought some woods, in a direction to be indicated by Lieutenant Ives, of General Rodman's staff, who came back with him. The order was executed, the regiment moving by the left flank to the rear through a wooded gully, but partially concealed from the enemy, who continued their heavy fire of shell and solid shot. The regiment was then drawn up in a farm lane, well protected by a hill. As the brigade filed thorough the wooded gully, a battery placed in roar of our original position commenced replying to the enemy, too late, however, to cover our retrograde movement, which was almost completed. Our loss in this affair was 2 killed and 8 wounded, amount the latter the color bearer and two color-corporals.

After about an hour the brigade advanced in line of battle to the top of the hill in front, making a right half-wheel, and after crossing several fields took a position on the top of the hills, at the foot of which ran the Antietam Creek, on the opposite side of which was the enemy. The action on our right was now very sharp, both artillery and infantry being engaged. Our division constituted the extreme left of the line. After a halt of some duration, the division moved by the left flank to the creek at a ford under fire from the enemy's skirmishers, who were sheltered behind a stone wall. The Fourth, after crossing the ford, filed to the left (the other brigade going to the right, and the rest of Harland's brigade not yet having crossed), and after throwing

out Company H as skirmishers to cover the front, and Company K to the left, advanced in line toward the stone wall, the enemy retiring, but shortly after opening a fire of musketry on our left, which was soon silenced by the fire from our battery covering the ford.

The enemy then commenced a fire of grape and shell upon us, and the Sixteenth Connecticut, which had just crossed the ford and was taking a position to support our left, retired, passing along our rear. After it had passed, this regiment, by Colonel Harland' s orders, took a more sheltered position at right angles to our original one. From here we moved to the right, in the direction taken by Colonel Fairchild's brigade, through a wooded ravine, through which ran the creek. The steepness of the hill-side, the thickness of the wood, and the accurate range of the enemy's batteries made the passage through this defile a matter of considerable difficulty. Upon clearing the woods we lay waiting orders for a short time under a hill-side, which the enemy were shelling, the rest of the brigade having passed on while we were in the woods. From here the regiment was ordered by Colonel Harland's aide to cross the hill behind which it was laying (a plowed field), and to form in line in a corn-field, and to move to the support of the Sixteenth Connecticut, which lay in a deep valley between two hills planted with corn. The regiment moved forward by the right flank in fine order, although subjected to the fire of rebel batteries, of which it was in full view. Descending into the valley to its support, it found the Sixteenth Connecticut giving way and crowding upon its right, compelling it to move to the left, and rendering it almost impossible to dress the line, which an advance in line of battle across two fields of full-grown corn had slightly deranged. It was now subjected to sharp musketry fire from the front, but as the enemy showed the national flag (the corn concealing their uniform), and as our troops had been seen in advance on our right, moving diagonally across our front, the order to cease firing was given, and a volunteer officer to go forward to ascertain who was in our front was called for. Lieutenant George E. Curtis and George H. Watts immediately stepped forward, and placing themselves one on each side of the color bearer (Corporal Tanner, Company G), carried the flag up the hill within 20 feet of the rebels, when the enemy fired, killing the corporal. Lieutenant Curtis seized the colors and returned, followed by Lieutenant Watts. The order to commence firing was then given, and Colonel Steere sent me to the Sixteenth Connecticut to see if they would support us in charge up the hill, but the corn being very thick and high, I could find no one to whom to apply. I returned to tell the colonel that we must depend upon ourselves. He then sent to the rear for support.

Before they could arrive, the enemy outflanked us with a brigade of infantry, which descended the hill to our left in three lines, one firing over the other and enfilading us. The regiment on our right now broke, a portion of them crowding on our line. Colonel Steere ordered the regiment to move out of the gully, by the right flank, and I left him to carry the order to the left, of which wing I had charge, the colonel taking the right (the major being sick, and no adjutant, there were only two field officers to handle the regiment.) The regiment commenced the movement in an orderly manner, but, under the difficulty of keeping closed up in a corn-field, the misconception of their order on the left, and the tremendous fire of the enemy, consisting of musketry, shell, and grape, the regiment broke. Colonel Steere, as I afterward learned, was severely wounded in the left thigh, immediately after I left him to repeat on the left the order to leave the corn-field. An attempt was made rally the regiment to the support of a battery at some distance back from the corn-field, but before many had been collected the battery retired, when the efforts became unavailing.

I desire to bring to your notice Lieutenants Curtis and Watts, who volunteered to carry the colors forward in the corn-field, and the following non-commissioned officers and privates: Sergeants Wilson, Company A; Coon, Company B; Morris, Company C; Corporals Leonard, Company A; Farley, Company C, and Privates McCann, Company B, and Peck, Company C, who rallied, after the regiment was broken, on the left of the Fifty-first Pennsylvania, and continued fighting until all their ammunition was gone, when I ordered them to recross the river to regain the regiment. All the food the men had during the entire day was the very small quantities of salt pork and hard bread they were able to find in an abandoned camp, during the short rest after the morning.

The entire loss during the day was 21 enlisted men killed, 5 officers and 72 enlisted men wounded, and 2 missing. A list of the names, as furnished by the captains of companies, has been forwarded to the Adjutant General.

Colonel Steere commends in the highest terms the conduct of the regiment upon that day. I can only add that throughout the day I never saw an officer but that he was encouraging and directing his men.

The men fought well, as is proved by the fact that they were engaged constantly with the enemy during nine or ten hours, all of which time they were under arms; that they finally broke, under such a very severe fire, and the pressure of a broken regiment, is not surprising, although much to be regretted. Of the present state of the regiment I have only the most favorable report to give.

By direction of Colonel Steere, I have organized the regiment into eight companies, the members of Companies I and K being divided among the others temporarily, although in all reports and musters they will be borne upon their own rolls. In this way officers are gained to officer the other companies, and the companies are made practically larger. The three days just spent in camp although broken by marching orders, have in part rested the men from the fatigues of the two battles and constant marches to which they have been subjected since the 4th of this month. The temporary loss of its commanding officer at the time when his experience can be of so much use is a severe blow to the regiment.

I have the honor to be, sir, very respectfully, your obedient servant,

JOSEPH B. CURTIS, Lieutenant-Colonel, Commanding Fourth Rhode Island

Notes

Introduction

1. Darrah, *Cartes de Visite*, 87.
2. "Lee's Letter to President Davis on Moving into Maryland," Antietam on the Web, accessed October 10, 2018, http://antietam.aotw.org/exhibit.php?exhibit_id=8.
3. United States War Department, *Official Records of the War of the Rebellion* [hereafter *OR*], series 1, volume 19, part 1 (Washington, D.C.: Government Printing Office, 1889), 25.

Chapter 1

4. *Union Army*, 2:67.
5. Raus, *Banners South*, 205–6.
6. Carman and Clemens, *Maryland Campaign*, 2:572.
7. Priest, *Antietam*, 332.
8. Ames, Military Service Records.
9. "Trimmings," Revised Regulations for the Army of the United States 1861, January 10, 2017, http://howardlanham.tripod.com/unireg.htm.
10. Woodhead, *Echoes of Glory*, 125.
11. *Union Army*, 2:73.
12. Murry, *Madison County Troops*, 31.
13. Carman and Clemens, *Maryland Campaign*, 2:572.
14. Priest, *Antietam*, 332.
15. McWayne, Military Service Records.
16. *Full Report*, 63–64.
17. Pension Card Index, www.fold3.com/image/249/3705773.

18. Woodhead, *Echoes of Glory*, 190–91.

19. Ibid., 185.

20. *Union Army*, 2:66.

21. *OR*, series 1, volume 19, part 1, 233.

22. Priest, *Antietam*, 332.

23. Baker, Military Service Records.

24. Pension Card Index, www.fold3.com/image/249/2551517.

25. Dyer, *Compendium of the War*, 2:1413.

26. Woodhead, *Echoes of Glory*, 117; authors' personal collection.

27. United States War Department, *Revised United States Army Regulations* [hereafter *Revised Regulations*].

28. Woodhead, *Echoes of Glory*, 183.

29. *Union Army*, 2:67.

30. Carman and Clemens, *Maryland Campaign*, 2:73.

31. *OR*, series 1, volume 19, part 1, 227.

32. Adriance, Military Service Records.

33. Pension Card Index, www.fold3.com/image/249/3302700.

34. Woodhead, *Echoes of Glory*, 119.

35. "Buttons from New York," Ridgeway Reference Archive, http://www.relicman.com/buttons/zArchiveButton2NewYork.htm.

36. *Revised Regulations*, 481.

37. *Union Army*, 2:70.

38. Priest, *Antietam*, 332.

39. *Union Army*, 2:202.

40. Gurney, Military Service Records.

41. Pension Card Index, www.fold3.com/image/249/3276197.

42. Woodhead, *Echoes of Glory*, 193.

43. Ibid., 200.

44. Konstam, *Civil War Soldier*, 134.

45. Woodhead, *Echoes of Glory*, 180.

46. "30th Infantry Regiment," New York State Military Museum and Veterans Research Center, https://dmna.ny.gov/historic/reghist/civil/infantry/30thInf/30thInfMain.htm.

47. Priest, *Antietam*, 332.

48. *OR*, series 1, volume 19, part 1, 227.

49. Fisk, Military Service Records.

50. Pension Card Index, www.fold3.com/image/249/5162696.

51. Woodhead, *Echoes of Glory*, 117.

52. "Uniform, Dress, and Horse Equipments Coat," Revised Regulations for the Army of the United States, http://howardlanham.tripod.com/unireg.htm.

Chapter 2

53. Massachusetts Adjutant General's Office, *Massachusetts Soldiers*, 2.
54. Priest, *Antietam*, 333.
55. Carman and Clemens, *Maryland Campaign*, 2:64.
56. Ibid., 65.
57. Reimer, *One Vast Hospital*, 112–13.
58. Burbank, Military Service Records.
59. Pension Card Index, www.fold3.com/image/249/5639589.
60. Cook, *History of the 12th Massachusetts*, 11.
61. Woodhead, *Echoes of Glory*, 117.
62. *Revised Regulations*, 481.
63. Woodhead, *Echoes of Glory*, 179.
64. Massachusetts Adjutant General's Office, *Massachusetts Soldiers*, 70.
65. Priest, *Antietam*, 333.
66. Carman and Clemens, *Maryland Campaign*, 2:64–65.
67. "Following the Ambulance Train with Sam Webster and Appleton Sawyer," 13th Massachusetts Volunteers, http://www.13thmass.org/1863/chancellorsville.html#mozTocId111747.
68. Pension Card Index, www.fold3.com/image/249/3120117.
69. "The Band Musters Out," 13th Massachusetts Volunteers, http://www.13thmass.org/1862/new_leaders.html#mozTocId492730.
70. Woodhead, *Echoes of Glory*, 236.
71. *Union Army*, 1:173.
72. *OR*, series 1, volume 19, part 1, 261.
73. Sellers, Military Service Records.
74. Pension Card Index, www.fold3.com/image/249/6644199.
75. Woodhead, *Echoes of Glory*, 190.
76. *Revised Regulations*, 129.
77. *Union Army*, 2:68.
78. Priest, *Antietam*, 333.
79. Carman and Clemens, *Maryland Campaign*, 2:81.
80. Miller, Military Service Records.
81. Pension Card Index, www.fold3.com/image/249/5646655.
82. Woodhead, *Echoes of Glory*, 119.
83. Taylor, *Glory Was Not Their Companion*, 10.
84. Woodhead, *Echoes of Glory*, 183.
85. Carman and Clemens, *Maryland Campaign*, 2:118.
86. Priest, *Antietam*, 341.
87. *Union Army*, 2:69.
88. Kelcher, Military Service Records.

89. Pension Card Index, www.fold3.com/image/249/4880124.
90. "Badges to Distinguish Rank," Revised Regulations for the Army of the United States, 1861, http://howardlanham.tripod.com/unireg.htm.
91. *Union Army*, 2:272.
92. *OR*, series 1, volume 19, part 1, 511.
93. Keiner, Military Service Records.
94. Woodhead, *Echoes of Glory*, 122.
95. "Shoulder Scales," Revised Regulations for the Army of the United States, 1861, http://howardlanham.tripod.com/link25.htm.

Chapter 3

96. Carman and Clemens, *Maryland Campaign*, 2:574.
97. Priest, *Antietam*, 335.
98. *OR*, series 1, volume 19, part 2, 316.
99. Clark, Military Service Records.
100. Ibid.
101. Pension Card Index, www.fold3.com/image/249/3285731.
102. Billings, *Hard Tack*, 258.
103. *Union Army*, 1:174.
104. Ibid.
105. Ibid., 176.
106. Priest, *Antietam*, 335.
107. Ford, *Story of the Fifteenth Regiment*, 197.
108. Russell, Military Service Records.
109. Pension Card Index, www.fold3.com/image/249/2721705.
110. "Trowsers," Revised Regulations for the Army of the United States, 1861, http://howardlanham.tripod.com/unireg.htm.
111. Woodhead, *Echoes of Glory*, 125.
112. *Union Army*, 1:176.
113. Carman and Clemens, *Maryland Campaign*, 2:574.
114. Priest, *Antietam*, 337.
115. History Committee, *History of the Nineteenth Regiment*, 136.
116. Kimball, Military Service Records.
117. Pension Card Index, www.fold3.com/image/249/2561927.
118. Revised Regulations, "Trowsers."
119. Woodhead, *Echoes of Glory*, 122–23.
120. Carman and Clemens, *Maryland Campaign*, 2:574.
121. Priest, *Antietam*, 336.
122. Bruce, *Twentieth Regiment*, 169–70.
123. Milton, Military Service Records.

124. Ibid.

125. Woodhead, *Echoes of Glory*, 193.

126. Revised Regulations, "Trowsers."

127. "Buttons from Massachusetts," Ridgeway Reference Archive, http://www.relicman.com/buttons/Button4100-Massachusetts.html.

128. "Various Components: Sash," Revised Regulations for the Army of the United States, 1861, http://howardlanham.tripod.com/unireg.htm.

129. Woodhead, *Echoes of Glory*, 74–75.

130. Ibid., 200.

131. "Sword Components," Revised Regulations for the Army of the United States, 1861, http://howardlanham.tripod.com/unireg.htm.

132. Woodhead, *Echoes of Glory*, 180.

133. *Union Army*, 2:93.

134. Carman and Clemens, *Maryland Campaign*, 2:574.

135. Priest, *Antietam*, 336.

136. Carman and Clemens, *Maryland Campaign*, 2:210.

137. Purdy, Military Service Records.

138. Pension Card Index, www.fold3.com/image/249/5636639.

139. *OR*, series 3, volume 5, 552.

140. Ibid., series 3, volume 3, 338.

141. Ibid.

142. "A Study of Enlisted Invalid Corps Jackets 1863–1866," C.J. Daley: Historical Reproductions, http://www.cjdaley.com/vrc.htm.

143. "Soldier Details: Purdy, Sanford," Civil War Soldiers and Sailors Database, https://www.nps.gov/civilwar/search-soldiers-detail.htm?soldierId=A05A5BC5-DC7A-DF11-BF36-B8AC6F5D926A.

144. *Union Army*, 2:94.

145. Ibid., 342.

146. Richard, *History of the Sixtieth Regiment*, 177.

147. Ibid., 180.

148. Ibid., 181.

149. Ibid., 177.

150. Powell, *Officers*, 50.

151. Willson, Military Service Records.

152. Pension Card Index, www.fold3.com/image/249/3731073.

153. Revised Regulations, "Uniform, Dress and Horse Equipments Coat."

Chapter 4

154. *OR*, series 1, volume 19, part 1, 172–73.

155. Smith, et al., *Record of Service*, 551.

156. Priest, *Antietam*, 336.
157. Page, *History of the Fourteenth*, 37–38.
158. Simpson, Military Service Records.
159. Woodhead, *Echoes of Glory*, 193.
160. Revised Regulations, "Trowsers."
161. *Union Army*, 2:101.
162. Priest, *Antietam*, 335.
163. McMahon, Military Service Records.
164. *OR*, series 1, volume 19, part 1, 277, 282–83.
165. McMahon, Military Service Records.
166. *OR*, series 1, volume 36, part 1, 345.
167. Revised Regulations, "Uniform, Dress and Horse Equipments Coat."
168. "164th Infantry Regiment—Civil War," New York State Military Museum and Veterans Research Center, https://dmna.ny.gov/historic/reghist/civil/infantry/164thInf/164thInfMain.htm.
169. Ibid.
170. *Union Army*, 1:182.
171. *OR*, series 1, volume 19, part 1, 293–95.
172. Osborne, *History of the Twenty-Ninth*, 185.
173. Ibid., 186.
174. Corbett, Military Service Records.
175. "Massachusetts," Ridgeway Reference Archive, http://www.relicman.com/buttons/Button4100-Massachusetts.html.
176. Woodhead, *Echoes of Glory*, 105.
177. Child, *History of the Fifth*, 6.
178. "Battle Unit Details: 5th Regiment, New Hampshire Infantry," Civil War Soldiers and Sailors Database, https://www.nps.gov/civilwar/search-battle-units-detail.htm?battleUnitCode=UNH0005RI.
179. *OR*, series 1, volume 19, part 1, 288.
180. Goodwin, Military Service Records.
181. Darrah, *Cartes de Visite*, 87.
182. "Buttons," Revised Regulations for the Army of the United States, 1861, http://howardlanham.tripod.com/unireg.htm.
183. *Union Army*, 2:92.
184. Priest, *Antietam*, 335.
185. Jones, Military Service Records.
186. *OR*, series 1, volume 19, part 1, 302–3.
187. "New York Fifty-Seventh Infantry," Civil War Research and Genealogy Database, http://civilwardata.com/active/hdsquery.dll?RegimentHistory?1540&U.
188. Woodhead, *Echoes of Glory*, 114–16.
189. Ibid., 117.
190. *Union Army*, 1:384–85.

191. Priest, *Antietam*, 335.
192. *OR*, series 1, volume 19, part 1, 304.
193. Schmearer, Military Service Records, Company K, 53rd Pennsylvania Infantry Regiment, National Archives.
194. Woodhead, *Echoes of Glory*, 191.
195. Revised Regulations, "Trowsers"; Woodhead, *Echoes of Glory*, 127.
196. Woodhead, *Echoes of Glory*, 189.
197. "Unit Insignia," Revised Regulations for the Army of the United States 1861, http://howardlanham.tripod.com/unireg.htm.

Chapter 5

198. Ibid., 432.
199. Smith, et al., *Record of Service*, 431.
200. Priest, *Antietam*, 340.
201. Stedman, Military Service Records.
202. Revised Regulations, "Uniform, Dress, and Horse Equipments Coat."
203. Darrah, *Cartes de Visite*, 87.
204. Ayling, *Revised Register*, 285.
205. *Union Army*, 1:84.
206. *OR*, series 1, volume 19, part 1, 197.
207. Jackman, *History of the Sixth*, 104.
208. *Union Army*, 3:110; Griffin, Military Service Records.
209. Revised Regulations, "Uniform, Dress, and Horse Equipments Coat."
210. Darrah, *Cartes de Visite*, 87.
211. Civil War Soldiers and Sailors Database, "Battle Unit Details: 9th Regiment, New Hampshire Infantry."
212. Lord, *History of the Ninth*, 559.
213. Carman and Clemens, *Maryland Campaign*, 2:580.
214. Priest, *Antietam*, 340.
215. Judkins, Military Service Records.
216. Pension Card Index, https://www.fold3.com/image/249/5116432.
217. *OR*, series 3, volume 3, 338.
218. Darrah, *Cartes de Visite*, 87.
219. "Battle Unit Details: 51st Regiment, Pennsylvania Infantry," Civil War Soldiers and Sailors Database, https://www.nps.gov/civilwar/search-battle-units-detail.htm?battleUnitCode=UPA0051RI.
220. Carman and Clemens, *Maryland Campaign*, 2:580.
221. Priest, *Antietam*, 340.
222. Parker, *History of the 51st*, 234.
223. Van Lew, Military Service Records.

224. Pension Card Index, www.fold3.com/image/249/5837032.
225. Woodhead, *Echoes of Glory*, 116–17.
226. Revised Regulations, "Various Components: Sash."
227. Civil War Soldiers and Sailors Database, "Battle Unit Details: 51st Regiment, New York Infantry," https://www.nps.gov/civilwar/search-battle-units-detail.htm?battleUnitCode=UNY0051RI.
228. *Union Army*, 2:88.
229. Carman and Clemens, *Maryland Campaign*, 2:580.
230. *OR*, series 1, volume 19, part 1, 321–22.
231. Carman and Clemens, *Maryland Campaign*, 2:419.
232. Leonard, Military Service Records.
233. Revised Regulations, "Various Components: Sash."
234. "Uniform: Sword and Scabbard," in *Revised Regulations*, 469, http://quod.lib.umich.edu/m/moa/AGY4285.0001.001?rgn=main;view=fulltext.
235. Woodhead, *Echoes of Glory*, 72–73.
236. Ibid., 177.
237. "Uniform-Forage Cap-Cravat," in Revised Regulations, 467, http://quod.lib.umich.edu/m/moa/agy4285.0001.001/451?page=root;size=100;view=image.
238. Carman and Clemens, *Maryland Campaign*, 2:580.
239. Priest, *Antietam*, 340.
240. Carman and Clemens, *Maryland Campaign*, 2:484.
241. Grant, Military Service Records.
242. "Soldier Details: Grant, Frederick," Civil War Research and Genealogy Database, http://www.civilwardata.com/active/hdsquery.dll?SoldierHistory?U&81878.
243. Pension Card Index, www.fold3.com/image/249/2742502.
244. "Battle Unit Details: 2nd Massachusetts Heavy Artillery," Civil War Soldiers and Sailors Database, https://www.nps.gov/civilwar/search-battle-units-detail.htm?battleUnitCode=UMA0002RAH.
245. Revised Regulations, "Trowsers."
246. Revised Regulations, "Badges to Distinguish Rank."
247. Woodhead, *Echoes of Glory*, 175.
248. Revised Regulations, "Sword Components."
249. Woodhead, *Echoes of Glory*, 78.
250. Ibid., 174.
251. Revised Regulations, "Trimmings."

Chapter 6

252. *Union Army*, 1:381–82.
253. Carman and Clemens, *Maryland Campaign*, 2:79.
254. Priest, *Antietam*, 339.

255. "Soldier History: Samuel Klinger Schwenk," Civil War Research and Genealogy Database, http://civilwardata.com/active/hdsquery.dll?Soldier History?U&1049222.
256. Schwenk, Military Service Records.
257. Pension Card Index, www.fold3.com/image/249/7985424.
258. Darrah, *Cartes de Visite*, 87.
259. "Stamp Duties," *New York Herald-Tribune*, April 13, 1865.
260. Revised Regulations, "Badges to Distinguish Rank."
261. *Union Army*, 2:383–84.
262. Carman and Clemens, *Maryland Campaign*, 2:582.
263. Priest, *Antietam*, 341.
264. Whitford, Military Service Records.
265. Pension Card Index, www.fold3.com/image/249/6002925.
266. Woodhead, *Echoes of Glory*, 101.
267. Revised Regulations, "Badges to Distinguish Rank."
268. Ibid., 328.
269. *OR*, series 1, volume 19, part 1, 455.
270. Smith, et al., *Record of Service*, 327.
271. *OR*, series 1, volume 19, part 1, 452.
272. Ibid., 453–54.
273. Ibid., 455.
274. Ibid.
275. Carman and Clemens, *Maryland Campaign*, 2:581.
276. Austin, Military Service Records.
277. Pension Card Index, www.fold3.com/image/249/109378.
278. "Dating Old Family Photographs with Civil War Revenue Stamps," Genealogy Bank, https://blog.genealogybank.com/dating-old-family-photographs-with-civil-war-revenue-stamps.html.
279. Woodhead, *Echoes of Glory*, 101.
280. *Union Army*, 2:364.
281. Carman and Clemens, *Maryland Campaign*, 2:581.
282. Priest, *Antietam*, 341.
283. *OR*, series 1, volume 19, part 1, 466.
284. Ripley, Military Service Records.
285. Pension Card Index, www.fold3.com/image/249/13952710.
286. *Union Army*, 1:247–48.
287. *OR*, series 1, volume 19, part 1, 456–57.
288. Carman and Clemens, *Maryland Campaign*, 2:581.
289. Priest, *Antietam*, 340.
290. Allen, *Forty-Six Months*, 146.
291. *OR*, series 1, volume 19, part 1, 455–58.
292. Steele, Military Service Records.

293. Pension Card Index, www.fold3.com/image/249/25583314.
294. "Soldier History: William Henry Peck Steere," Civil War Research and Genealogy Database, http://civilwardata.com/active/hdsquery.dll?SoldierHistory?U&793058.
295. Revised Regulations, "Trowsers."
296. Revised Regulations, "Badges to Distinguish Rank."
297. Woodhead, *Echoes of Glory*, 177.
298. Revised Regulations, "Trimmings."
299. *Union Army*, 1:290–91.
300. Carman and Clemens, *Maryland Campaign*, 2:581.
301. *OR*, series 1, volume 19, part 1, 197.
302. Blakeslee, *History of the Sixteenth*, 11.
303. Ibid., 16.
304. Landon, Military Service Records.
305. Pension Card Index, www.fold3.com/image/249/279206.
306. Revised Regulations, "Badges to Distinguish Rank."

Epilogue

307. Carman and Clemens, *Maryland Campaign*, 506–7.
308. Ibid., 512–13.
309. Ibid., 508–10.
310. Lee, "Origin and Evolution of the National Military Park Idea," National Park Service, accessed 10/28/18, http://www.nps.gov/history/history/online_books/history_military/index.htm.

Appendix

311. *OR*, series 1, volume 19, part 1, 226–29.
312. Ibid., 261–62.
313. Ibid., 263–64.
314. Ibid., 510–11.
315. Ibid., 315–16.
316. Ibid., 312–14.
317. Ibid., 323.
318. Ibid., 515–16.
319. Ibid., 333–34.
320. Ibid., 296–98.
321. Ibid., 282–83.
322. Ibid., 302–3.
323. Ibid., 287–88.
324. Ibid., 304–5.
325. Ibid., 471–72.
326. Ibid., 464–66.
327. Ibid., 454–55.
328. Ibid., 452–54.

Bibliography

Primary Sources

Allen, George H. *Forty-Six Months with the Fourth R.I. Volunteers in the War of 1861 to 1865: Comprising a History of Its Marches, Battles, and Camp Life.* Salem, MA: Higginson Book Company 1998.

Ayling, Augustus D. *Revised Register of the Soldiers and Sailors of New Hampshire in the War of the Rebellion, 1861–1865.* Concord, NH: Ira C. Evans, Public Printer, 1895.

Billings, John D. *Hard Tack and Coffee.* Boston: George M. Smith & Company, 1888.

Birch, Harold B. *The 50th Pennsylvania's Civil War Odyssey: The Exciting Life and Hard Times of a Union Volunteer Infantry Regiment, 1861 to 1865.* Bloomington, IN: 1st Books, 2003.

Blakeslee, B.F. *History of the Sixteenth Connecticut Volunteers.* Hartford, CT: Case, Lockwood & Brainard Company, 1875.

Bruce, Brevet Lieutenant Colonel George A. *The Twentieth Regiment of Massachusetts Volunteer Infantry 1861–1865.* Baltimore, MD: Butternut & Blue, 1988.

Carman, Ezra A., and Dr. Thomas G. Clemens, ed. *The Maryland Campaign of September 1862.* Vol. 2. *Antietam.* El Dorado Hills, CA: Savas Beatie, 2012.

Chapin, Louis N. *A Brief History of the Thirty-Fourth Regiment, N.Y.S.V.* Whitefish, MT: Kessinger Publishing's Rare Reprints, 2010.

Child, William. *The History of the Fifth Regiment New Hampshire Volunteers in the American Civil War, 1861–1865.* Bristol, NH: R.W. Musgrove, Printer, 1893.

Coco, Gregory A., ed. *From Ball's Bluff to Gettysburg and Beyond: The Civil War Letters of Private Roland E. Bowen 15th Massachusetts Infantry 1861–1865.* Gettysburg, PA: Thomas Publications, 1994.

Cook, Lieutenant Colonel Benjamin F. *History of the 12th Massachusetts Volunteers (Webster Regiment).* Boston: Twelfth (Webster Regiment) Association, 1882.

BIBLIOGRAPHY

Eddy, Richard. *History of the Sixtieth Regiment New York State Volunteers.* Philadelphia, PA: self-published, 1864.

Favill, Josiah M. *The Diary of a Young Officer.* Baltimore, MD: Butternut & Blue, 2000.

Ford, Andrew E. *The Story of the Fifteenth Regiment Massachusetts Volunteer Infantry in the Civil War 1861–1864.* Clinton, MA: Press of W.J. Coulter, 1898.

Frederick, Gilbert, Late Captain 57th N.Y.V.I. *The Story of a Regiment being the Record of the Military Service of the Fifty-Seventh New York State Volunteer Infantry in the War of the Rebellion 1861–1865.* Published by the Fifty-Seventh Veteran Association, 1895.

A Full Report of the First Re-union and Banquet of the Thirty-Fifth N.Y. Vols., held at Watertown, N.Y. on December 13th, 1887. Watertown, NY: Times Printing and Publishing House, 1888.

History Committee. *History of the Nineteenth Regiment Massachusetts Volunteer Infantry 1861–1865.* Salem, MA: Salem Press Company, 1906 (reprint Salem, MA: Higginson Book Company, 1998).

Holden, Walter, William E. Ross and Elizabeth Slomba, eds. *Stand Firm and Fire Low: The Civil War Writings of Colonel Edward E. Cross.* Hanover: University of New Hampshire Press of New England, 2003.

Jackman, Captain Lyman, and Amos Hadley, ed. *History of the Sixth New Hampshire Regiment in the War for the Union.* Concord, NH: Republican Press Association, 1891 (reprint Salem, MA: Higginson Book Company, 2000).

Kent, Arthur A., ed. *Three Years with Company K, Sergt. Austin C. Stearns Company K, 13th Mass. Infantry.* Rutherford, NJ: Farleigh Dickson University Press, 1976.

Lord, Edward O., ed. *History of the Ninth Regiment New Hampshire Volunteers in the War of the Rebellion.* Concord, NH: Republican Press Association, 1895.

Massachusetts Adjutant General's Office. *Massachusetts Soldiers, Sailors and Marines.* Vol. 2. Norwood, MA: Norwood Press, 1931.

————. *Massachusetts Soldiers, Sailors and Marines.* Vol. 3. Norwood, MA: Norwood Press, 1932.

New York Herald-Tribune. "Stamp Duties." April 13, 1865.

Osborne, William H. *The History of the Twenty-Ninth Regiment of Massachusetts Volunteer Infantry, in the Late War of the Rebellion.* Boston: Albert J. Wright, Printer, 1877.

Page, Charles D. *History of the Fourteenth Regiment, Connecticut Volunteer Infantry.* Meriden, CT: Horton Printing Company, 1906.

Parker, Thomas H. *History of the 51st Regiment of Pennsylvania Volunteers.* Baltimore, MD: Butternut & Blue, 1998.

Powell, Lieutenant Colonel William H., ed. *Officers of the Army and Navy (Volunteer) Who Served in the Civil War.* Philadelphia: L.R. Hamersly & Company, 1893.

Radigan, Emily N., ed. *"Desolating This Fair Country": The Civil War Diary and Letters of Lt. Henry C. Lyon, 34th New York.* Jefferson, NC: McFarland & Company, 1999.

Richard, Chaplain Eddy. *History of the Sixtieth Regiment New York Volunteers.* Philadelphia, PA: self-published, 1864.

Sauers, Richard A., ed. *The Civil War Journal of Colonel Bolton, 51ˢᵗ Pennsylvania, April 20, 1861–August 2, 1865.* Conshohocken, PA: Combined Publishing 2000.

Smith, Brigadier General Stephen R., et al. *Record of Service of Connecticut Men in the Army and Navy of the United States in the War of the Rebellion.* Hartford, CT: Press of the Case, Lockwood & Brainard Company, 1889.

The Union Army. 10 vols. Wilmington, NC: Broadfoot, 1997. First published 1908 by Federal Publishing Company.

United States War Department. *Official Records of the War of the Rebellion: A Compilation of the Official Records of the Union and Confederate Armies.* Series 1, volume 19, part 1. Washington, D.C.: Government Printing Office, 1889.

———. *Official Records of the War of the Rebellion, A Compilation of the Official Records of the Union and Confederate Armies.* Series 1, volume 19, part 2. Washington, D.C.: Government Printing Office, 1889.

———. *Official Records of the War of the Rebellion: A Compilation of the Official Records of the Union and Confederate Armies.* Series 1, volume 21. Washington, D.C.: Government Printing Office, 1888.

———. *Official Records of the War of the Rebellion: A Compilation of the Official Records of the Union and Confederate Armies.* Series 1, volume 40, part 1. Washington, D.C.: Government Printing Office, 1892.

———. *Official Records of the War of the Rebellion: A Compilation of the Official Records of the Union and Confederate Armies.* Series 3, volume 3. Washington, D.C.: Government Printing Office, 1889.

———. *Official Records of the War of the Rebellion: A Compilation of the Official Records of the Union and Confederate Armies.* Series 3, volume 5. Washington, D.C.: Government Printing Office, 1889.

———. *Revised United States Army Regulations of 1861, with an Appendix Containing the Changed and Laws Affecting Army Regulations and Articles of War to June 25, 1863.* Washington, D.C.: Government Printing Office, 1863.

Military Service Records

Adriance, William H. Military Service Records, *Company B, 24ᵗʰ New York Volunteer Infantry,* National Archives and Records Administration, Record Group 94.

Ames, Harlow. Military Service Records, *Company D, 23ʳᵈ New York Volunteer Infantry,* National Archives and Records Administration, Record Group 94.

Austin, Albert. Military Service Records, *Company F, 8ᵗʰ Connecticut Volunteer Infantry,* National Archives and Records Administration, Record Group 94.

Baker, John J. Military Service Records, *Company K, 22ⁿᵈ New York Volunteer Infantry,* National Archives and Records Administration, Record Group 94.

Burbank, Elisha. Military Service Records, *Field and Staff, 12ᵗʰ Massachusetts Infantry,* National Archives and Records Administration, Record Group 94.

BIBLIOGRAPHY

Clark, Irving D. Military Service Records, *Company B, 34th New York Volunteer Infantry*, National Archives and Records Administration, Record Group 94.

Corbett, Waldo. Military Service Records, *Company H, 29th Massachusetts Infantry*, National Archives and Records Administration, Record Group 94.

Fisk, Ephraim. Military Service Records, *1st New Hampshire Light Artillery*, National Archives and Records Administration, Record Group 94.

Goodwin, George. Military Service Records, *Company F, 5th New Hampshire Infantry*, National Archives and Records Administration, Record Group 94.

Grant, Frederick. Military Service Records, *Company D/F, 35th Massachusetts Volunteer Infantry*, National Archives and Records Administration, Record Group 94.

Griffin, Simon. Military Service Records, *Field & Staff, 6th New Hampshire Volunteer Infantry*, National Archives and Records Administration, Record Group 94.

Gurney, Asa L. Military Service Records, *Company G, 30th New York Volunteer Infantry*, National Archives and Records Administration, Record Group 94.

Jones, George. Military Service Records, *Company G, 57th New York Infantry Regiment*, National Archives and Records Administration, Record Group 94.

Judkins, Charles. Military Service Records, *Company A, 9th New Hampshire Volunteer Infantry*, National Archives and Records Administration, Record Group 94.

Keiner, William. Military Service Records, *Company E, 3rd Maryland Volunteer Infantry*, National Archives and Records Administration, Record Group 94.

Kelcher, Peter B. Military Service Records, *Company B, 28th New York Volunteer Infantry*, National Archives and Records Administration, Record Group 94.

Kimball, Marcus. Military Service Records, *Company A, 19th Massachusetts Volunteer Infantry*, National Archives and Records Administration, Record Group 94.

Landon, Herbert. Military Service Records, *Company B, 16th Connecticut Volunteer Infantry*, National Archives and Records Administration, Record Group 94.

Leonard, William H. Military Service Records, *Field and Staff, 51st New York Volunteer Infantry*, National Archives and Records Administration, Record Group 94.

McMahon, James P. Military Service Records, *Company K, 69th New York Volunteer Infantry*, National Archives and Records Administration, Record Group 94.

McWayne, Jay. Military Service Records, *Company K, 35th New York Volunteer Infantry*, National Archives and Records Administration, Record Group 94.

Miller, Jabez. Military Service Records, *Company A, 26th New York Volunteer Infantry*, National Archives and Records Administration, Record Group 94.

Milton, William F. Military Service Records, *Company G, 20th Massachusetts Volunteer Infantry*, National Archives and Records Administration, Record Group 94.

Morgan, Frank. Military Service Records, *Company B, 14th Connecticut Volunteer Infantry*, National Archives and Records Administration, Record Group 94.

Purdy, Sanford. Military Service Records, *Company I, 59th New York Volunteer Infantry*, National Archives and Records Administration, Record Group 94.

Ripley, David. Military Service Records, *Company G, 12th Ohio Volunteer Infantry*, National Archives and Records Administration, Record Group 94.

Russell, Edward. Military Service Records, *Company F, 15th Massachusetts Volunteer Infantry*, National Archives and Records Administration, Record Group 94.

Sawyer, Appleton. Military Service Records, *Company K, 13th Massachusetts Volunteer Infantry*, National Archives and Records Administration, Record Group 94.

Schmearer, Tobias. Military Service Records, *Company K, 53rd Pennsylvania Infantry Regiment*, National Archives and Records Administration, Record Group 94.

Schwenk, Samuel. Military Service Records, *Company A, 50th Pennsylvania Volunteer Infantry*, National Archives and Records Administration, Record Group 94.

Sellers, Philips. Military Service Records, *Company F, 107th Pennsylvania Volunteer Infantry*, National Archives and Records Administration, Record Group 94.

Simpson, James. Military Service Records, *Company C, 14th Connecticut Infantry*, National Archives and Records Administration, Record Group 94.

Stedman, Griffin. Military Service Records, *Field and Staff, 11th Connecticut Volunteer Infantry*, National Archives and Records Administration, Record Group 94.

Steere, William. Military Service Records, *Field & Staff, 4th Rhode Island Volunteer Infantry*, National Archives and Records Administration, Record Group 94.

Van Lew, John. Military Service Records, *Company K, 51st Pennsylvania Volunteer Infantry*, National Archives and Records Administration, Record Group 94.

Whitford, James. Military Service Records, *Field & Staff, 36th Ohio Volunteer Infantry*, National Archives and Records Administration, Record Group 94.

Willson, Lester. Military Service Records, *Company A, 60th New York Volunteer Infantry*, National Archives and Records Administration, Record Group 94.

Secondary Sources

Banks, John, *Connecticut Yankees at Antietam*. Charleston, SC: The History Press, 2013.

Darrah, William C. *Cartes de Visite in Nineteenth Century Photography*. Gettysburg, PA: W.C. Darrah Publisher, 1981.

Dyer, Frederick H. *Compendium of the War of the Rebellion*. Vol. 2. Dayton, OH: Morningside Bookshop, 1978.

Konstam, Angus. *The Civil War Soldier*. New York: Universe Publishing, 2015.

Murry, R.L. *Madison County Troops in the Civil War*. Wolcott, NY: Benedum Books, 2004.

Priest, John Michael. *Antietam: The Soldier's Battle*. New York: Oxford University Press, 1989.

Radcliffe, George E. *Governor Thomas H. Hicks of Maryland and the Civil War*. Baltimore, MD: Johns Hopkins Press, 1901.

Raus, Edmund J., Jr. *Banners South: A Northern Community at War*. Kent, OH: Kent State University Press, 2005.

Reimer, Terry. *One Vast Hospital: The Civil War Hospital Sites in Frederick, Maryland after Antietam*. Frederick, MD: National Museum of Civil War Medicine, 2001.

Taylor, Paul. *Glory Was Not Their Companion: The 26th New York Volunteer Infantry in the Civil War.* Jefferson, NC: McFarland and Company, 2005.

Warner, Ezra J. *Generals in Blue: Lives of the Union Commanders.* Baton Rouge: Louisiana State University Press, 1964.

Woodhead, Henry, ed. *Echoes of Glory: Arms and Equipment of the Union.* Alexandria, VA: Time Life Books, 1991.

Primary Source Websites

Antietam on the Web. http://antietam.aotw.org/index.php.

Civil War Research and Genealogy Database. "New York Fifty-Seventh Infantry." Accessed June 7, 2017. http://civilwardata.com/active/hdsquery. dll?RegimentHistory?1540&U.

———. "Personnel Directory." http://www.civilwardata.com/active/pers_dir.html.

———. "Soldier Details: Grant, Frederick." Accessed February 28, 2018. http:// www.civilwardata.com/active/hdsquery.dll?SoldierHistory?U&81878.

———. "Soldier History: Samuel Klinger Schwenk." Accessed December 14, 2017. http://civilwardata.com/active/hdsquery.dll?SoldierHistory?U&1049222.

———. "Soldier History: William Henry Peck Steere." Accessed February 28, 2018. http://civilwardata.com/active/hdsquery.dll?SoldierHistory?U&793058.

Civil War Soldiers and Sailors Database. "Battle Unit Details: 4th Massachusetts Heavy Artillery." Accessed July 30, 2017. https://www.nps.gov/civilwar/search-battle-units-detail.htm?battleUnitCode=UMA0004RAH.

———. "Battle Unit Details: 11th Regiment, Connecticut Infantry." Accessed November 27, 2017. https://www.nps.gov/civilwar/search-battle-units-detail. htm?battleUnitCode=UCT0011RI.

———. "Battle Unit Details: 2nd Massachusetts Heavy Artillery." Accessed July 29, 2017. https://www.nps.gov/civilwar/search-battle-units-detail. htm?battleUnitCode=UMA0002RAH.

———. "Battle Unit Details: 6th Regiment, New Hampshire Infantry." Accessed November 27, 2017. https://www.nps.gov/civilwar/search-battle-units-detail. htm?battleUnitCode=UNH0006RI.

———. "Soldier Details: Baker, John J." Accessed January 7, 2017. https://www. nps.gov/civilwar/search-soldiers-detail.htm?soldierId=1130817E-DC7A-DF11-BF36-B8AC6F5D926A.

———. "Soldier Details: Purdy, Saford." Accessed May 4, 2017. https://www.nps. gov/civilwar/search-soldiers-detail.htm?soldierId=A05A5BC5-DC7A-DF11-BF36-B8AC6F5D926A.

Pension Card Index, National Archives and Records Administration. www.fold3.com.

Revised Regulations for the Army of the United States, 1861. "Badges to Distinguish Rank." Accessed February 21, 2017. http://howardlanham.tripod.com/unireg.htm.

———. "Buttons." Accessed June 4, 2017. http://howardlanham.tripod.com/unireg.htm.

———. "General Orders Relating to the Uniform of the US Army 1861–1865." Accessed February 28, 2017. http://howardlanham.tripod.com/go.htm.

———. "General's Uniform." Accessed February 27, 2017. http://howardlanham.tripod.com/unireg.htm.

———. "Officers and Enlisted Men's Sashes." Accessed February 28, 2017. http://howardlanham.tripod.com/unireg.htm.

———. "Shoulder Scales." Accessed February 27, 2017. http://howardlanham.tripod.com/link25.htm.

———. "Sword Components." Accessed May 14, 2017. http://howardlanham.tripod.com/unireg.htm.

———. "Trimmings." Accessed January 1, 2017. http://howardlanham.tripod.com/unireg.htm.

———. "Trowsers." Accessed May 1, 2017. http://howardlanham.tripod.com/unireg.htm.

———. "Uniform, Dress, and Horse Equipments Coat." Accessed January 11, 2017. http://howardlanham.tripod.com/unireg.htm.

———. "Unit Insignia." Accessed June 7, 2017. http://howardlanham.tripod.com/unireg.htm.

———. "Various Components: Sash." Accessed May 14, 2017. http://howardlanham.tripod.com/unireg.htm.

13th Massachusetts Volunteers. "The Band Musters Out." Accessed February 10, 2017. http://www.13thmass.org/1862/new_leaders.html#mozTocId492730.

———. "Following the Ambulance Train with Sam Webster and Appleton Sawyer." Accessed February 13, 2017. http://www.13thmass.org/1863/chancellorsville.html#mozTocId111747.

United States War Department. *Revised United States Army Regulations of 1861, with an Appendix Containing the Changed and Laws Affecting Army Regulations and Articles of War to June 25, 1863*. Ann Arbor: University of Michigan Library, 2005. Accessed July 20, 2017. http://quod.lib.umich.edu/m/moa/agy4285.0001.001/451?page=root;size=100;view=image.

Secondary Source Websites

American Battlefield Protection Program: CWSAC Battle Summaries. "Fort Macon." https://www.nps.gov/abpp/battles/nc004.htm.

C.J. Daley: Historical Reproductions. "A Study of Enlisted Invalid Corps Jackets 1863–1866." Accessed May 4, 2017. http://www.cjdaley.com/vrc.htm.

Genealogy Bank. "Dating Old Family Photographs with Civil War Revenue Stamps." Accessed September 14, 2017. https://blog.genealogybank.com/dating-old-family-photographs-with-civil-war-revenue-stamps.html.

Lee, Ronald F. "The Origin and Evolution of the National Military Park Idea." National Park Service. Accessed October 28, 2018. http://www.nps.gov/history/history/online_books/history_military/index.htm.

National Archives and Records Administration. "Veteran Reserve Corps (VRC), 1863–1865." Accessed February 27, 2017. https://www.archives.gov/files/research/military/civil-war/veteran-reserve-corps.pdf.

New York State Military Museum and Veterans Research Center. "164th Infantry Regiment—Civil War." Accessed May 28, 2017. https://dmna.ny.gov/historic/reghist/civil/infantry/164thInf/164thInfMain.htm.

———. "30th Infantry Regiment." Accessed December 29, 2016. https://dmna.ny.gov/historic/reghist/civil/infantry/30thInf/30thInfMain.htm.

Ridgeway Reference Archive, Civil War Buttons. "Buttons from Massachusetts." Accessed May 14, 2017. http://www.relicman.com/buttons/Button4100-Massachusetts.html.

———. "Buttons from New York." Accessed November 10, 2016. http://www.relicman.com/buttons/zArchiveButton2NewYork.htm.

———. "Buttons from Pennsylvania." Accessed February 4, 2017. http://www.relicman.com/buttons/zArchiveButton2Pennsylvania.htm.

Index

AUTHOR PROFILES

Matthew Borders is a 2004 graduate of Michigan State University with a BA in U.S. history. While at MSU he was first an intern and then a seasonal ranger for the National Park Service at Antietam National Battlefield. Following his undergrad coursework, he immediately went to Eastern Michigan University for his MS in historic preservation, with a focus in battlefield interpretation, which he earned in 2006. While at Eastern he again worked at Antietam as a seasonal ranger.

Upon graduation he taught for a year at Kalamazoo Valley Community College before accepting a position with the National Park Service's American Battlefield Protection Program. Moving to Maryland in 2007 with his wife, Kira, he worked as the historian for the ABPP for the next six years, personally surveying over one hundred different American Civil War battlefields in the Deep South and western United States. Over this period, he also became involved with the Save Historic Antietam Foundation (SHAF) and a member, later the president, of the Frederick County Civil War Round Table. He continues to work with Antietam National Battlefield as a volunteer and Certified Battlefield Guide, as well as a Certified Guide for Harpers Ferry National Historical Site.

Currently Matthew is a park ranger at Monocacy National Battlefield in Frederick, Maryland. He continues to volunteer regularly as a living history volunteer, portraying both Federal infantry and artillery during the American Civil War, and is a member of the Company A, 3rd Maryland Infantry reenacting organization. *Faces of Union Soldiers at Antietam* is his first book.

Joseph W. Stahl retired from the Institute for Defense Analyses, where he authored or coauthored more than fifty reports on defense issues. Since his retirement he has become a volunteer and NPS Certified Battlefield Guide at Antietam and Harpers Ferry. He grew up in St. Louis. He received BS and MS degrees from Missouri University of Science and Technology and an MBA from Washington University in St. Louis. He is a member of the Company of Military Historians, Save Historic Antietam Foundation (SHAF) and Hagerstown Civil War Round Table. He has spoken to various Civil War groups, including the Northern Virginia Relic Hunters; South Mountain Coin and Relic Club; Rappahannock, York, Chambersburg and Hagerstown Round Tables; Chambersburg Civil War Tours; SHAF; and the NPS Antietam. In addition, Joe has authored more than two dozen articles about items in his collections for *Gettysburg Magazine*, the Washington Times Civil War Page, *Manuscripts*, *America's Civil War*, *Military Collector & Historian*, the Journal of the Company of Military Historians, the *Civil War Historian* and the *Skirmish Line* of the North-South Skirmish Association. Displays of items from of his collection have won awards at several Civil War shows. He has been a member of the North-South Skirmish Association for more than twenty-five years and has shot Civil War–type muskets, carbines and revolvers in both individual and team competitions.